FANTASY
ART NOW

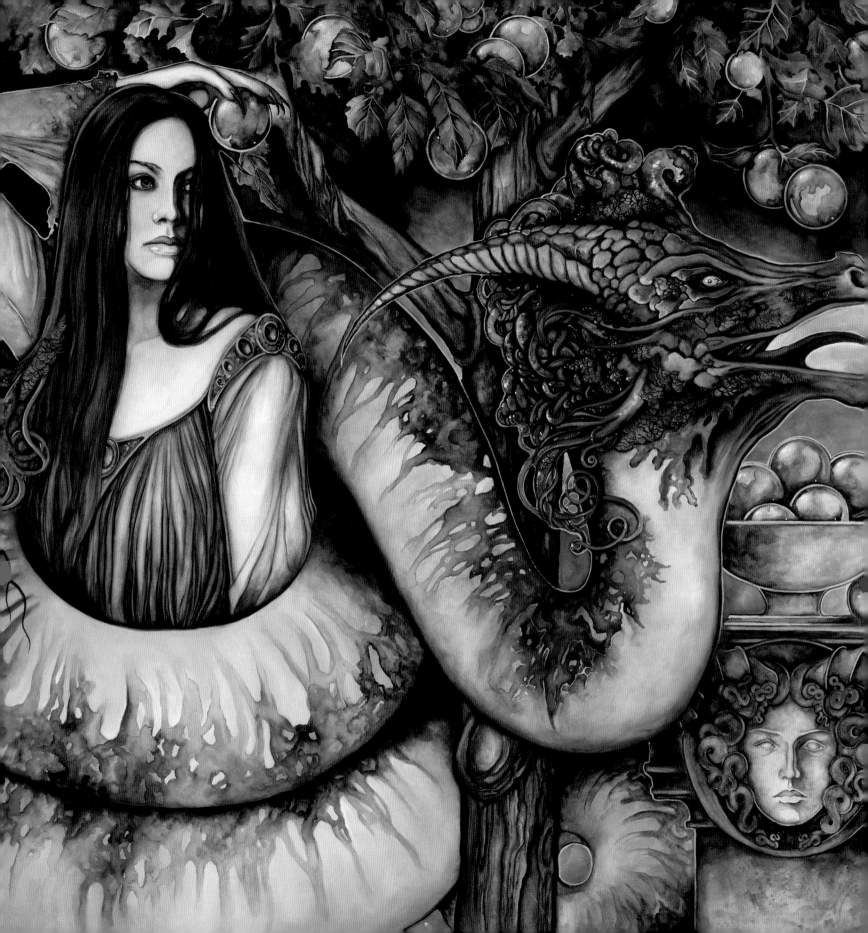

FANTASY ART NOW

THE VERY BEST IN CONTEMPORARY FANTASY ART & ILLUSTRATION

General Editor **MARTIN MCKENNA**
Foreword by **BORIS VALLEJO**

COLLINS | DESIGN

An Imprint of HarperCollins*Publishers*

FANTASY ART NOW

Copyright © 2007 by The Ilex Press Limited

All rights reserved. No part of this book may be used or
reproduced in any manner whatsoever without written
permission except in the case of brief quotations embodied
in critical articles and reviews. For information, address
Collins Design, 10 East 53rd Street, New York, NY 10022.

HarperCollins books may be purchased for educational,
business, or sales promotional use. For information,
please write: Special Markets Department, HarperCollins
Publishers, 10 East 53rd Street, New York, NY 10022.

First published in North America in 2007 by:
Collins Design
An Imprint of HarperCollins*Publishers*
10 East 53rd Street
New York, NY 10022
Tel: (212) 207-7000
Fax: (212) 207-7654
collinsdesign@harpercollins.com
www.harpercollins.com

Distributed throughout North America by:
HarperCollins*Publishers*
10 East 53rd Street
New York, NY 10022
Fax: (212) 207-7654

Library of Congress Cataloging-in-Publication Data

McKenna, Martin.
 Fantasy art now / Martin McKenna. -- 1st ed.
 p. cm.
 ISBN-13: 978-0-06-137097-7 (hardcover)
 ISBN-10: 0-06-137097-5 (hardcover)
 1. Fantasy in art. 2. Art, Modern--21st century. I. Title.

N8217.F28M34 2007
704.9'4--dc22

 2007021737

ISBN: 978-0-06-137097-7
ISBN-10: 0-06-137097-5

For more information on Fantasy Art Now, go to:
www.web-linked.com/moodus

Printed in China
Second printing, 2008

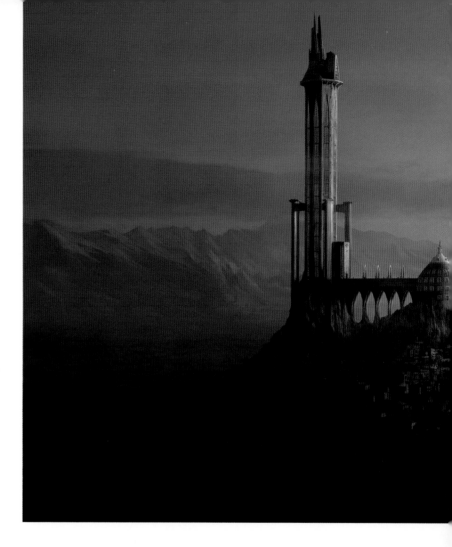

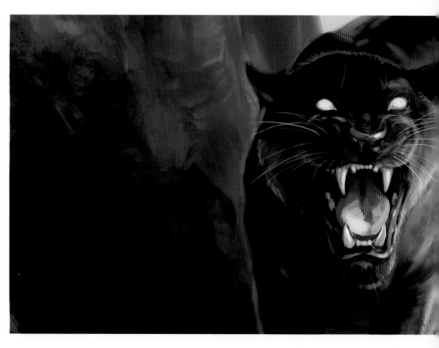

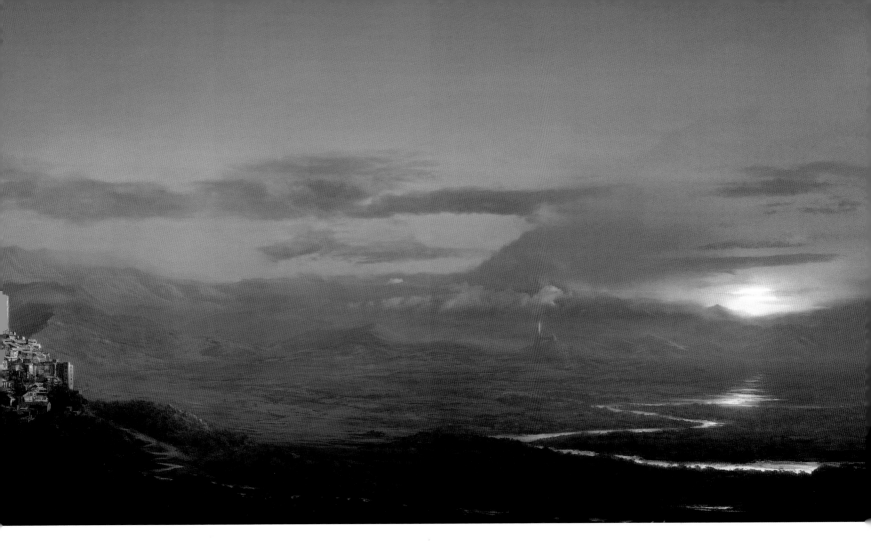

Contents

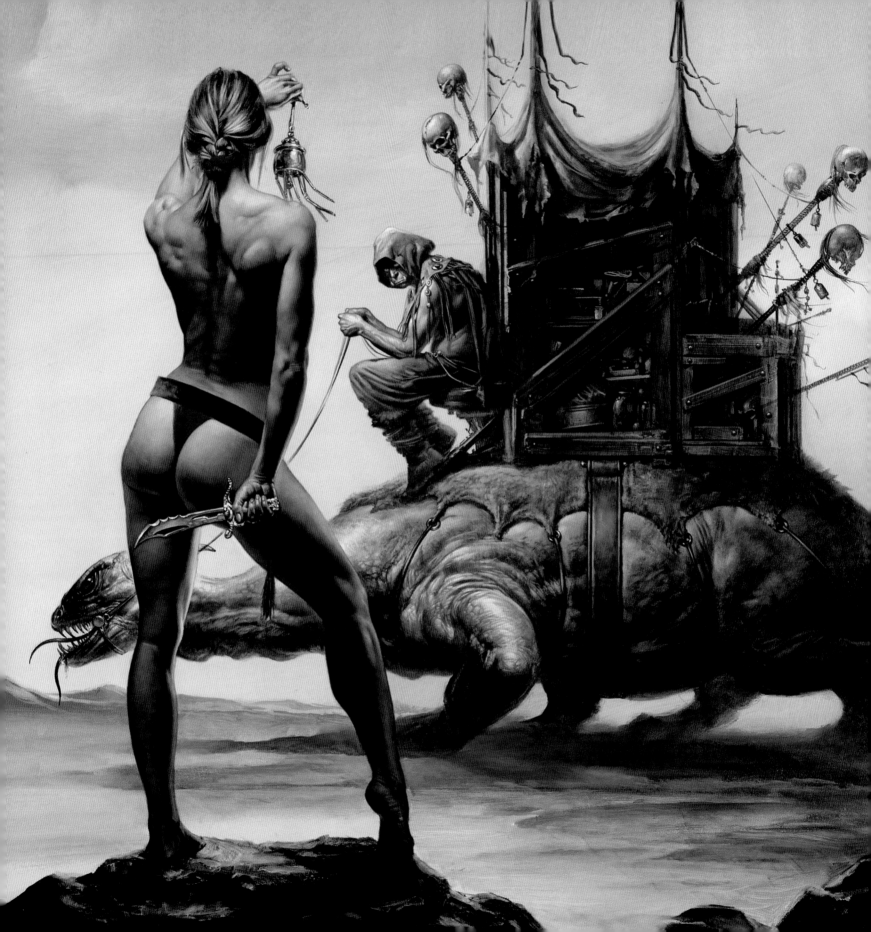

Reality is stranger than fiction, or so we are told. Present technology seems to confirm that statement. The arrival of personal computers has revolutionized the way we do most things in our daily lives, including art. It was not too long ago that Chesley Bonestell amazed the world with hyper-realistic renditions in oil of other worlds' landscapes, and today we have the luxury of seeing this in actual photographs.

The job of a fantasy artist is to even out the odds and make fiction stranger than reality. Years ago, during the first third of the 20th century, publications known as pulps featured fantasy short stories. Accompanied by somewhat garish illustrations, they often showed an artist's vision of alien inhabitants on other planets. For some reason, all of them were very anxious to invade our Earth; it was the infancy of this artistic genre. The artists worked for low pay, and always under the pressure of tough deadlines. The pulps came to an end in the early part of the 1950s, but not before having earned large legions of fans. Although paperback books have been around since the 19th century, the '50s saw the start of higher quality art on the covers of these mass-market publications. The following decade was to be crucial in establishing the quality of an art form that was now achieving maturity.

In order to create a good illustration, an artist must have a number of attributes; training, good imagination, and good narrative, among other things. In order to create a good fantasy illustration, the artist has to also be capable of pulling ideas out of thin air, since often they have to paint things that do not exist. To do this, the artist has to refer to their mental knowledge of things that *do* exist, and be able to modify them to be both strangely different and believable; this is what will make the finished illustration successful.

The 21st century is here.
Is reality stranger than fiction?
Is fiction stranger than reality?
You hold this book in your hands—you are the judge.

Boris Vallejo, 2007

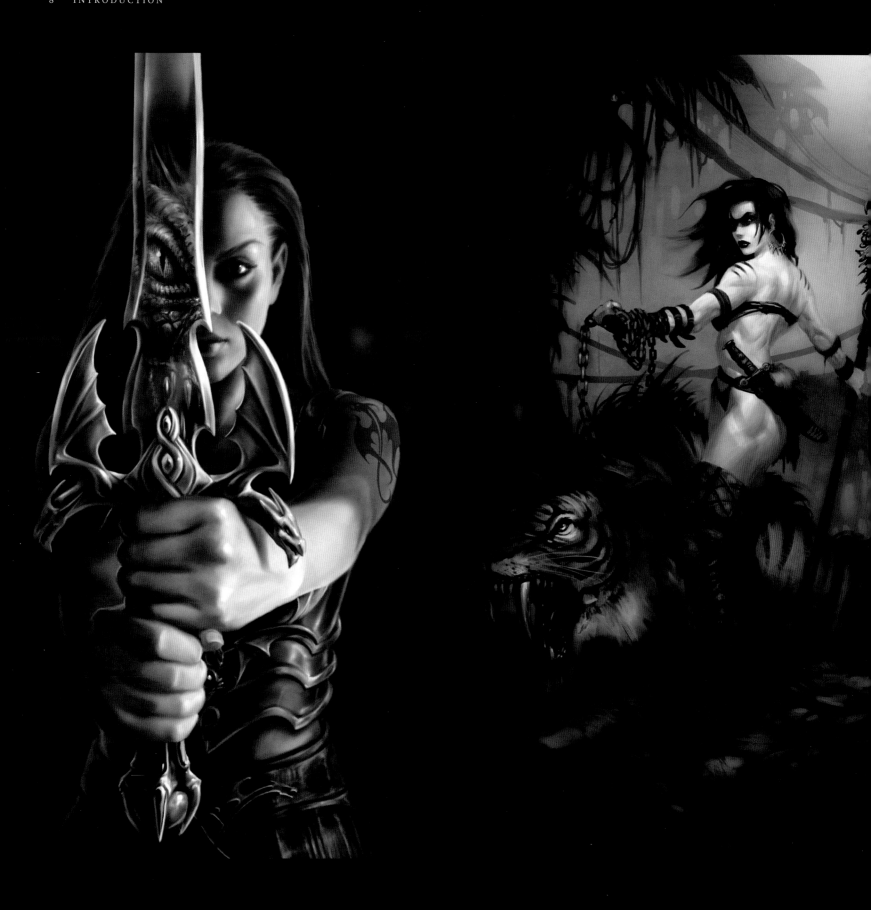

Introduction

Bringing *Fantasy Art Now* to fruition has been something of an epic journey.

Editing this book, and collecting together such a wealth of exceptional artwork, has given me the opportunity to embark on a truly global exploration of modern fantasy illustration. It has been a delightful, horizon-broadening expedition that, albeit for the most part undertaken in only electronic form via the Internet, has been nonetheless intrepid. It has enabled me to work with artists I've admired for many years, providing a great excuse to investigate the latest exciting projects by old friends and colleagues within the industry, and perhaps best of all, I discovered the work of a new wave of incredibly talented creators.

My search has brought me into contact with leading artists all over the world; across the U.S, Canada and South America, throughout Europe, Asia, and the Middle East. With such an international gathering, it's fascinating to observe the various differences, and perhaps more interestingly, the great many similarities of contemporary fantasy art that comes from different countries and cultures around the world.

The best fantasy art can provide a seductive escape route into a world of make believe; a way of blurring the borderline between the external reality we all share, and an artist's individual mental landscape. But a certain globalization of the high fantasy genre is apparent today; undoubtedly due to the widespread influence of fantasy films, computer games, and other popular media from Western Europe and the U.S. This often leads to artwork that conforms to accepted interpretations of over-familiar high fantasy themes.

Combined with this, painting styles also become extremely similar in the pursuit of fashionable effects, particularly in the field of concept design. Here, individualism can be obscured through the emulation of certain universally adopted fast-and-loose digital techniques, which can produce quick and effective, but sometimes anonymous, results. It's refreshing to encounter distinctive work that reflects an artist's unique cultural heritage and a wider frame of reference, and I hope I've presented some exciting examples of such work in *Fantasy Art Now*.

I've selected work from a broad spectrum of artists, some of whom are already extremely well-known and respected in fantasy art circles, some who are exciting rising stars well on their way to great success, and also from a range of brilliant new artists who, through this book, will see their art in print for the very first time. I'm delighted to have had the opportunity to bring together all these tremendously talented people and showcase their work, and working with each one has been an interesting experience. I think you'll agree that the book's combination of established fantasy artists and fresh new talent has resulted in an inspirational collection of fantastic imagery.

An interesting mixture of traditional and digital media is presented in the wide range of artwork on show in *Fantasy Art Now*. This reflects the degree to which the two disciplines currently coexist, but the widespread adoption of the digital approach will continue to increase as its advantages are obvious, particularly to busy illustrators with a need to speed up production time within tight deadlines, leveraging their natural talents and techniques. Many artists employ a workflow that utilizes elements of both, most commonly maintaining the spontaneity of sketching on paper, and then scanning to paint digitally. A software package like Corel Painter can emulate so many aspects of natural media successfully to be virtually indistinguishable from the real thing, and, with many paintings in this collection, you may find it is necessary to consult the caption to learn whether digital or traditional media has been used. As the digital medium matures, it's gaining something of its own aesthetic, as previous new media have done before it. The digital artwork in this collection heralds the new wave of contemporary creators and their endlessly adaptable new medium: the computer.

Many of the pieces presented here are brand new and exclusive to this volume. Other artwork comes from virtually every kind of fantasy-themed media, including book and graphic novel covers, role-playing games, and collectible card games. The material appears here uncropped and free from additional graphics, so in many cases it's the first time the imagery can be seen the way the artist created it. Also showcased is concept and production art for computer games and film projects, which includes work not intended for print elsewhere; so many of these images are seen here for the very first time.

The role of an art book like this could conceivably be questioned in the modern digital age, given the prevalence of excellent online fantasy art galleries. From an artist's point of view, it's true that an effective personal website will ultimately provide them with more exposure, reaching a far larger potential audience than a book release is ever likely to achieve. Nevertheless, no matter how much wonderful artwork there is to view with ease online, it ultimately feels like a rather transitory interaction. No amount of Internet clicking quite equals the greater sense of permanence gained from the intimate, tactile experience of leafing through the glossy pages of a book which contains well-reproduced and carefully chosen examples of the best of a genre's art, and that has been our ambition with this volume.

Here, you will find some of the finest, freshest, and most exciting talents in the world of fantasy illustration, brought together in a dazzling array of artwork presented for the first time in one luxurious showcase volume. This is not a book of retrospectives, but examines what illustrators and painters are creating today in their approach to fantasy art, and represents them in a book that looks forward rather than back. The following pages are graced with some of the very best in contemporary fantasy art. This is fantasy art now!

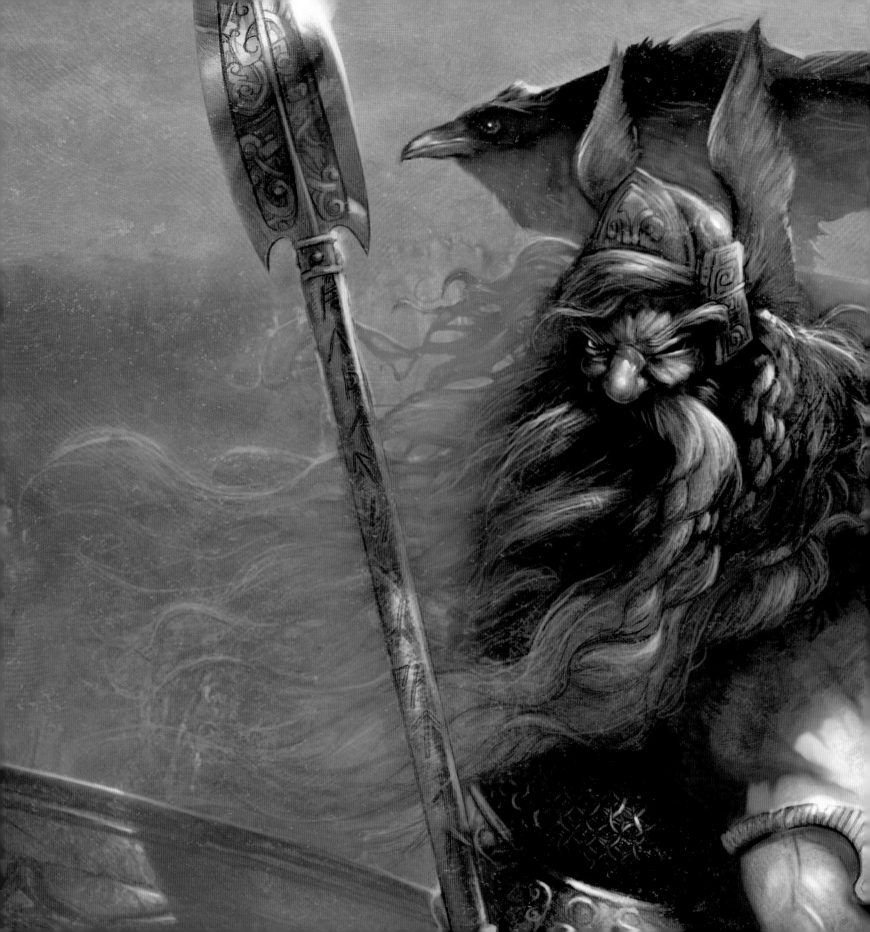

CHAPTER 1
BRAWNY BARBARIANS AND HULKY HEROES

◄ **Odin**

Glen Angus
Portfolio work
Adobe Photoshop
www.gangus.net

This character was created in the wake of the artwork Glen had done for Wizards of The Coast's new edition of the Dungeons & Dragons Deities and Demigods book. "An earlier edition of this book first inspired me as a budding artist to get into the fantasy art business. I was extremely lucky to get to illustrate many of the Norse Gods in the new book, but wanted to do my own interpretation of Odin as I have always been fascinated by all things Viking."

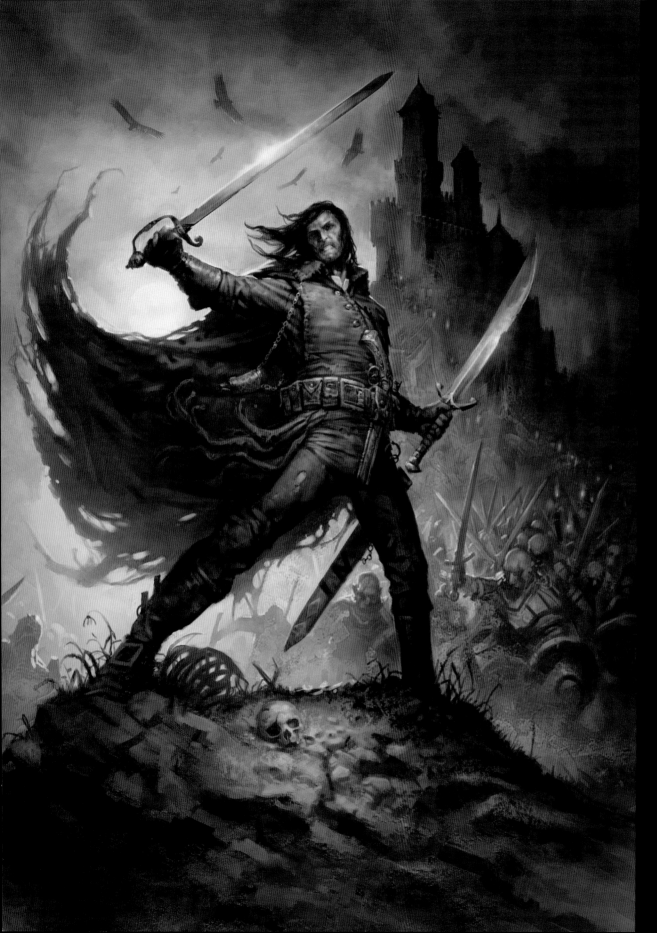

Solomon Kane
Greg Staples
Movie poster illustration
Solomon Kane from Davis Films
Corel Painter
www.gregstaples.co.uk

This painting was created as a poster for a film festival, to promote the movie version of Robert E. Howard's Solomon Kane. *The film has since gone into production, and Greg is the concept artist on the project. "I've been working on the movie, doing concept art, production paintings, and this poster, which I produced for the Berlin film market. It's a great script, and I'm looking forward to seeing the finished film."*

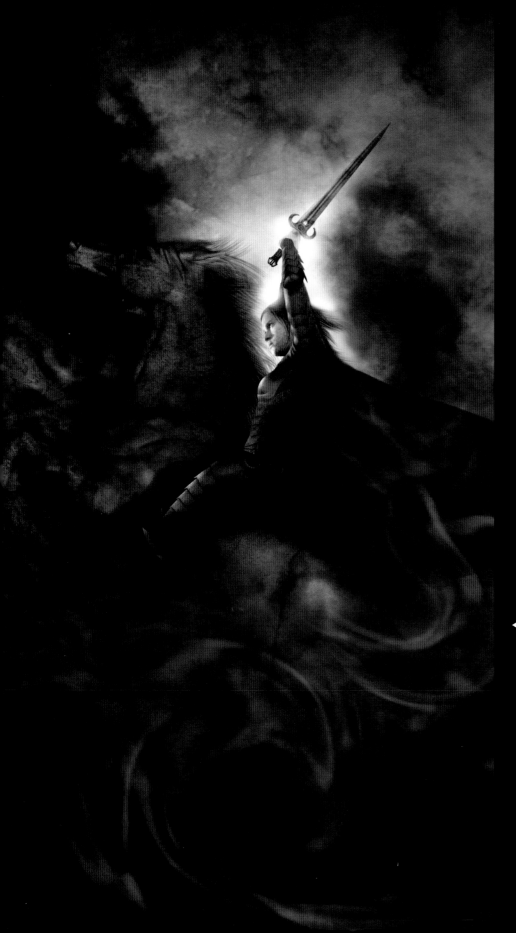

◀ **The Golden Armor**
Felipe Machado Franco
Portfolio work
Adobe Photoshop
http://finalfrontier.thunderblast.net

*Felipe created this artwork as
a gift. "My girlfriend playfully
hinted that recently I hadn't
featured her in any artwork, so
I made something especially that
she would like. I started with a
photograph of her, taken from a
series of sword attack poses. As the
basis for the horse, I used a photo
of a sculpture, and the armor
was made from simple shapes,
carefully repeated and shaded."*

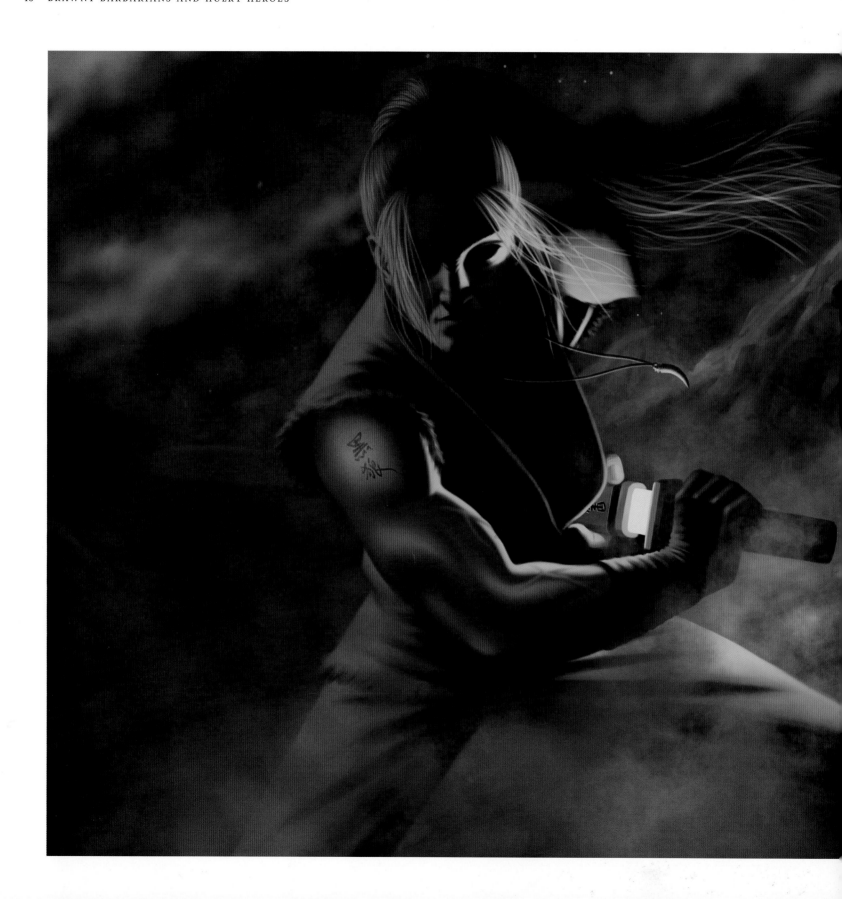

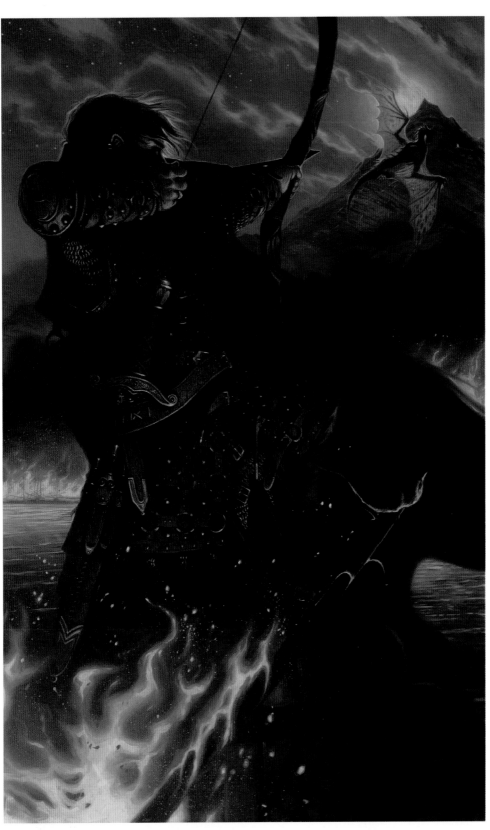

◄◄ Black Wolf Ronin
Robert Chang
Portfolio work
Adobe Photoshop and Corel Painter
www.ethereality.info

*Robert describes this as a spur
of the moment idea, which he
then decided to render fully.
"I think part of the origin of
the idea was that I felt a little
guilty about mostly depicting
attractive females. But so far,
since finishing this piece, I've not
produced any other paintings
featuring only male characters…
I guess I stopped feeling guilty!
The tattoo on his arm says, you
guessed it, 'Black Wolf.'"*

◄ Fire and Water
William O'Connor
Portfolio work
Oil on masonite
www.wocillo.com

*An illustration inspired by
Tolkien's* The Hobbit. *Bill sets
the scene; "Bard, the captain of
the guard, fires the last magic
arrow at the rampaging Smaug.
The lonely mountain looms in
the background. The bird with
the secret of Smaug's weakness
watches as the arrow is about to
be fired." The composition of this
image is influenced by Japanese
woodblock prints, and the limited
palette infuses the painting with
a sense of age and timelessness.*

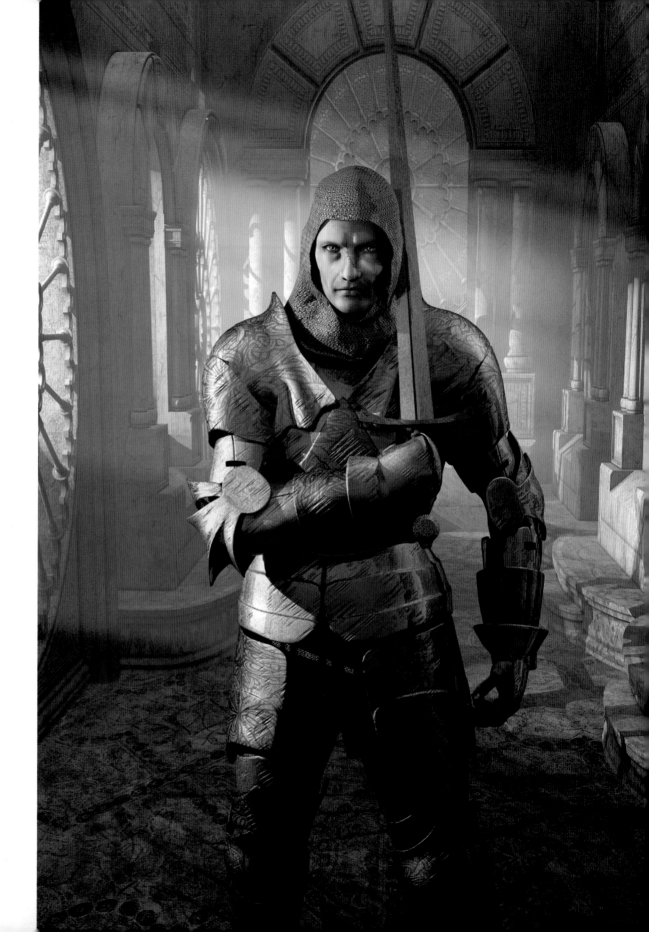

▶ **"Thou Shall Not Pass!"**
Paul Bourne
Portfolio work
Daz Bryce and Corel Paint Shop Pro
www.contestedground.co.uk

*With this image, Paul wanted
to portray true bravery, as he
reveals: "The brave knight who
fights a dragon is not brave
if he is not afraid, but the
terrified knight who fights a
dragon shows genuine bravery
and strength of character. This
knight, who has clearly seen
some action already, confronts
the viewer, or an unseen
aggressor, outside the picture.
He is alone, and without the
protection of a helmet."*

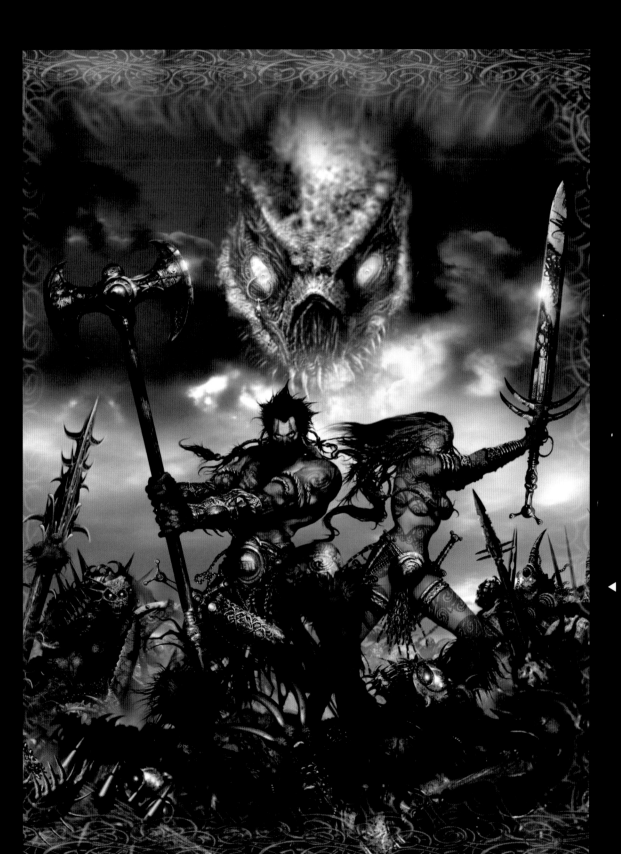

◄ **Slaine**
Clint Langley
Book cover
*Slaine: The Books of Invasions
Vol. 1* from Rebellion
Adobe Photoshop
www.clintlangley.com

*Clint was commissioned by
Rebellion to create this powerful
cover. "I collaborated closely
with the writer Pat Mills over
four years, to create a cast of
Celtic characters for* Slaine,
*who fought it out over 300
pages of comic art. The three
volumes chart my progression
as an artist, representing
some of my finest work."*

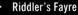 **Hard Day's Work**
Kory Heinzen
Portfolio work
Adobe Photoshop
http://korysdiner.homestead.com

*This painting illustrates a
short story that Kory has been
writing. "This is the first time
these characters have been shown
to the world. In the aftermath
of a battle, this unlikely duo
revel in victory. As legendary
mercenaries, they wander the
land; one fighting for the money,
one for the thrill. Their reasons
for fighting may be different, but
the results are always the same;
when their swords are raised,
armies will fall. I painted this
in Photoshop over a rough 3D
layout created in Lightwave."*

▶ **Riddler's Fayre**
Jeff Anderson
Book cover
Riddler's Fayre No.1
from Highland Books
Photoshop

*This is one of several character-
based covers Jeff is painting for
a series of graphic novels set
during the Crusades. "I usually
convert a scanned pencil sketch
to a sepia tone, then block the
paint in. I find it really is a
case of working as if I'm using
real paper and paint. The
endless opportunities to make
adjustments are hard to ignore,
but I try to be disciplined and
not overwork the image."*

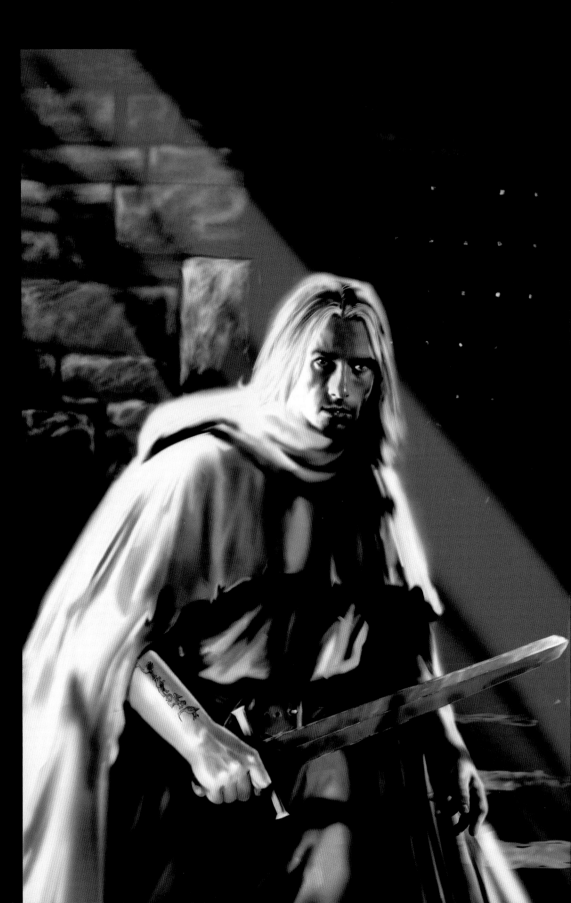

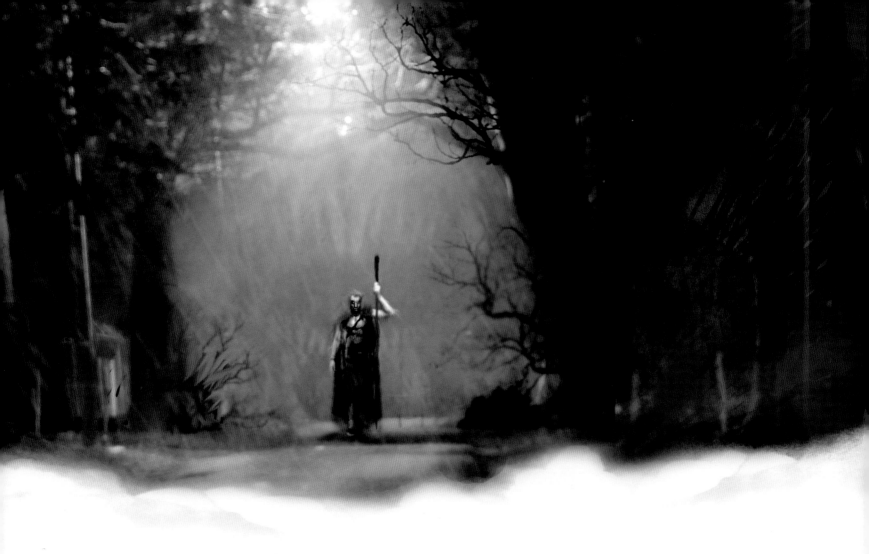

▲ **Whispers**
Sam Araya
Game illustration for
White Wolf Publishing
Adobe Photoshop
www.paintagram.com

*One of the recurring themes
in Sam's work is the use of
disengagement and separateness;
an exploration of distance, both
physical and emotional. Here,
along a track in the lonely depths
of a winter forest, we suddenly see
a figure approaching us. "I feel
compelled to isolate the viewer,
to place them where emptiness is
supreme, and then throw in some
element of confrontation staring
right back at the viewer."*

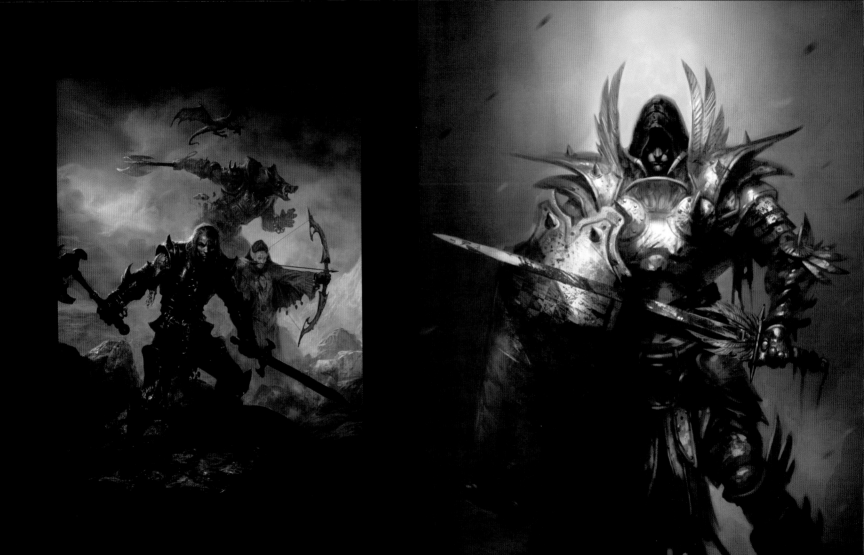

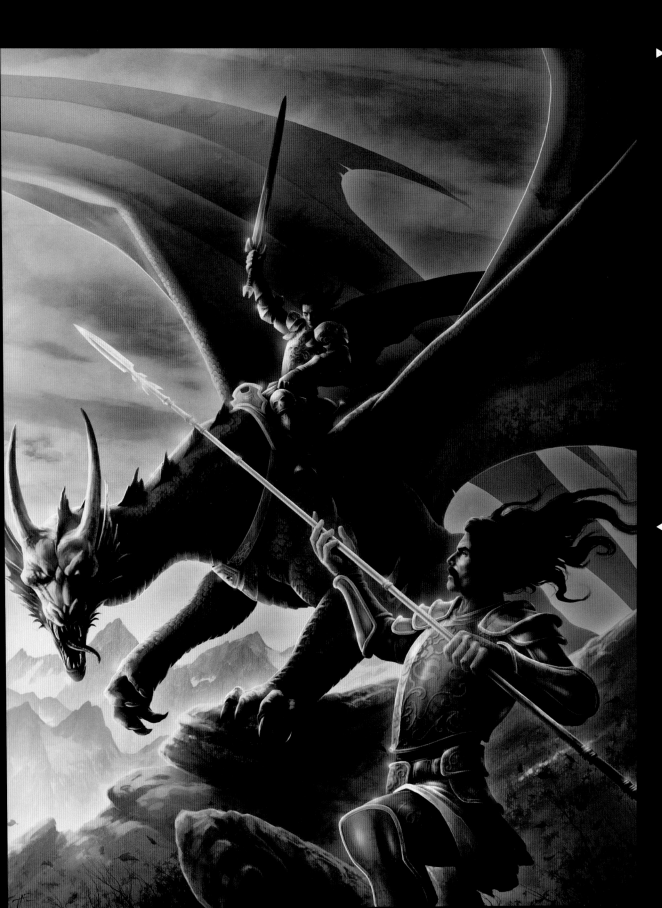

▶ **Riddler's Fayre 2**
Jeff Anderson
Book cover
Riddler's Fayre No.2
from Highland Books
Adobe Photoshop

Initially, Jeff was reluctant to adopt a digital way of working. "I had hoped digital art was a craze that wouldn't affect me, and that I could carry on painting traditionally. But eventually, I made the leap and loved it. It has been a slow process but very rewarding. This is one of the first full pieces I've made, other than coloring some of my comic book line work."

◀ **Knights of Ansalon**
Jason Engle
Game book cover
Dragonlance: Knightly Orders of Ansalon from Margaret Weis Productions
www.jaestudio.com

Jason has worked in games publishing for many years, and has always been an avid gamer. "Occasionally, I've been lucky enough to get my hands on a commission that involves a game I played as a child. This was one of those occasions, and I can't stress enough how refreshing it can be to put your time and energy into something that you already have such a strong familiarity with, and such a great sense of inspirational nostalgia as well."

▶ **Hunters**
Pascal Blanche
Portfolio work
Autodesk 3ds Max and
Adobe Photoshop
www.3dluvr.com/pascalb

*Pascal's very solid 3D figure
work is in direct homage to
the dynamic paintings of the
master of heroic fantasy, Frank
Frazetta, and is also inspired by
the powerful character designs of
Katsuya Terada. In turn, Terada's
distinctive rakugaki style (the
practice of drawing constantly,
everywhere and anywhere) was
influenced by European artists
such as Moebius.*

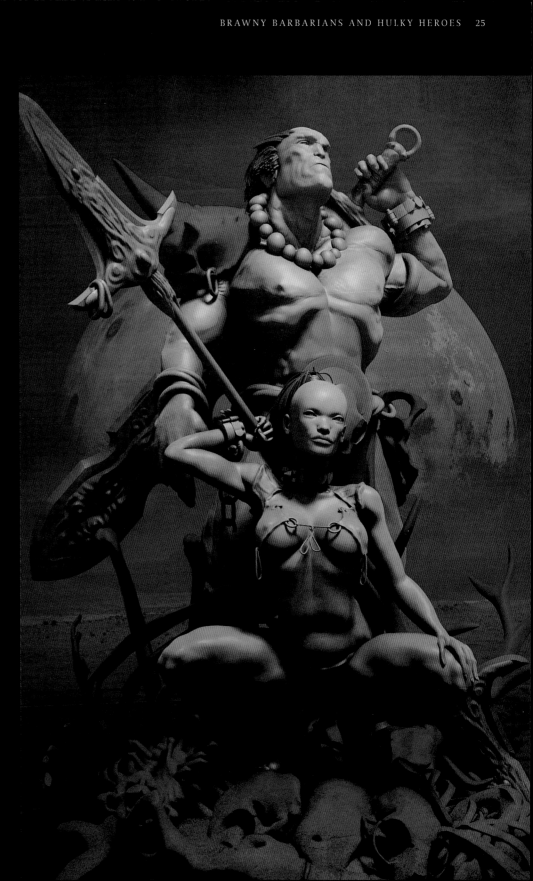

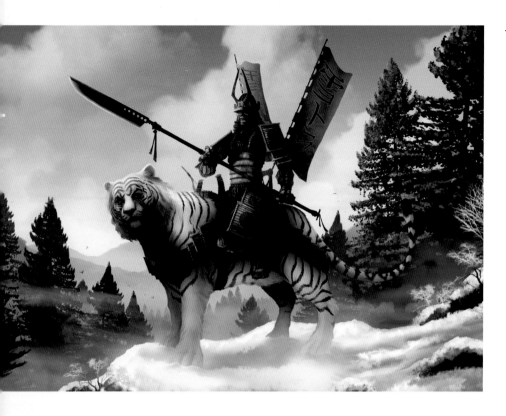

◀ **White Tiger Clan**
Kerem Beyit
Game illustration
Hukumran Senfoni from Sovereign Symphony
Adobe Photoshop
http://kerembeyit.gfxartist.com

A majestic white tiger makes a truly powerful steed for this fully armored samurai rider. In Kerem's monochromatic composition, the muted and cool color palette conveys the freezing surroundings of a hostile mountain environment, providing an evocative backdrop for this striking character concept. The thick covering of snow in the foreground is reflected in the glinting, steely eyes of the great beast, as it fixes them hungrily upon the viewer.

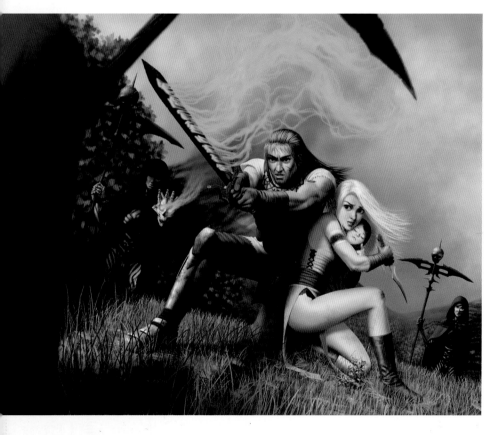

◀ **Till Death Do Us Part**
Robert Chang
Magazine illustration for ImagineFX
Adobe Photoshop and Corel Painter
www.ethereality.info

This piece was a work in progress for years before Robert completed it as a magazine tutorial. However, this version has been updated since being published. "This painting depicts a family of three being hunted by demons; mother, father, and baby. The parents protect the baby with their lives, while the demons conjure dark magic, using the skull of a fallen comrade as their source of power. The father counters the assault with his own magic, channeled through his sword."

▶ **Necro Warrior**
Rob Thomas
Portfolio work
Adobe Photoshop
www.mindsiphon.com

Rob describes how this piece was not created for any specific client, but painted entirely for fun. However, it was soon selected for an interesting commercial use: "I was contacted by the black metal band, Liche, who wanted to use it for the cover of their album Within the Valley of Megiddo. *I was delighted to grant permission."*

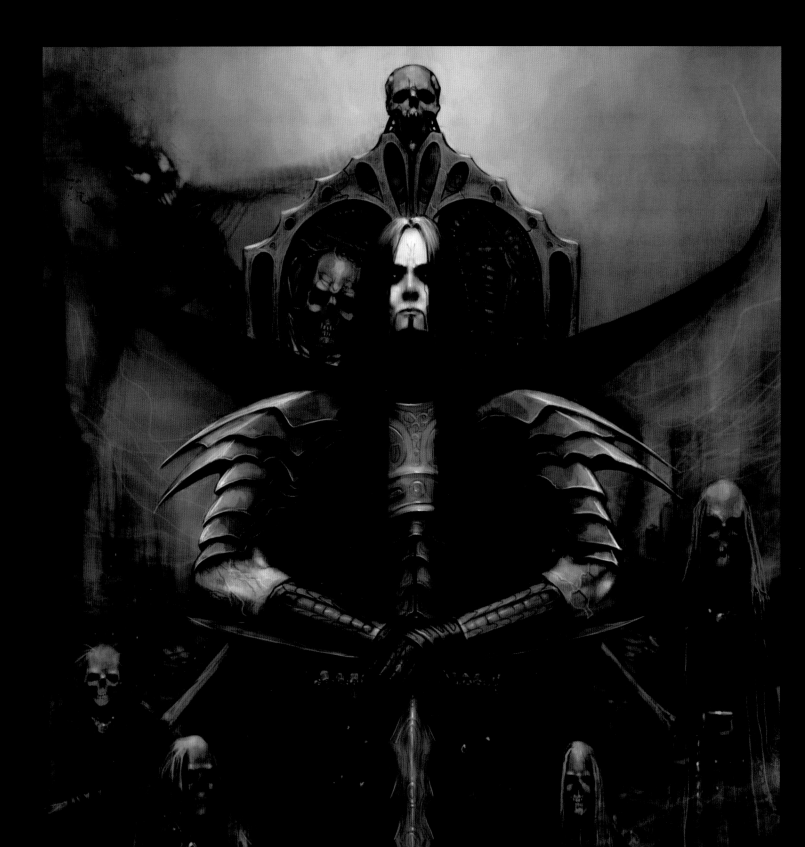

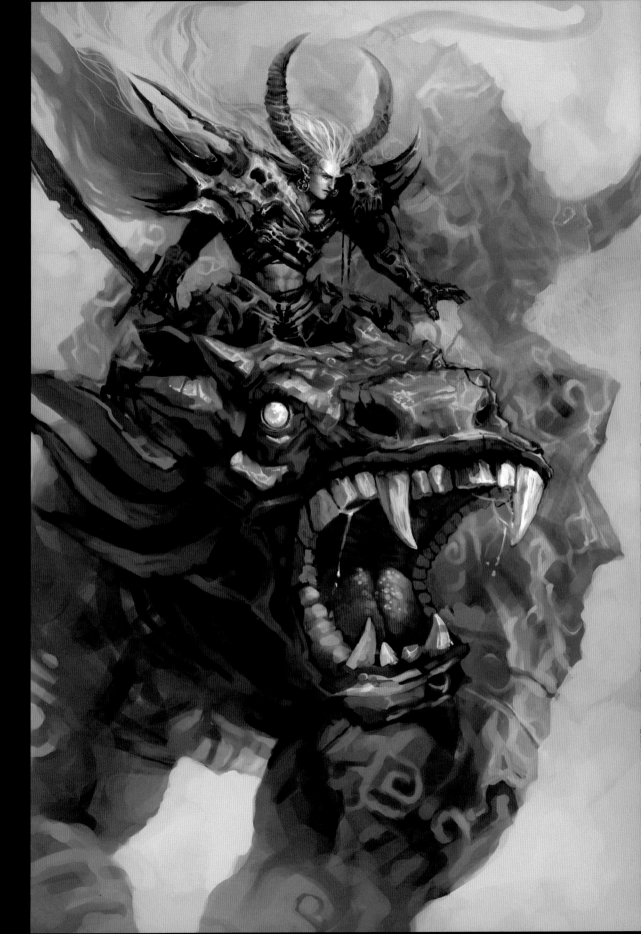

Chi You and Taotie
Xiao-chen Fu
Portfolio work
Adobe Photoshop
www.krishnafu.com

In this painting, Fu has portrayed Chi You, a legendary leader, and a powerful war deity from ancient Chinese and Korean mythology. Chi You is riding the fearsome Taotie; a creature frequently depicted in bronze sculpture. Fu explains more: "Chi You is a god of the Miao people, and the Taotie is one of the biggest and most evil of the ancient monsters. Taotie's body is made of bronze, and he possesses a voracious appetite. In a war with other gods, Chi You summoned Taotie and rode him into battle."

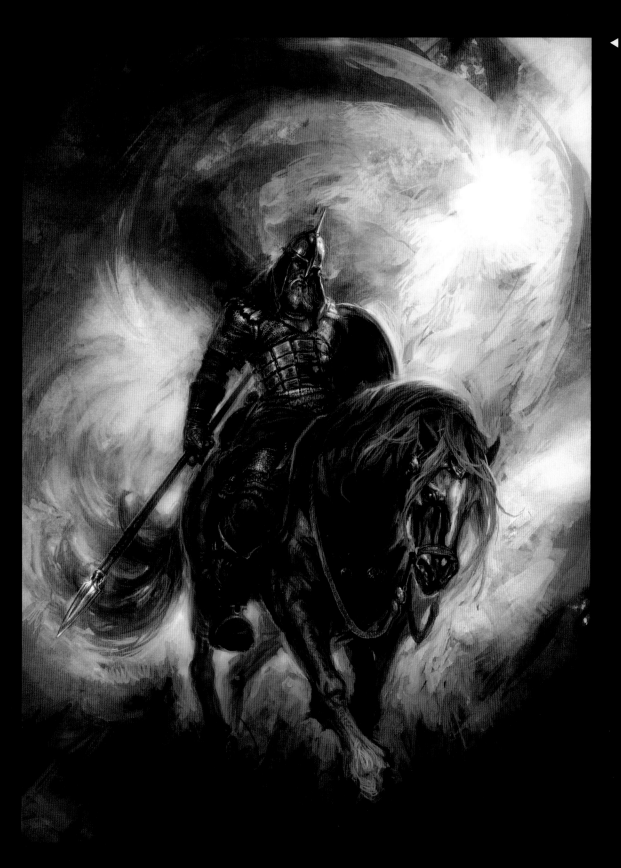

◄ **Bogatyr**
Michal Ivan
Book cover
Adobe Photoshop
http://perzo.cgsociety.org/about

*In his painting for a fantasy
novel book cover, Michal has
depicted a mighty Bogatyr, one
of the heroic warriors from epic
medieval Russian folk poems.
"This particular character is the
great hero Ilya Muromets, who
suffered serious illness in his
youth, until he was miraculously
healed and given superhuman
strength, after which he became
the greatest of all the Bogatyrs."*

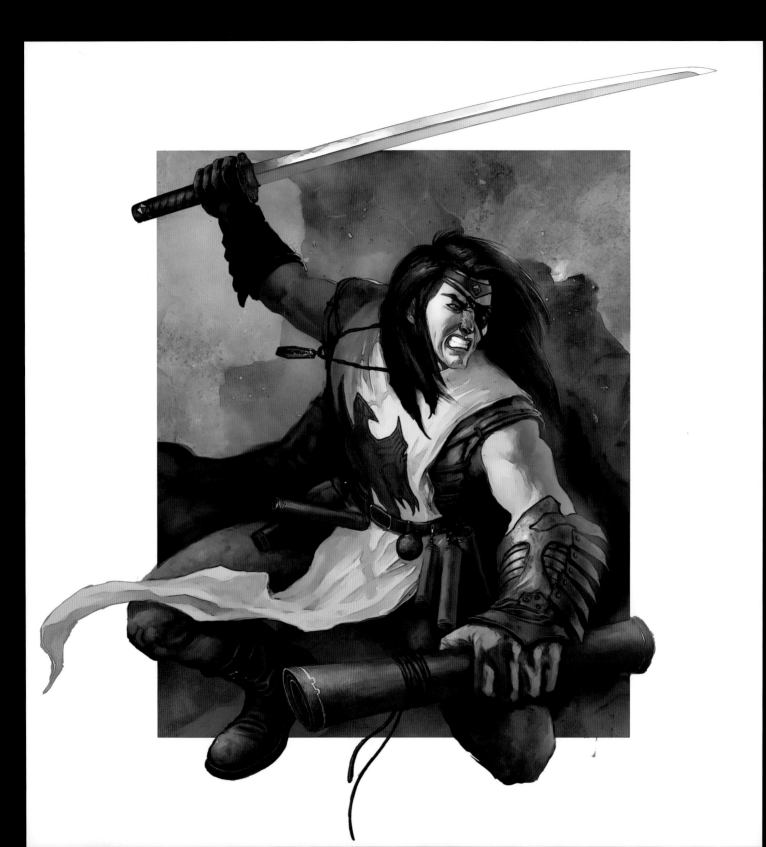

◀ **Magic Item**
Francis Tsai
Game book cover
Magic Item Compendium
from Wizards of the Coast
Adobe Photoshop
www.teamgt.com

*Wizards of the Coast wanted
their cover to show a character
equipped with many different
kinds of magic items that
are used in the Magic Item
Compendium role-playing
game. Francis explains, "The
challenge I faced was to compose
all of the equipment in a way
that didn't make the character
seem overly weighed down with
a lot of awkward gear."*

▶ **Ulk Rider**
Karl Richardson
Game illustration
Hordes: Evolution from
Privateer Press
Adobe Photoshop
http://karlrichardson.co.uk

*The brief for this artwork was
a fairly simple one for Karl,
in that he had to make sure
both the rider and his mount
looked as sinister as possible.
"This wasn't difficult, as these
particular characters have
deathly pale, angular features,
and wear black leather. I've done
quite a number of the Legion of
Everblight to which this rider
belongs, and must admit they
appeal to my darker side, which
comes to the fore, especially if
I'm still working on them at
two in the morning!"*

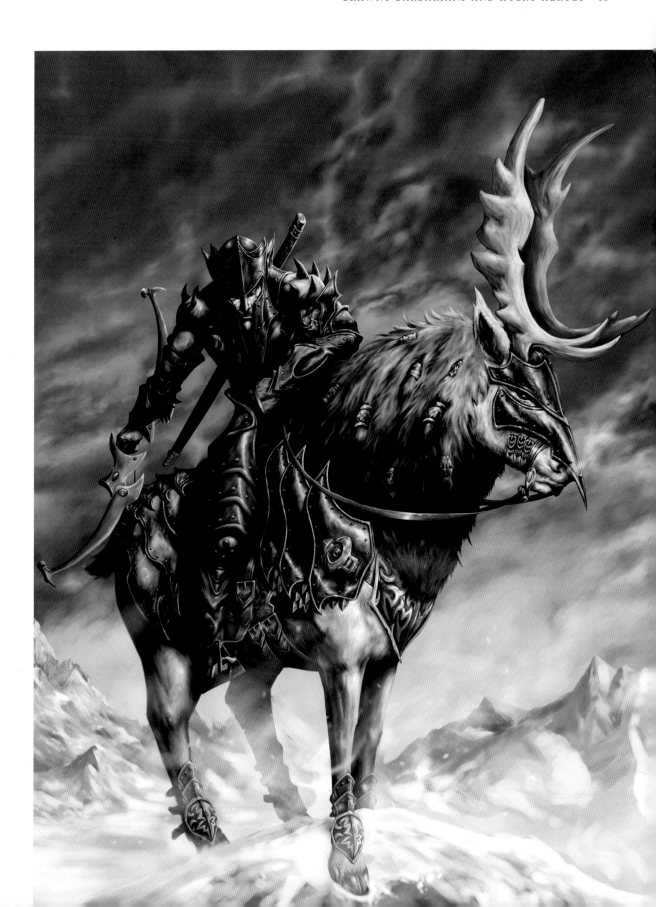

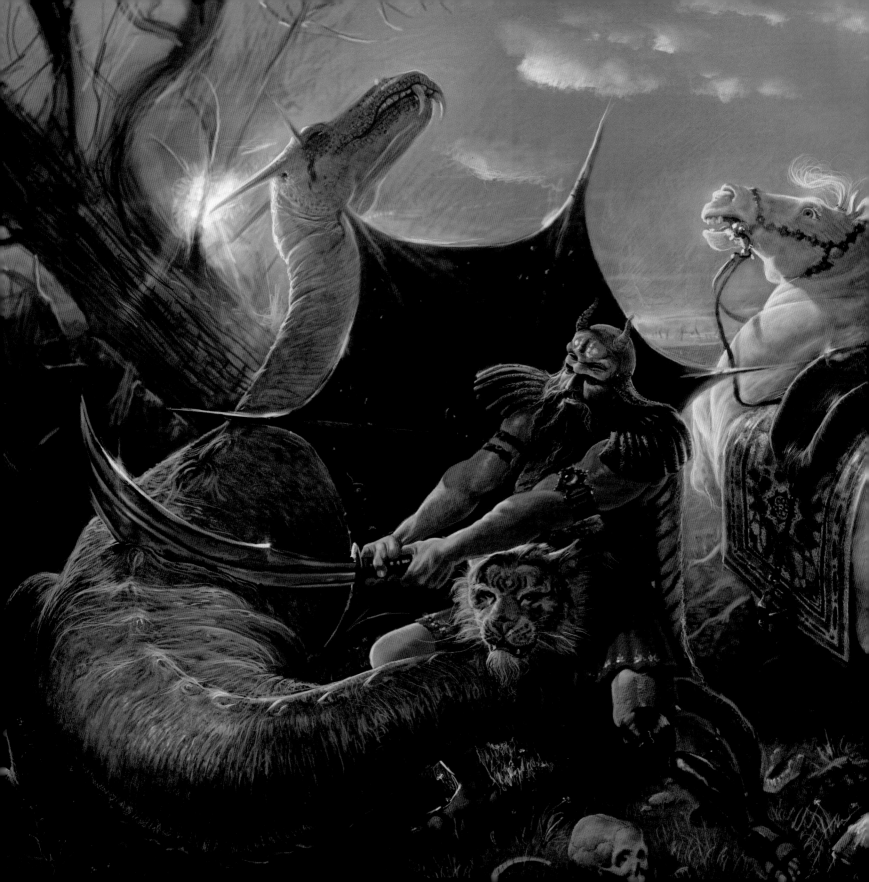

◄ Rostam
Adel Adili
Portfolio work
Adobe Photoshop
www.adel3d.com

*In ancient Persian mythology, Rostam is a legendary hero; mightiest
of Iranian paladins. He became immortalized in the 10th century*
Shahnameh *or* Epic of Kings, *which contains pre-Islamic folklore
and history. Similar to the legend of Hercules, Rostam passes through
a hero's journey, called Rostam's Seven Labors. Adel has chosen to
depict his Third Labor, which involves the slaying of a dragon.*

▶ Drizzt Do'Urden
Julia Alekseeva
Portfolio work
Adobe Photoshop
http://julax.ru

This is a painting inspired by the Forgotten Realms *books of
R. A. Salvatore. Julia explains, "The visuals in the stories impressed
me a great deal, with their unusual underground world, and strange,
frightening creatures; a really interesting universe to explore in my
imagination. I wanted to recreate the scenes exactly as I visualized
them while reading the books."*

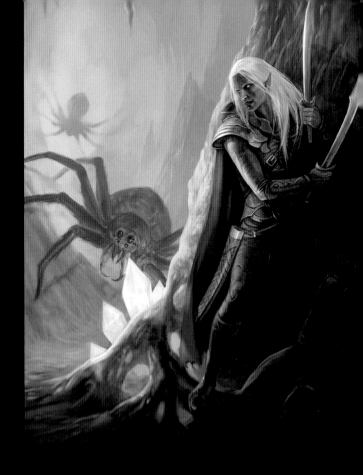

▶ Dark Knight
Jason Engle
Book cover
Infernum: The Art of Jason Engle from Paper Tiger
Adobe Photoshop
www.jaestudio.com

*Jason painted this death-dealing, dark knight in homage to Frank
Frazetta's work. "Frazetta has been an inspiration and catalyst
throughout my career. As with most images, once you begin work it
starts to shape itself. This figure was intended as that classic fantasy
archetype, the villainous knight; so dark he becomes almost a silhouette
against such a bright background. I worked with a limited palette,
just like Frazetta would have often done."*

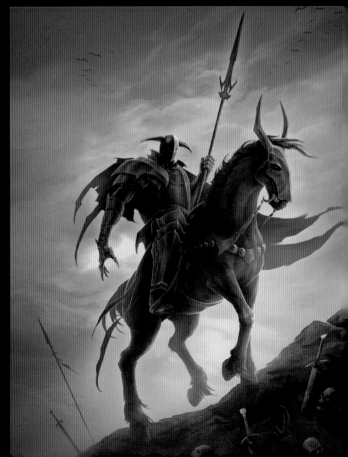

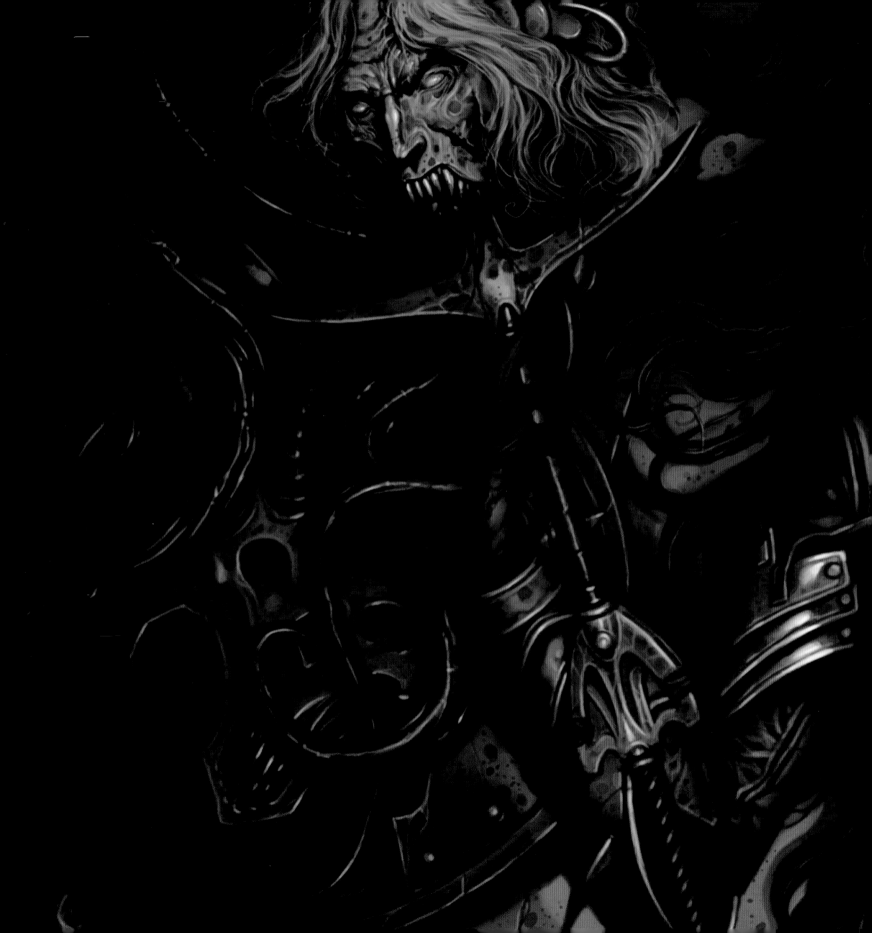

CHAPTER 2
WARRIOR WOMEN AND FEARLESS FEMALES

◀ **Eva in Repose**

R. K. Post
Promotional illustration
Dungeon Siege 2: Broken World
from Gas Powered Games
Adobe Photoshop
www.rkpost.net

From a dramatic viewpoint directly overhead, we see a golden-armored warrior maiden lying in a pool of light. Surrounded by spilled treasure and the slain bodies of her many monstrous foes, we assume she lies injured or recovering, after the prolonged and bloody slaughter. R. K. created this promotional piece at Gas Powered Games, and was lucky enough to use the very talented Veronika, from Perfect Muse, as his model.

▶ **Dragon Reflection**
Anne Stokes
Collectible card game illustration
Deck Armor from Max Protection
Adobe Photoshop
www.annestokes.com

The bold and attention-grabbing visual device that Anne set out to feature in her painting was this reflection of a dragon's glowing eye, shown in the mirror-like blade of a sword. The result is a simple, yet striking, image. Maybe the warrior has some affinity or symbiosis with this dragon, or maybe she's a dragon slayer. The artist wants to leave it to the viewer to decide.

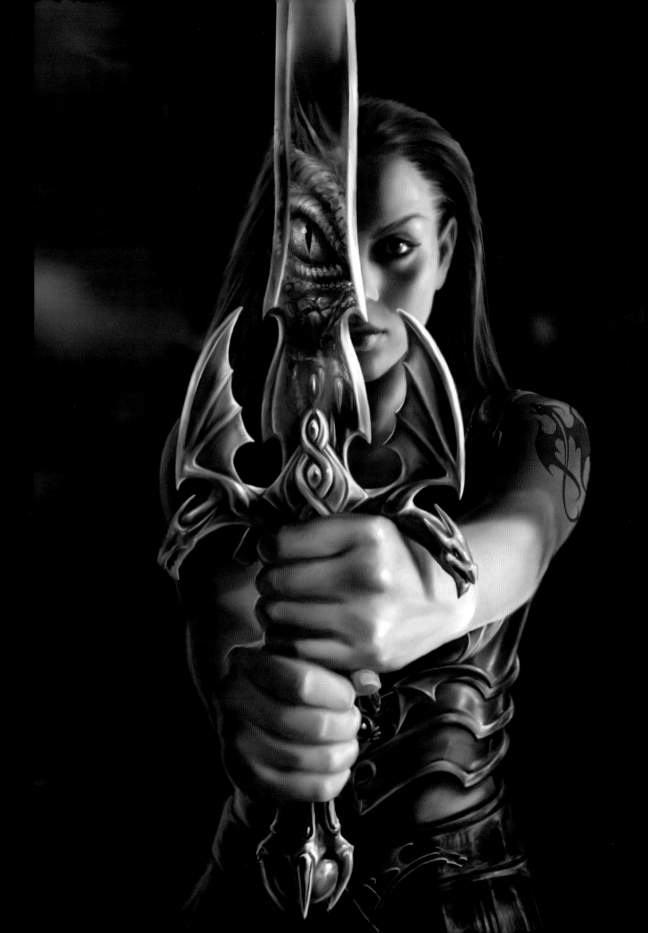

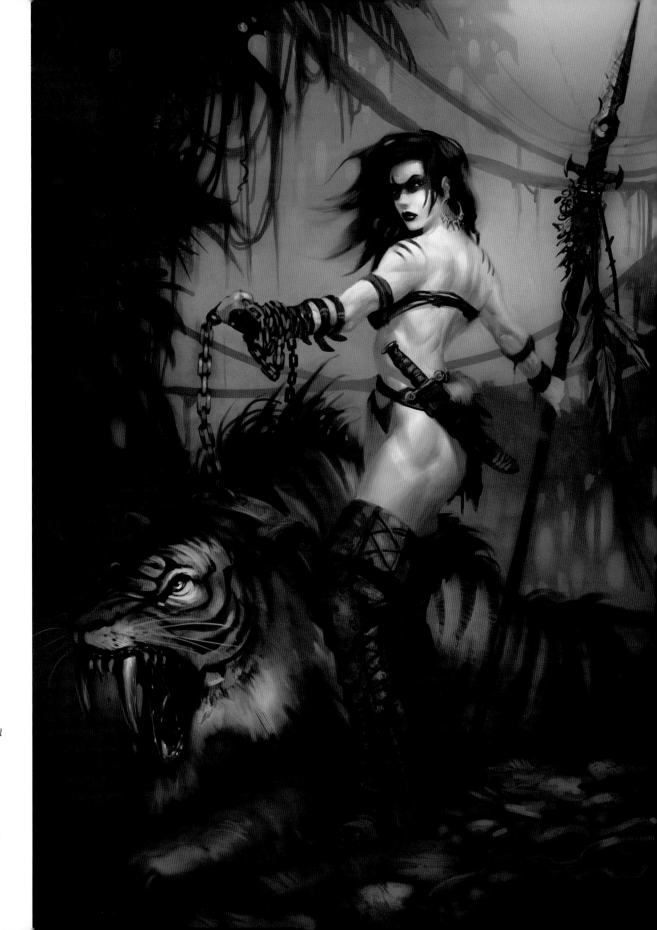

▶ **Stalker**
Daryl Mandryk
Portfolio work
Adobe Photoshop
www.mandrykart.com

This is Daryl's take on the clichéd image of a babe in the jungle with a tiger; something of a staple of classic heroic fantasy art. "I wanted her to be tough-looking, like she knows how to handle herself in the wilderness. There is a slight mystical quality about her as well, perhaps providing some explanation of how she tamed such a beast."

▶ **Bone of the Ocean**
Jian Guo
Portfolio work
Corel Painter
http://breathing2004.gfxartist.com

In this eerie, moonlit scene, Jian has shown a seductive sea witch standing within the huge rib cage of a sea creature she's lured to its death. Looming in the background we see, silhouetted, the rotting hulk of a wrecked galleon, overpowered by her dark magic. Signaling with her flaming skull lantern, the beguiling sea witch is intent upon luring more seafarers to their doom.

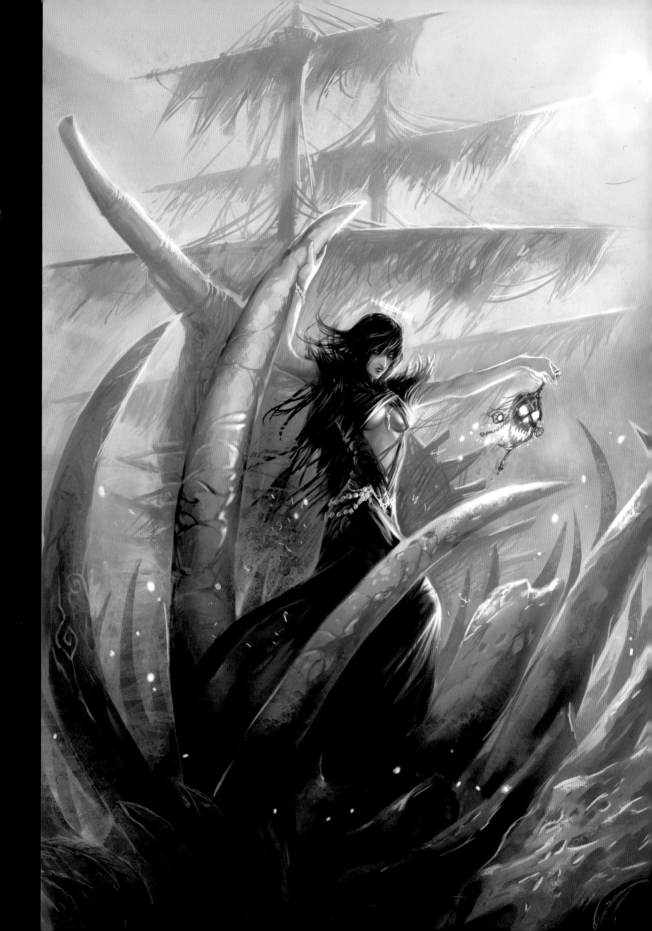

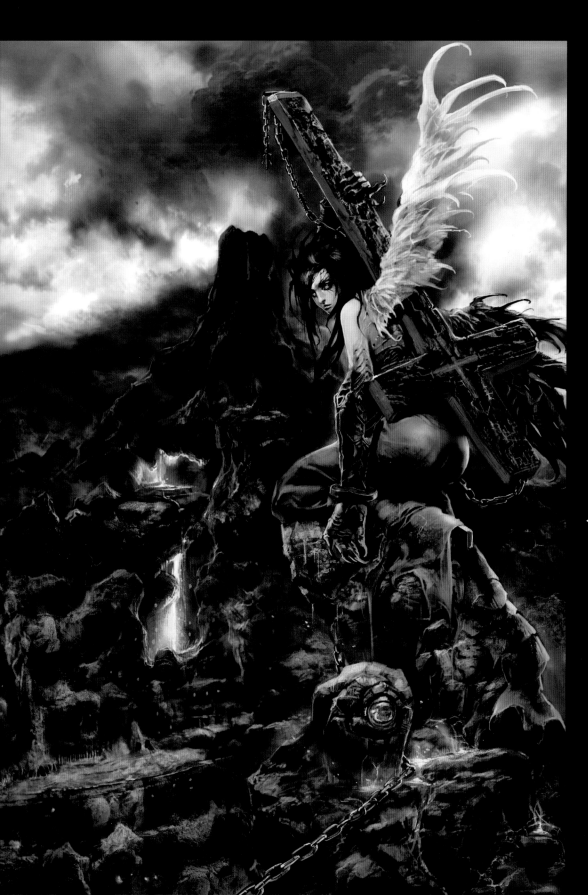

◀ **End of Godliness**
Kuang Hong
Portfolio work
Adobe Photoshop
www.zemotion.net

*In Christianity, a fallen angel
is an angel that has been exiled
or banished from Heaven.
According to some traditions,
fallen angels will roam the Earth
until Judgment Day, when they
will be sent to Hell. This is the
state of exile in which Kuang
shows his Angel character. "This
painting is about an angel that
is falling, and it is depicted
here on an earthly mountain
top. Carrying a bloodied cross,
the angel is hoping that a final
prayer can redeem its soul.
Alas, it has failed to escape the
eventual fate of the fallen."*

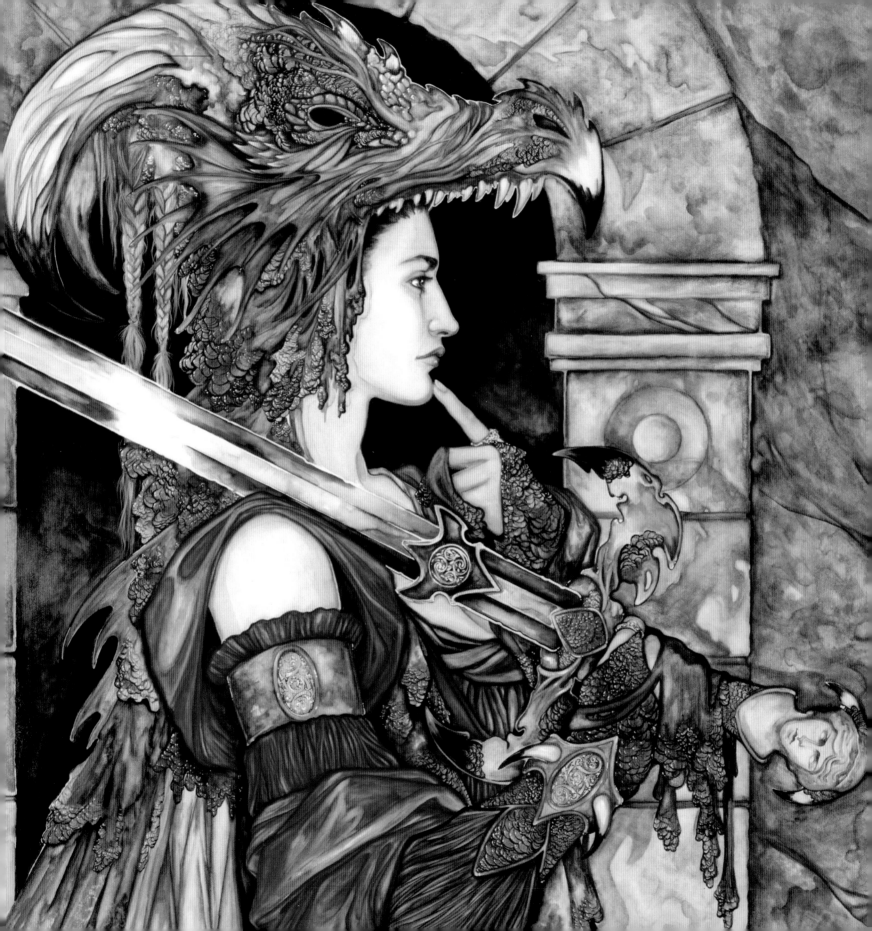

◀ **Dragon Skins**
Denise Garner
Portfolio work
Watercolor
www.towerwindow.com

*In this delicate watercolor, the
viewer is presented with the
incongruous figure of a slight
young woman wearing the
trophies of dragon slaying, and
brandishing a huge sword. Denise
reveals more about the painting:
"The original piece was created
in transparent and opaque
watercolor, on illustration board.
The purpose of the painting
was to experiment with various
textures, and to juxtapose the
feminine with the somewhat
violent. I created it specifically
to display at a world fantasy
convention."*

▶ **Jaga**
Michal Ivan
Book cover
Draci Carevna
from Wales Publishing
Adobe Photoshop
http://perzo.cgsociety.org/about

*This painting by Michal was
used for a novel based on Russian
legends. "The picture depicts
Baba Jaga in the shadowy world
between life and death; a limbo
full of gigantic saurians." In
traditional Russian tales, Baba
Jaga is a witch who flies through
the air in a mortar, using the
pestle as a rudder, and sweeping
away her tracks with a broom
of silver birch. In this portrayal,
she looks a little different as she is
depicted as young and athletic.*

◀ **Rowan Blackwood**
Francis Tsai
Game book illustration
Mysteries of the Moonsea
from Wizards of the Coast
Adobe Photoshop
www.teamgt.com

*The brief given to Francis
specified that this character is a
member of a thieves' guild, and
has the ability to turn into a
rat. However in this illustration
the character should appear
meek, and nothing in the image
should indicate her wererat alter
ego. "Many of the character
illustrations I create call for very
aggressive, action-filled poses, so
I found it was a nice change to
come up with a non-aggressive
look for this character."*

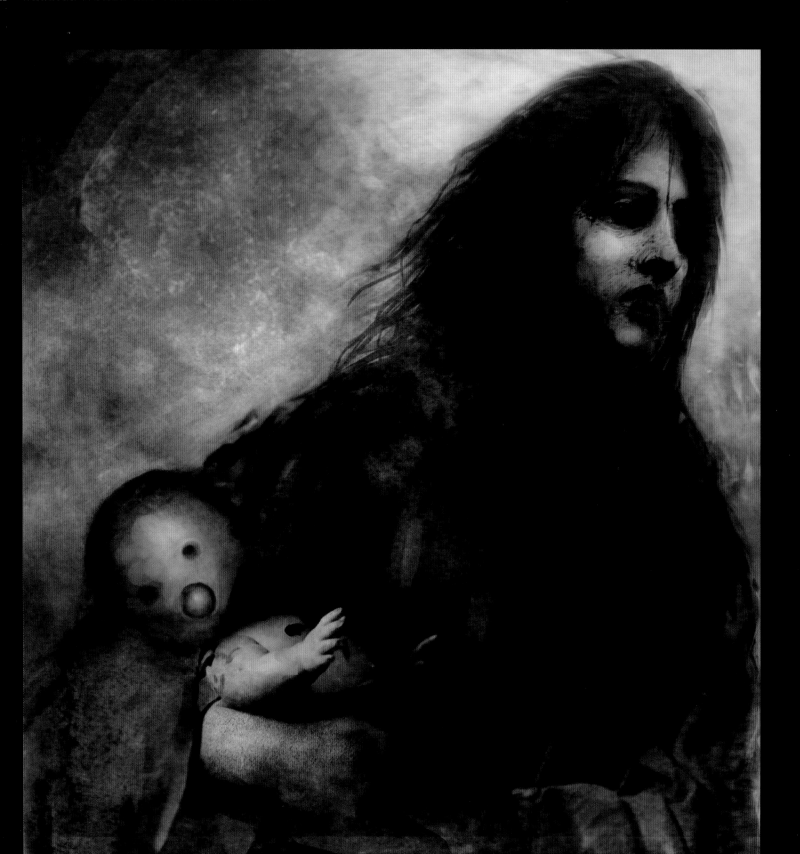

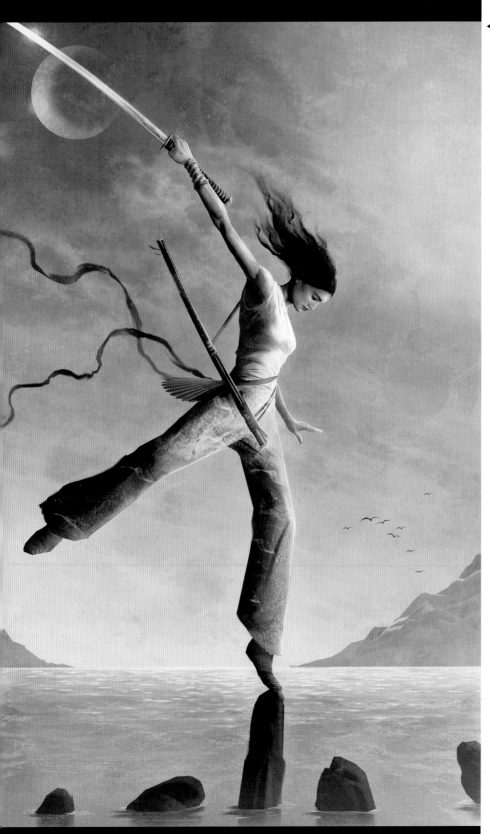

◀◀ **Aisha**
Sam Araya
Game illustration for
White Wolf Publishing
Adobe Photoshop
www.paintagram.com

A haunted young woman cradles a disturbing doll. Sam tells us more:
"One of the things I love about fantasy is its gritty side. With this image
I sought to take a 'realistic,' dirty approach to the fantastic. Whether
this female character is haunted by ghosts, or is a ghost herself, it is up
to the viewer to decide. What really matters to me is the mood; the
atmosphere of decay and filth that permeated a world before the
invention of the shower."

◀ **Dreamfall**
Jason Engle
Portfolio work
Adobe Photoshop
www.jaestudio.com

Every so often, inspiration can
strike when it's least expected,
and it sometimes comes
from something as simple as
composition, as Jason found.
"Composition can be tricky,
but it can also do amazing
things. This image has a very
pure composition; I kept detail
and color to a minimum, and
avoided most of the usual tricks
used in fantasy art for adding
high drama and action. But this
still manages to create a scene
that seems both dreamlike and
enchanting in its own way."

▶ **Ressa**
R. K. Post
Promotional illustration
Dungeon Siege 2: Broken World
from Gas Powered Games
Adobe Photoshop
www.rkpost.net

With black, heavily spiked armor, and purple hair lending a distinctly
gothic air, this powerful warrior elf aims her elaborate magical bow.
The skull lying at her feet also adds a distinctly macabre touch, further
underlining her dark elf heritage. This is a character illustration that
was used within the Dungeon Siege 2 game, the game's manual,
and for promotional purposes.

 Kill the Winter
Xiao-chen Fu
Portfolio work
Adobe Photoshop
www.krishnafu.com

Fu has created a heavily stylized
portrayal of a goddess riding
into battle. "She is Heyha, the
goddess who kills gods. Four
gods once controlled the four
seasons; the Winter God was the
most powerful and capricious.
For over 4,000 years he ruled,
becoming mad with power until
the seasons and weather were in
disarray. Charging on her horse,
Heyha cut off the head of the
Winter God and the seasons
returned to normal."

▶▶ **Shugenja**
Jon Hodgson
Collectible card game illustration
Legend of the Five Rings from
Alderac Entertainment Group
Adobe Photoshop and Corel Painter
www.jonhodgson.net

Jon explains that he had a very
open brief for this image, and
he found it great fun to invent
the mountain setting. "It's a nice
change of pace to occasionally
paint something beautiful,
rather than a rotten zombie,
or stinking goblin. I often work
in earth colors, so this one was
a nice change on that front as
well. Painter creates heavy paint
marks well, and as the digital
medium matures, it's gaining
something of its own aesthetic,
as previous new mediums have
also done."

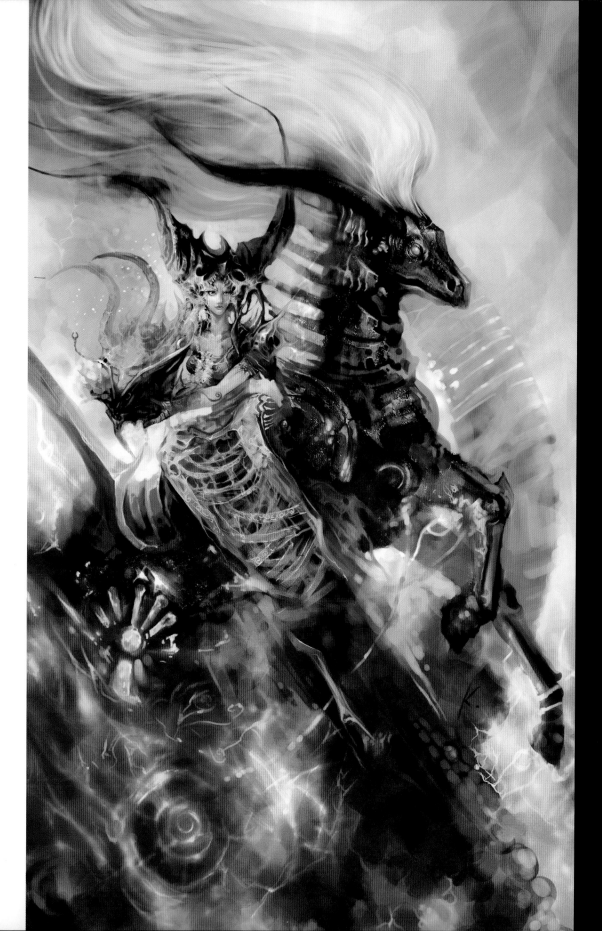

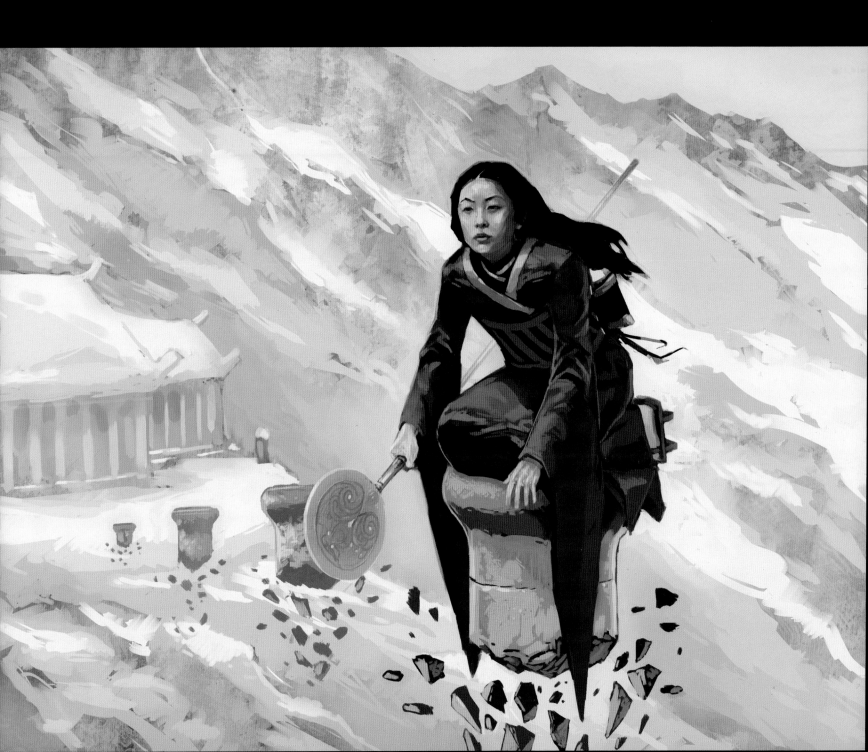

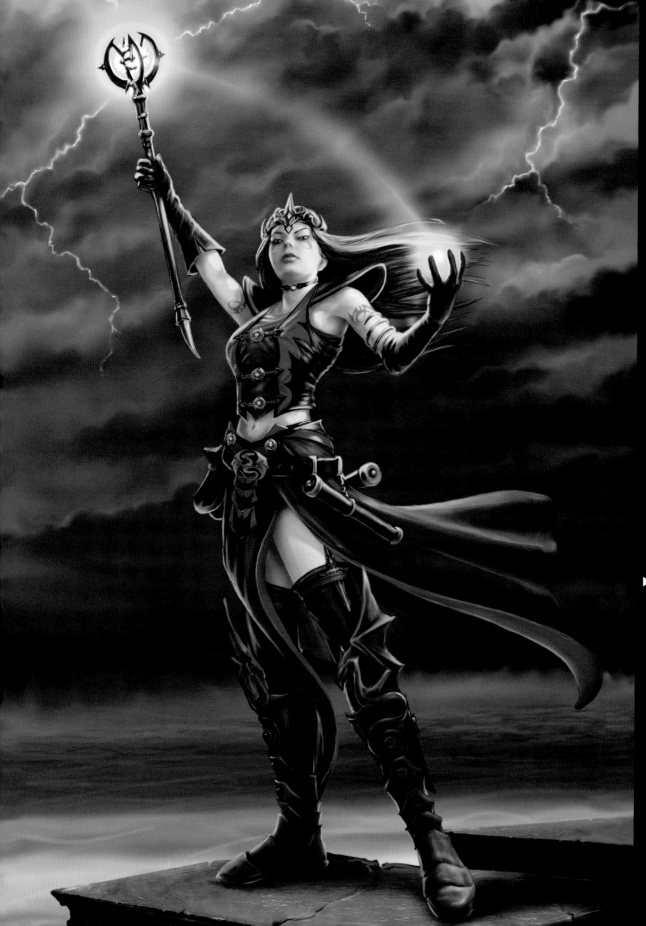

◀ **Scarlet Mage**
Anne Stokes
Private commission
Adobe Photoshop
www.annestokes.com

This image was commissioned privately from Anne to immortalize a gamer's cherished player character. "It was fun to design the costume, and I'm especially pleased with her dragon boots. The subtle blues in the background are designed to contrast with the bright red of the mage's clothing, and the brewing storm adds to the drama of her imminent spell-casting."

▶▶ **The Sharing Knife**
Matt Stawicki
Book cover
The Sharing Knife from
Harper Collins
Adobe Photoshop and Corel Painter
www.mattstawicki.com

This project was unique for Matt because of how the commission unfolded, as he relates: "My original concept remained true to the book's text, featuring white trees and other particulars. About halfway through the project, the client decided to go in a different direction with the cover. I was told to finish the painting, but was given free rein on details. Before I knew it I had a beautiful blonde riding through lush green forest."

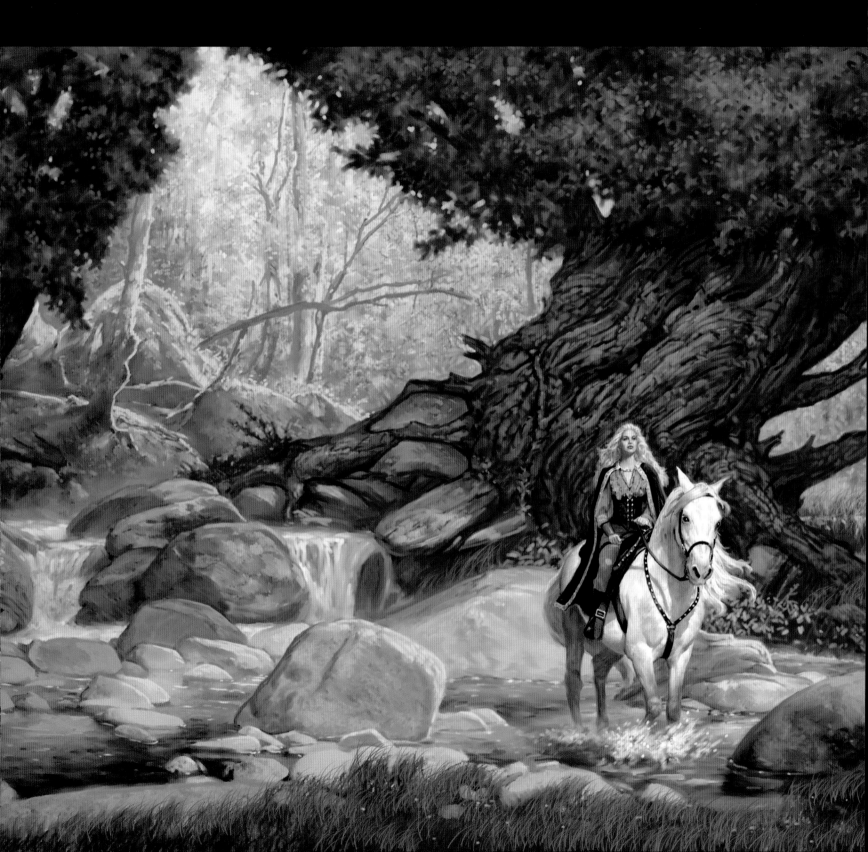

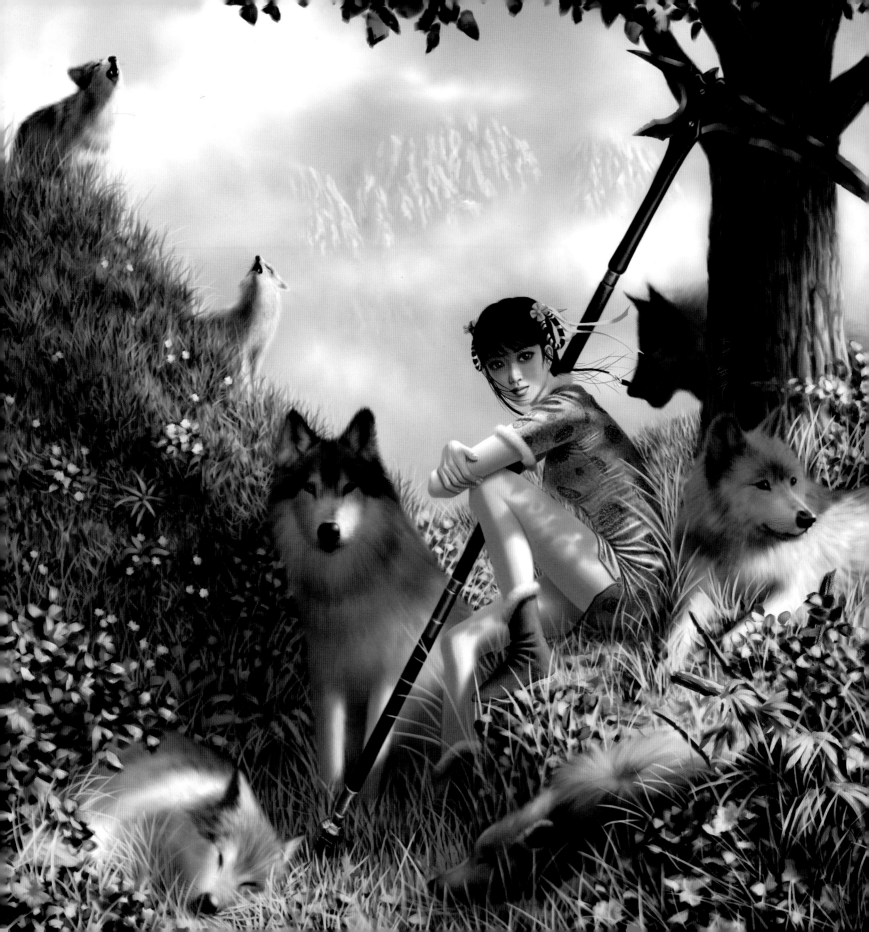

◀ **Scythe Wolf**
Robert Chang
Portfolio work
Adobe Photoshop and
Corel Painter
www.ethereality.info

This painting took Robert a long
time to complete due to its high
level of detail: "I really should
switch to a more relaxed style
that isn't so highly rendered.
The dress was especially hard to
paint, and I had to study a lot
of satin and silk references to get
it right. The wolves took a long
time too, but were much easier
in comparison, after studying
a lot of reference material."

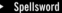
▶ **Spellsword**
Sacha "Angel" Diener
Portfolio work
Adobe Photoshop
www.angel3d.ch

Angel has depicted a fearless
elfin warrior maiden, striding
through a lost kingdom, and he
describes the background story
he invented: "A curse has plunged
this emerald valley into darkness,
with its long-dead inhabitants
resurrected as rotting creatures
that are neither alive nor dead.
For years no-one has dared enter
this evil place, until a lone elf,
ready to face all danger, enters
the haunted mists, her Spellsword
slicing through the fog."

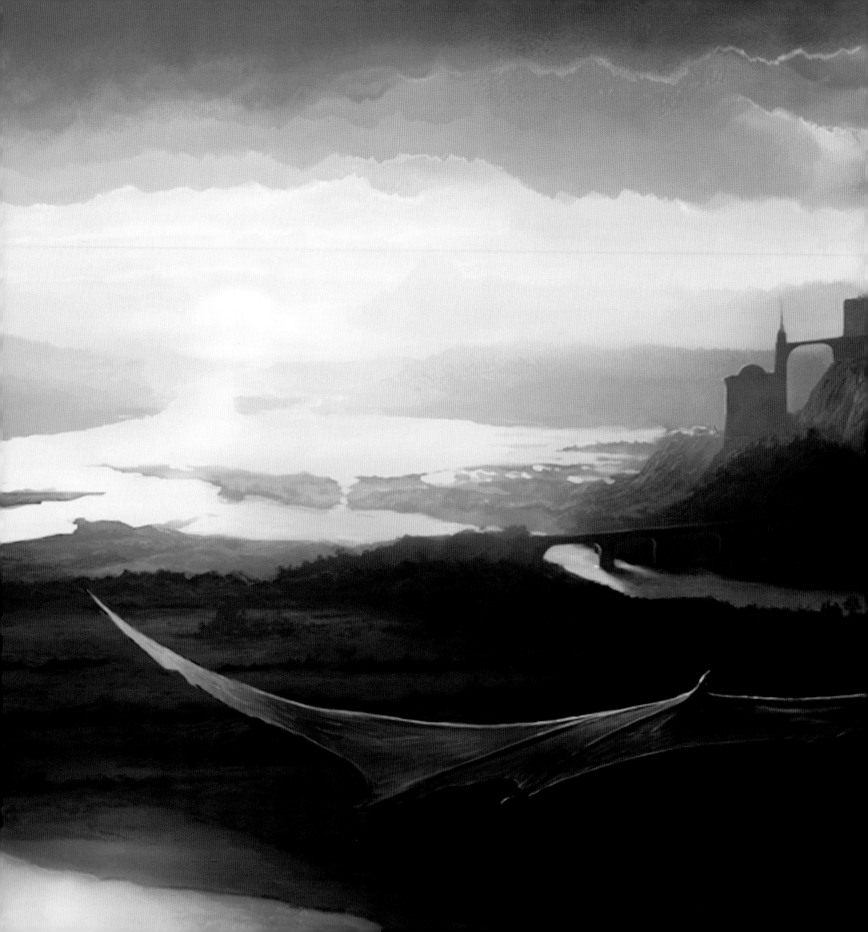

CHAPTER 3

MYTHS AND MONSTERS

◀ **Dragon Rider**
Matthew Bradbury
Portfolio work
Adobe Photoshop
www.epilogue.net/cgi/database/art/
list.pl?gallery=11601

Matthew describes how this
painting developed naturally
from his fondness for dragons. "Of
course, in the flying beast there is
some influence from The Lord of
the Rings *films, particularly the*
aerial sequences in The Return
of the King, *but I think I took*
the most pleasure in painting the
background. I've always loved
and admired the work of matte
painters, with Dylan Cole's film
work proving especially inspiring,
and I guess that's why I chose a
very cinematic aspect ratio."

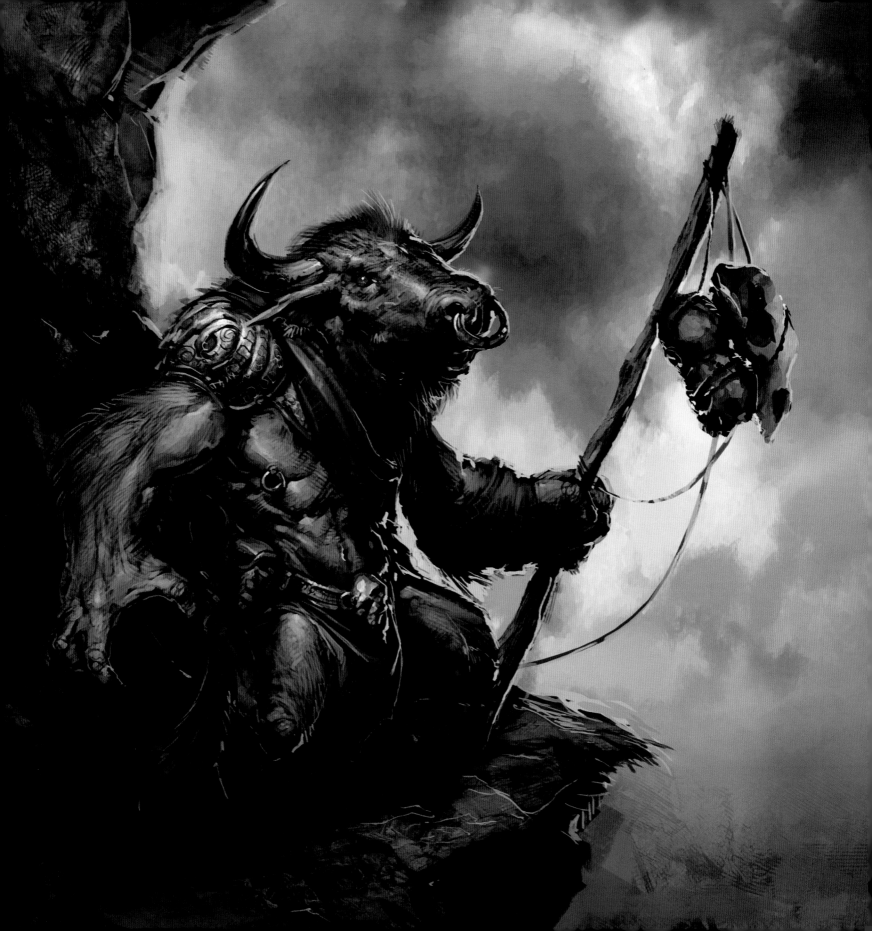

◄ **Minotaur**
Carlos Cabrera
Portfolio work
Corel Painter
www.carloscabrera.com.ar

*Having always loved the story
of Theseus, Carlos was inspired
to paint a Minotaur. In Greek
mythology, the Minotaur was
a creature that was part man
and part bull, to whom young
Athenians were sent to be
devoured. It dwelled at the center
of a gigantic labyrinth built for
King Minos of Crete, near his
palace in Knossos. Specially built
to hold the Minotaur, the huge
maze was designed by the architect
Daedalus, and the ferocious but
rather unfortunate creature was
eventually slain by Theseus with
the help of Ariadne. "Minotaur"
is Greek for "Bull of Minos."*

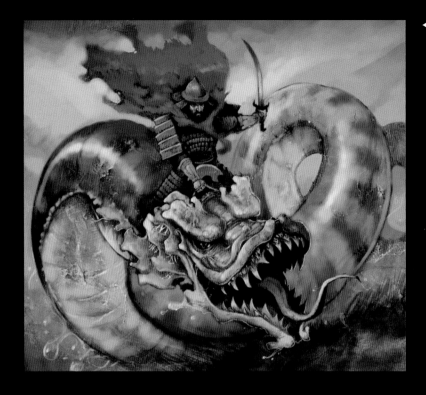

◄ **Yobanjin Wyrm**
Jon Hodgson
Collectible card game illustration
Legend of the Five Rings from
Alderac Entertainment Group
Adobe Photoshop and
Corel Painter
www.jonhodgson.net

*This game world is a deep and
inspiring one, as well as being
extremely popular. It demands
some thought when adding to it,
as Jon describes: "I had a great
time designing this creature. I
took inspiration from Chinese
dragon dancers, and tried to
work backward from their
stylized look, to something 'real.'
I like to bring as much real
world texture to my work as I
can, and have a huge stock of
handmade textures on file."*

▶ **Zombie Psycho**
Greg Staples
Collectible card game illustration
Magic: The Gathering from
Wizards of the Coast
Corel Painter
www.gregstaples.co.uk

*Greg is perhaps best known for
his paintings for* Magic: The
Gathering, *and for his dynamic
work in comic books. His art
for* Judge Dredd *marked the
beginning of his career as an
illustrator, and since then he has
painted some of the most popu-
lar comic book characters includ-
ing Spider-Man and Batman. He
has also worked on many other
projects, including* War of the
Worlds *with Jeff Wayne,*

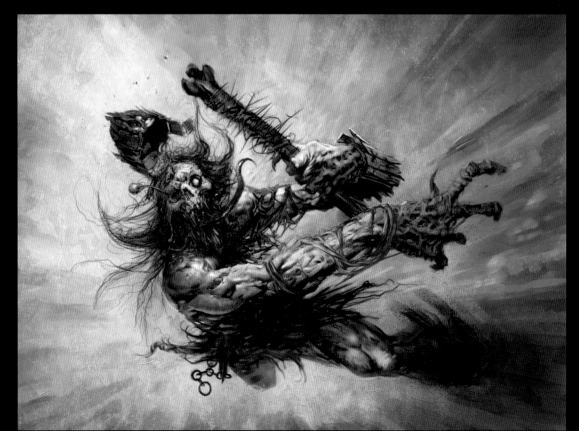

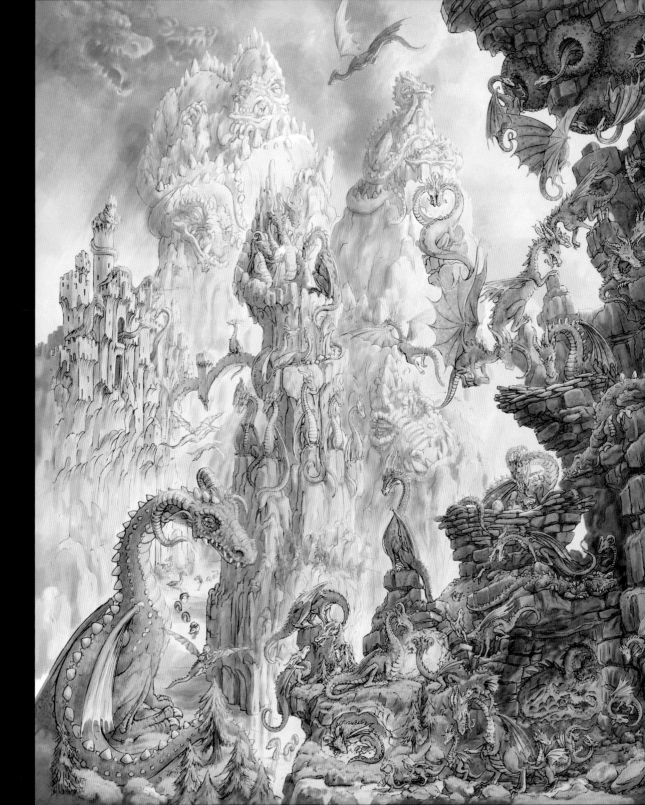

Mountain Dragons

Leo Hartas

Book illustration

Dragonquest from Fernleigh Books

Adobe Photoshop and Corel Painter

www.hartas.eclipse.co.uk

Leo describes how his brief for this piece was very open. "The idea was a puzzle picture, with a lot of dragons to count, some hidden and difficult to find. The challenge of composing so many dragons was to avoid the image turning into a messy 'dragon soup,' so I broke it up into the classic foreground, middle ground, and distance, to create an illusion of depth. My inspiration for the vertical rock forms came from photos I've seen of incredible limestone spires; aspects of nature that seem more fantastical than any fantasy."

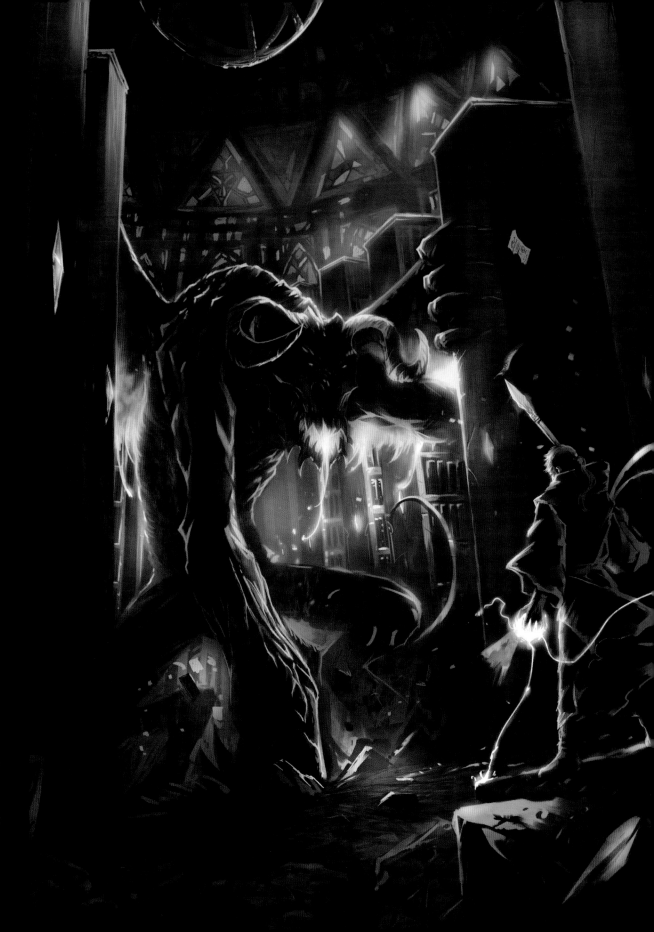

▶ **The Last Guardian**
Jian Guo
Portfolio work
Corel Painter
http://breathing2004.gfxartist.com

An arcane library is the setting for this clash between might and magic. Jian has depicted a colossal, demonic figure, molten drool dripping from its fiery maw, its hunched form taut with sinewy power. One enormous apelike arm has crashed to the floor, dwarfing the magician in the foreground, and highlighting the difference in scale. This is further intensified by the low point of view behind and below the human figure.

▶ **Byakhee**
Tony Hough
Portfolio work
Gouache on board
www.tonyhough.co.uk

Tony has long been inspired by the Cthulhu Mythos *tales of H. P. Lovecraft, and the Byakhee are a race of interstellar beings that feature in Lovecraft's story,* The Festival. *"There flapped rhythmically a horde of tame, trained, hybrid winged things… not altogether crows, nor moles, nor buzzards, nor ants, nor decomposed human beings, but something I cannot, and must not, recall."*

◀ **Wooden Wizard**
Jason Felix
Portfolio work
Adobe Photoshop
www.jasonfelix.com

This stylized, figurative work contains much of the feel of a collage piece, with flat cut-outs of bold texture, overlaid to create intriguing forms. Jason explains, "I was entertained by the idea of a wizard accidentally turning himself into wood. Like a wooden puppet, he would prance around and move by an unseen force from above."

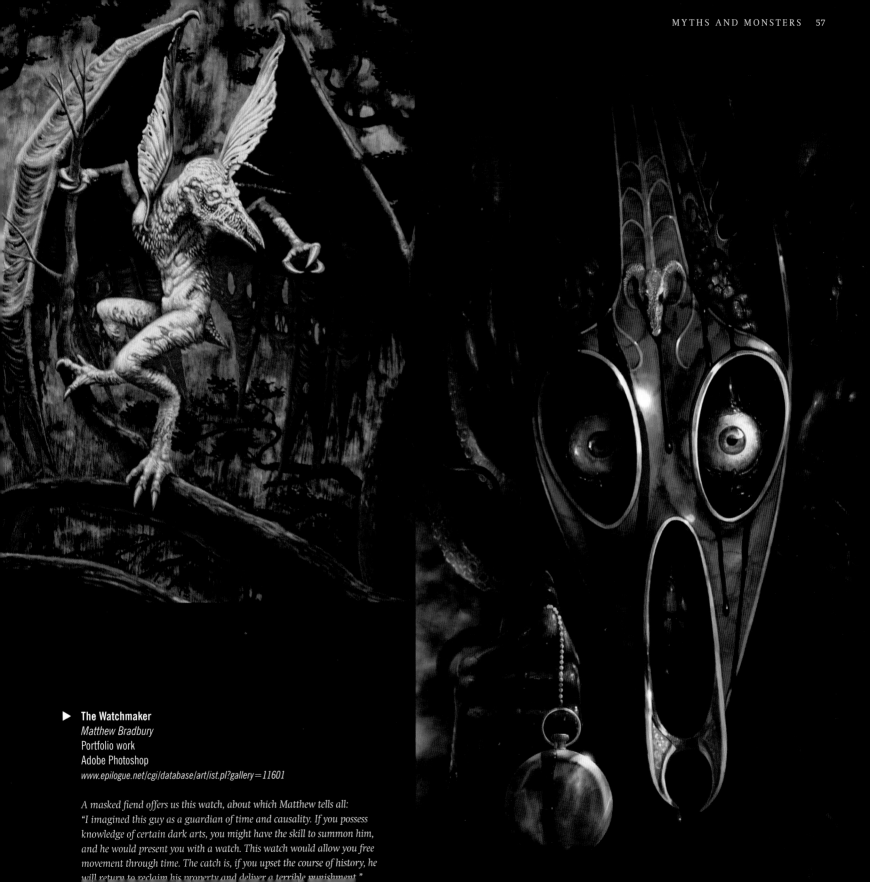

▶ **The Watchmaker**
Matthew Bradbury
Portfolio work
Adobe Photoshop
www.epilogue.net/cgi/database/art/ist.pl?gallery=11601

A masked fiend offers us this watch, about which Matthew tells all:
"I imagined this guy as a guardian of time and causality. If you possess
knowledge of certain dark arts, you might have the skill to summon him,
and he would present you with a watch. This watch would allow you free
movement through time. The catch is, if you upset the course of history, he
will return to reclaim his property and deliver a terrible punishment."

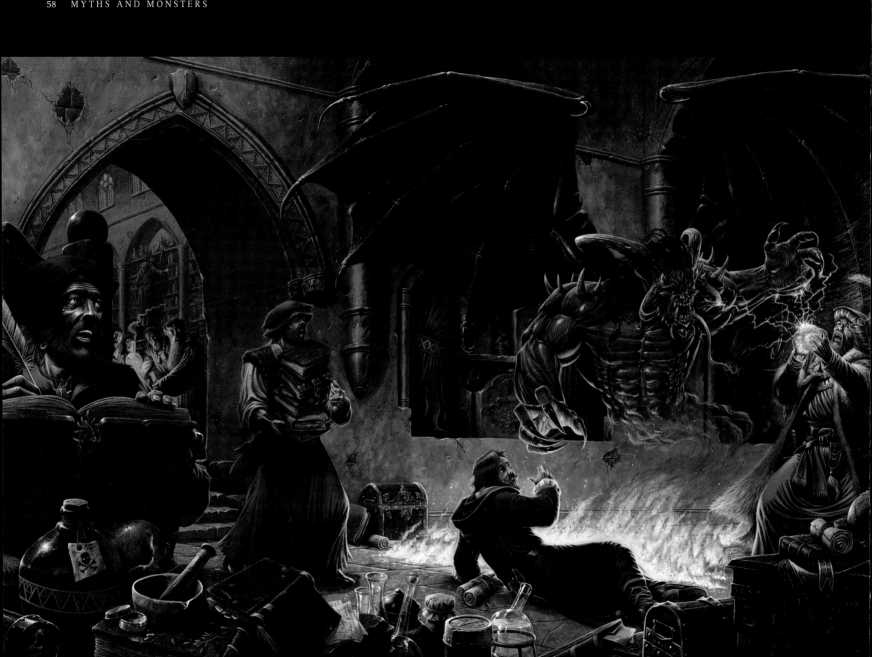

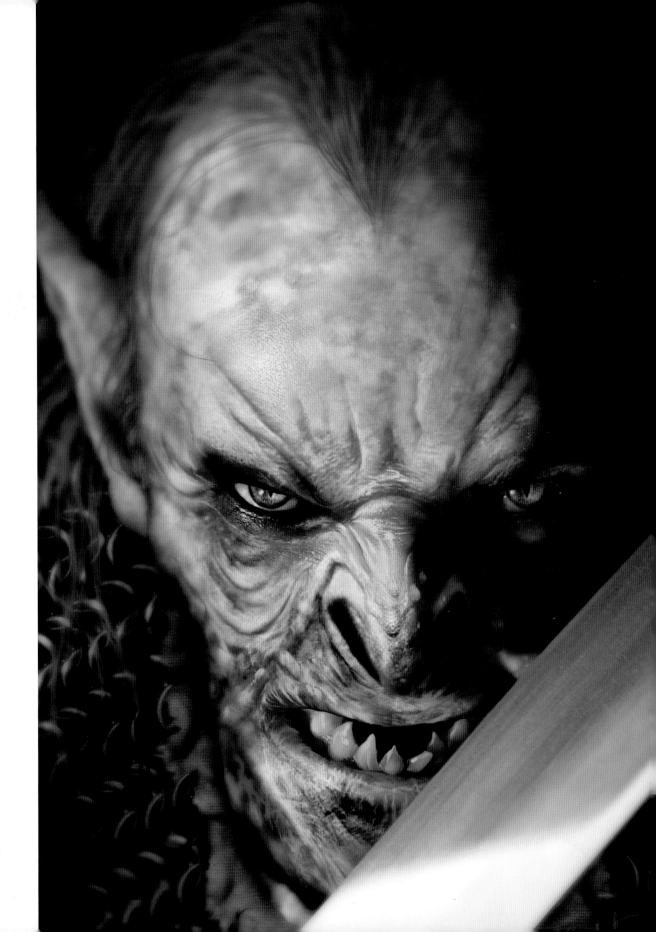

◄ Realms of Sorcery
Ralph Horsley
Game book cover
Realms of Sorcery from
Games Workshop
Acrylic
www.ralphhorsley.co.uk

*This image provided a challenge
for Ralph because it was going to
be used as a wraparound cover,
as he describes: "This meant
that the right half needed to
work as a front cover, as well as
part of the whole. Likewise, the
left half was going to have text
placed over it, and so required
less detail. To make the red
demon pop out, I chose a green
shade for the background. These
contrasting colors hopefully work
to really make the cover appear
prominent and attention-
grabbing on the shelf."*

► Temple of Terror
Martin McKenna
Book cover
Temple of Terror from Wizard Books
Adobe Photoshop
www.martinmckenna.net

*The idea for this piece was simply
to show an extreme closeup of a
goblin in pore-probing detail. To
achieve the photo-realistic feel of
the face, painting was combined
with areas of texture taken from
macro photos of a model's skin.
In a digital skin graft, the patches
of flesh texture were placed on the
face, incorporated and blended
in, merging with painted areas.
Adding to the photographic feel is
the soft blurring around the edges
of the portrait, to suggest a little
depth of field.*

► **Blood of the Dragon**
Clint Langley
Book cover
Blood of the Dragon courtesy The
Black Library/Games Workshop
Limited *(www.black-library.com)*.
Copyright Games Workshop Ltd
2006. Used with permission.
Photoshop
www.clintlangley.com

*Clint built this monster using
textures that were created in
Photoshop and then formed
into the dragon. "Once the
composition and mood looked
right, I started to sculpt the
details using a Wacom Stilos,
much the same as completing
an oil painting. The texture
on the dragon's fire gives the
whole image a more painted
look, which I try to capture
throughout my art."*

►► **Guenhwyvar**
Julia Alekseeva
Portfolio work
Adobe Photoshop
http://julax.ru

This image was inspired by the
Forgotten Realms *books by
R. A. Salvatore. As Julia explains,
"The books' visuals really grabbed
me, with their weird underground
realm and its fabulous denizens.
I painted scenes directly from
the books, visualizing all the
descriptive details as I imagined
them. I've now produced a series
of 11 paintings inspired by
the stories."*

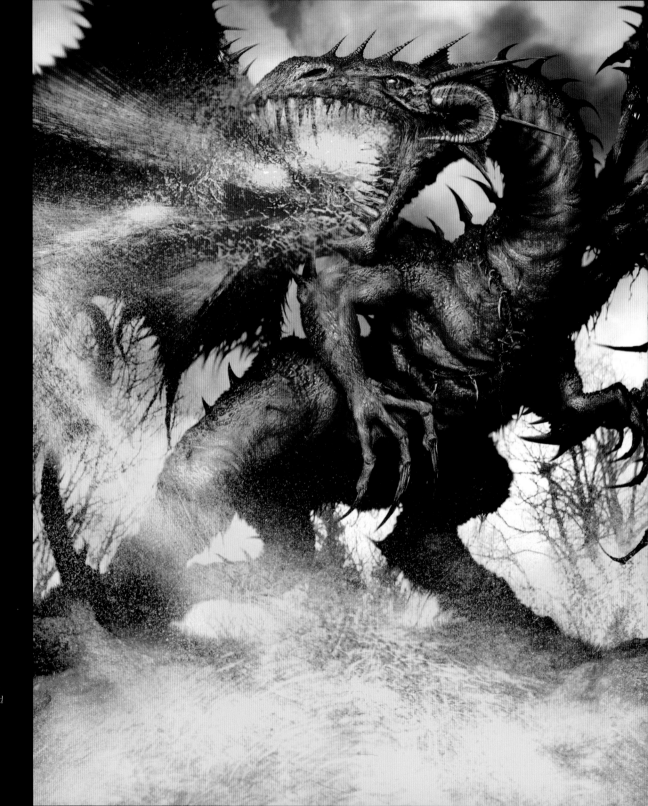

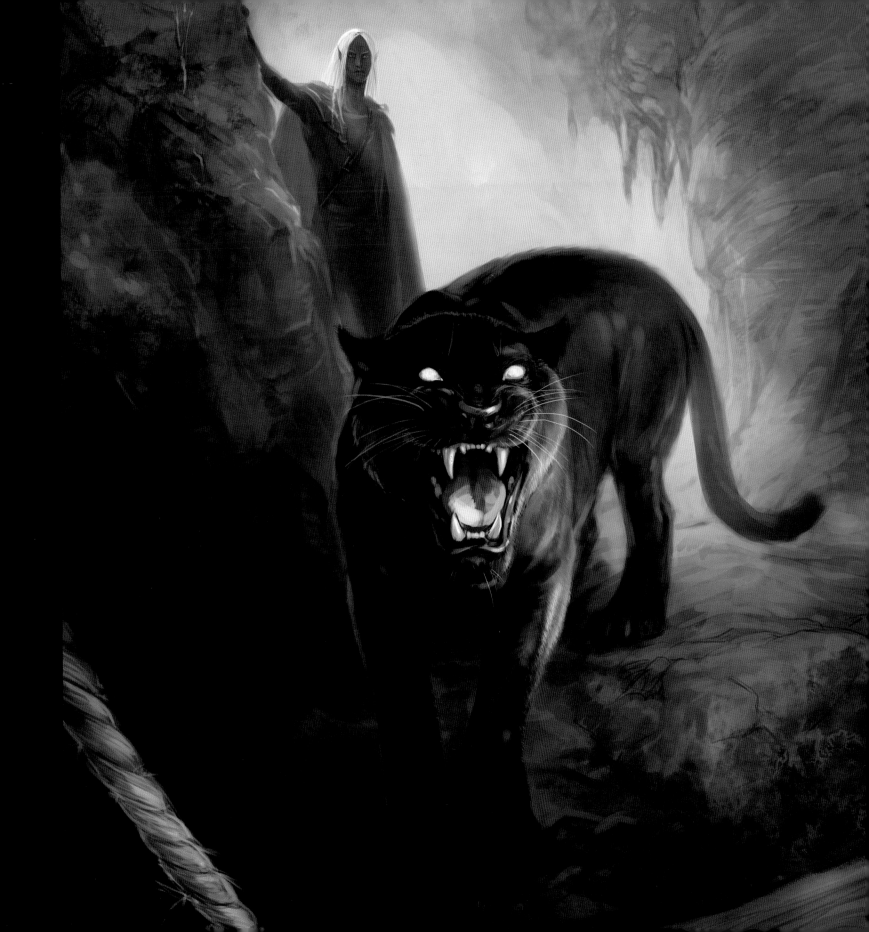

▶ **Ice Dragon**
Yvonne Gilbert
Book cover
Colored pencil
www.yvonnegilbert.com

*A little girl clings with delight
to the crisp, frozen mane of this
ice dragon as it flies through
the glittering, moonlit night.
Yvonne has shown the creature's
cold breath turning immediately
to solid ice as it streams behind
its head, upon which are horns
shaped from the upstanding
spikes of icicles. The outline of the
dragon's form is defined against
the night sky by a shimmering
halo of frost.*

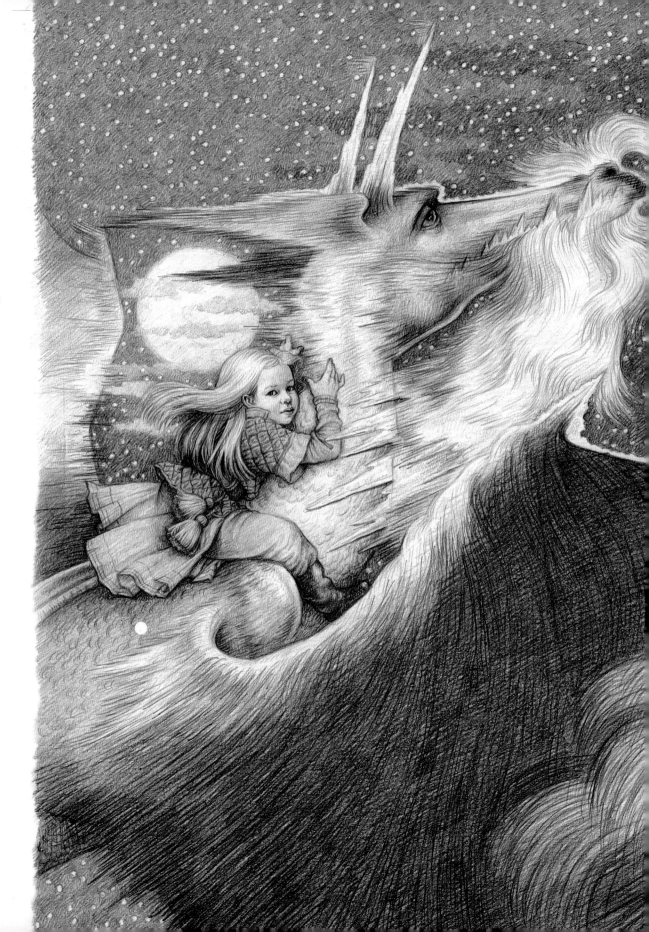

► **Cupid and Psyche**
Rebecca Guay
Portfolio work
Oil over gouache on paper
www.rebeccaguay.com

*Rebecca reveals this to be a
personal favorite, from a series
of mythologically themed works.
"Since childhood, I've been
obsessed with this story. The
journey and trials for love and
trust, and the deeply passionate
subtext of sensuality, have been
at the root of my inspirations
as an artist. I've always wanted
to illustrate this story, to show
the moment just before the
first kiss, and to capture the
mystery and energy of that
elusive, precious moment."*

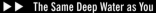

►► **The Same Deep Water as You**
Kristen Perry
Comic book cover
Nightmare World from
Aaron Weisbrod
Adobe Photoshop
www.merekatcreations.com

*Kristen created this two-part
cover for a comic book collection
of dark, fantasy stories in the
vein of* The Twilight Zone *and*
The Outer Limits. *"The cover
tells a story in two frames, using
a before and after presentation.
As the cover artist, I enjoyed
conjuring light and atmosphere
to convey sights and sounds,
enticing the viewer to enter the
book's nightmare world at their
own peril."*

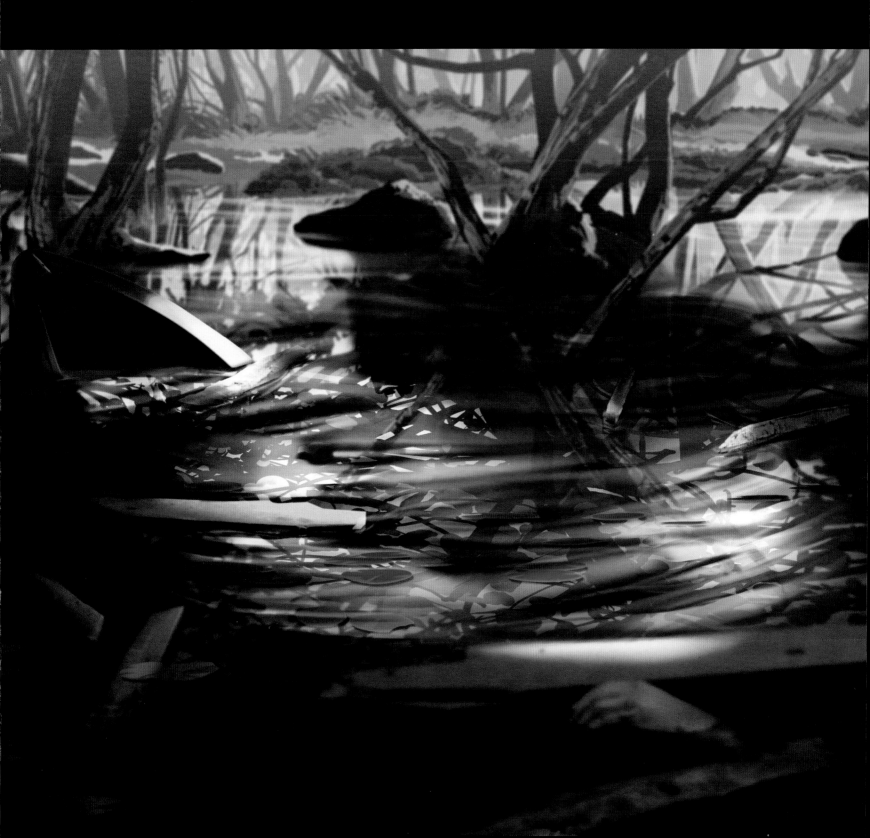

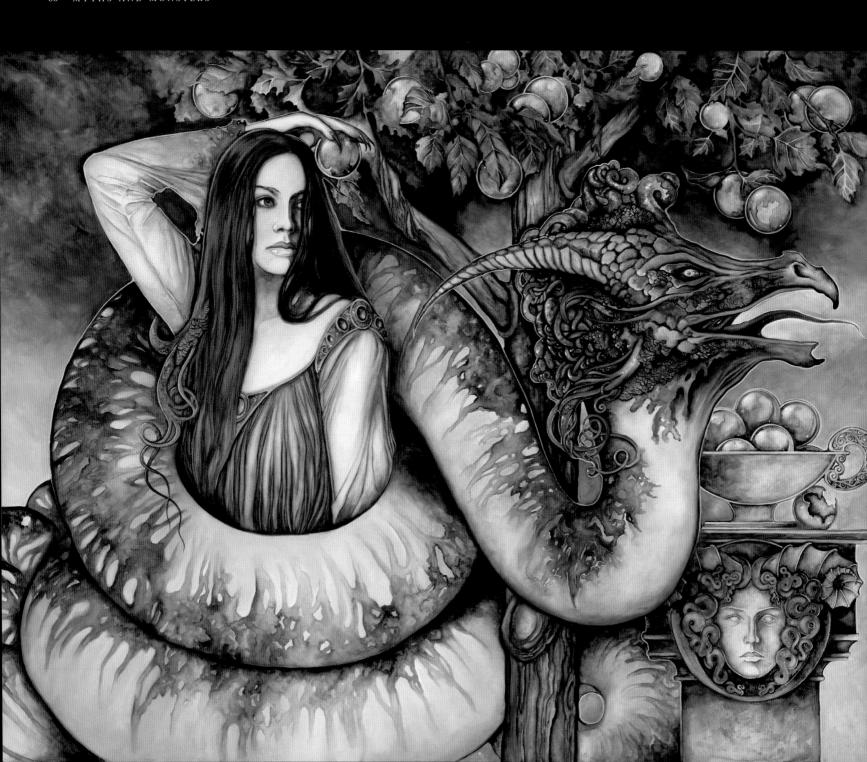

Temptation
Denise Garner
Portfolio work
Watercolor and gouache
www.towerwindow.com

This painting was a challenging work for Denise to complete to her satisfaction, as she relates: "The subject evolved over a number of weeks, and part of the process included a strong desire to throw the thing in the trash! I originally concentrated on the figure, filling in the rest of the scenery as I went. Ultimately, what I enjoy most about the picture is its softness and color harmony."

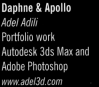

Daphne & Apollo
Adel Adili
Portfolio work
Autodesk 3ds Max and
Adobe Photoshop
www.adel3d.com

Adel rendered this amorous vignette, based on a story from Greek mythology. Daphne was Apollo's first love, brought about by the malice of Cupid who fired two arrows, a sharp one of gold to excite love, the other of blunt lead to repel love. With the leaden shaft, he struck the nymph Daphne, and with the golden one, Apollo, through his heart. Apollo was seized with love for the maiden, but she abhorred him, and to escape his advances, she changed into a laurel tree.

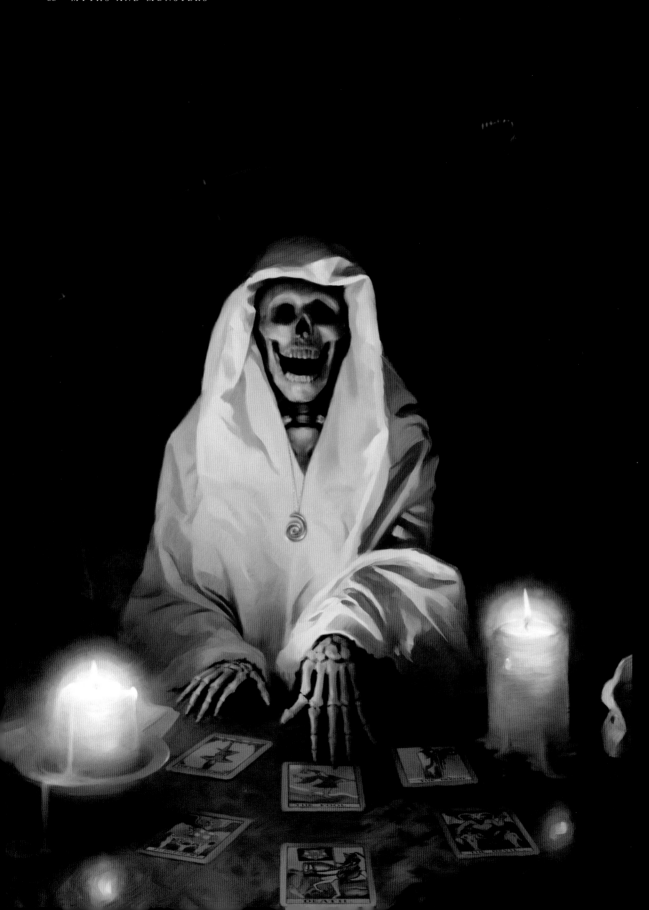

▶ **Forest Dragons**
John Garner
Portfolio work
Acrylic
www.shadowsofthunder.com

As with all of John's artwork, this piece was entirely hand painted in acrylics, without any digital enhancement. John explains: "I used an airbrush to create the background lighting effects. The idea of this work was to use nature's subtle camouflage, to create a seemingly peaceful and unpopulated scene, so that you may not immediately realize you are being observed by magical forest dwellers."

◀ **The Last Tarot**
Cyril Van Der Haegen
Portfolio work
Adobe Photoshop and
Corel Painter
www.tegehel.org

This painting was originally intended as a black and white interior illustration for a role-playing game release, but Cyril took the design further, as he describes: "I fell in love with the concept, so for my own pleasure, I decided to work it up as a full color painting. I worked on it primarily using Painter, but with finishing touches and final adjustments in Photoshop."

Sage of the Scroll
Greg Staples
Collectible card game illustration
Magic: The Gathering from Wizards of the Coast
Corel Painter

www.gregstaples.co.uk

Created as card art for *Magic the Gathering, Greg's
painting uses bold, confident strokes for reproduction at a
small size. "I've always had a love of fantasy art. Some of
my earliest memories are of visiting my neighbor, who had
a large collection of art books, in which I saw a picture of
Frazetta's* Death Dealer. *I couldn't have been any older
than seven or eight and I was totally bowled over."*

▲ **Spawning Ground**
John Garner
Portfolio work
Acrylic
www.shadowsofthunder.com

This painting, like much of John's
work, combines astronomical
themes with classic fantasy elements.
"This piece was done by hand,
entirely in acrylics, with no digital
enhancement. I used an airbrush
to paint much of the background,
create the atmospheric effects, and
finally add the highlights. Many
thin layers of paint were used to
create the shadows and slowly
work up to the highlights."

▶ **Eye of the Dragon**
Martin McKenna
Book cover
Eye of the Dragon from Wizard Books
Adobe Photoshop
www.martinmckenna.net

Not straying very far for inspiration from
the title of the book, in this picture we stare
straight into a dragon's eyeball. With
only a small area of the head around the
eye to play with, the challenge here was to
indicate reasonably clearly that this was
actually a dragon we are close to, and not
some other scaly monster. Helping to convey
this, is the suggestion of a great spiny mass
disappearing into the shadows, and the
inclusion of the smoking nostrils.

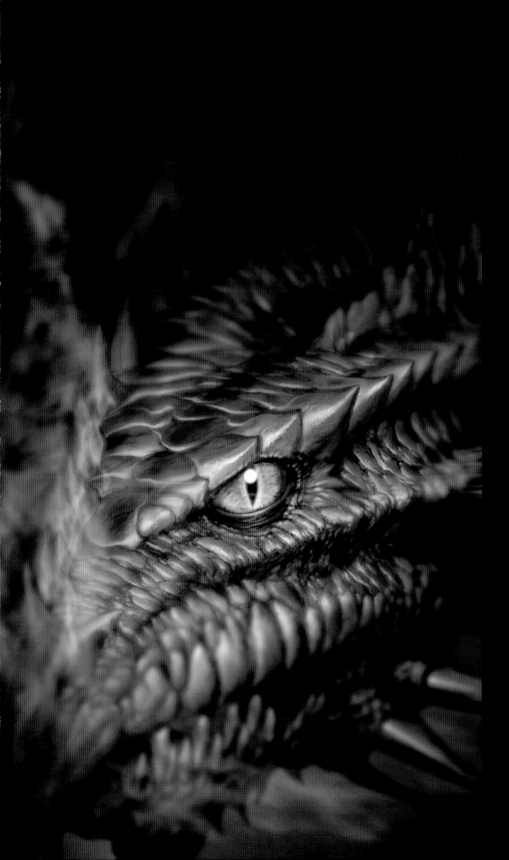

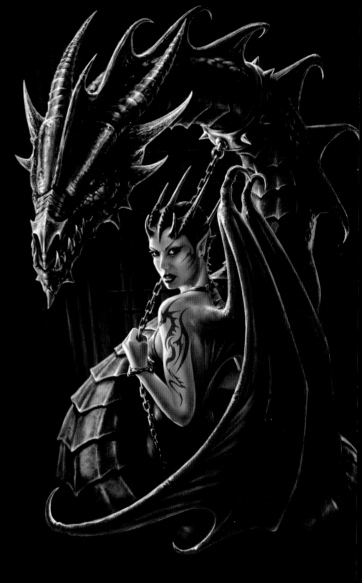

▲ **Controller**
Anne Stokes
T-shirt design for Spiral Direct Ltd
Adobe Photoshop
www.annestokes.com

Anne painted this exotic female with her dragon pet for the Dark Wear range of T-shirts; hence the strong design element of the image, intended to work when printed on black fabric. "The curl of the dragon's body is mirrored by the curve on the female's wings. A dragon can make for a useful pet, but you had better make sure you're in control."

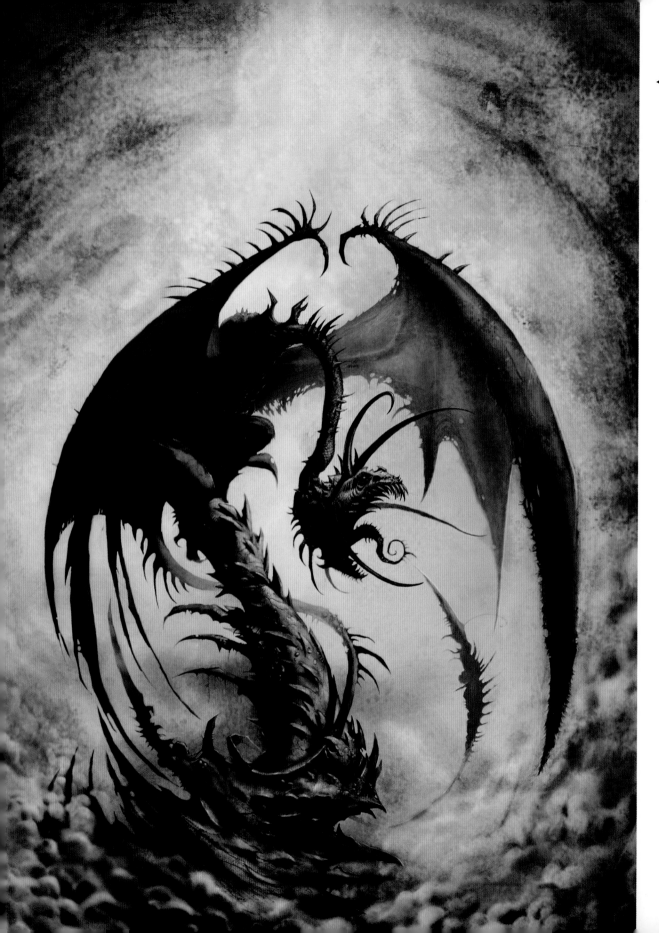

◀ **Krike Dragon**
Kevin Crossley
Portfolio work
Adobe Photoshop
www.kevcrossley.com

Kevin's spindly dragon recalls aspects of John Tenniel's Jabberwock *illustration for* Through the Looking Glass. *"The underdrawing was a very detailed pencil study, produced in my usual haphazard way. I then scanned this and used Photoshop exclusively during the painting process. I incorporated photographs of rust, lichen, scuffed metal, and other textures into the composition, using a variety of blending modes and levels of transparency, as well as selective erasing."*

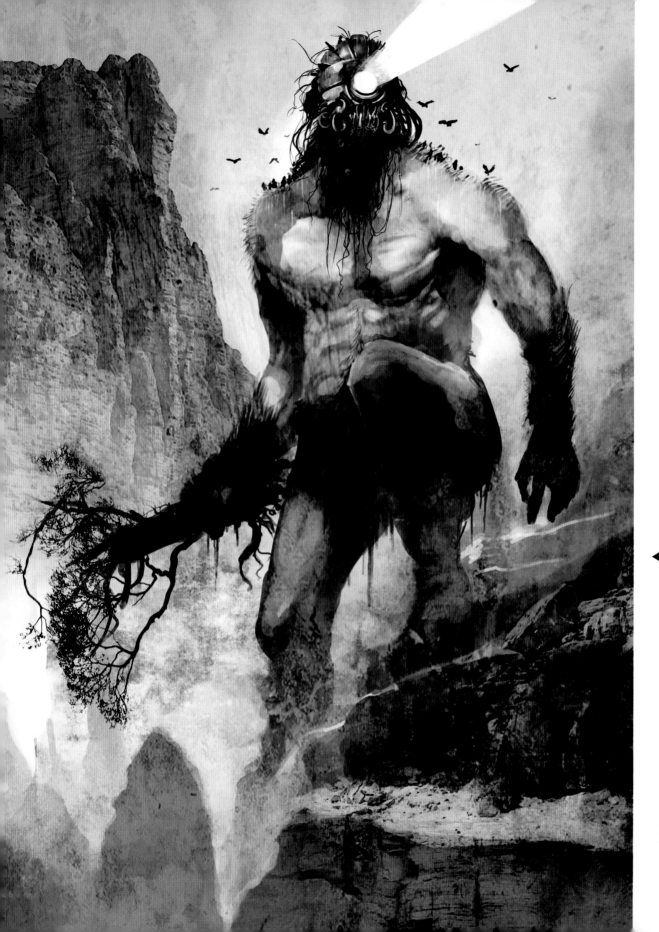

◀ **Ulysse**
Benjamin Carre
Book cover
*Odyssée, les Naufragés
de Poséidon* from
Père Castor-Flammarion
Adobe Photoshop
www.blancfonce.com

For this cover illustration,
Benjamin has imagined a truly
impressive reinvention of a
Cyclops. In Greek mythology,
the Cyclops is a member of a
primordial race of giants, each
with a single eye in the middle of
its forehead; seen here emitting
a powerful light beam. The
massive scale of this colossus is
cleverly conveyed through the
detail of the flock of birds, tiny at
this distance, that have perched
on the giant's shoulders.

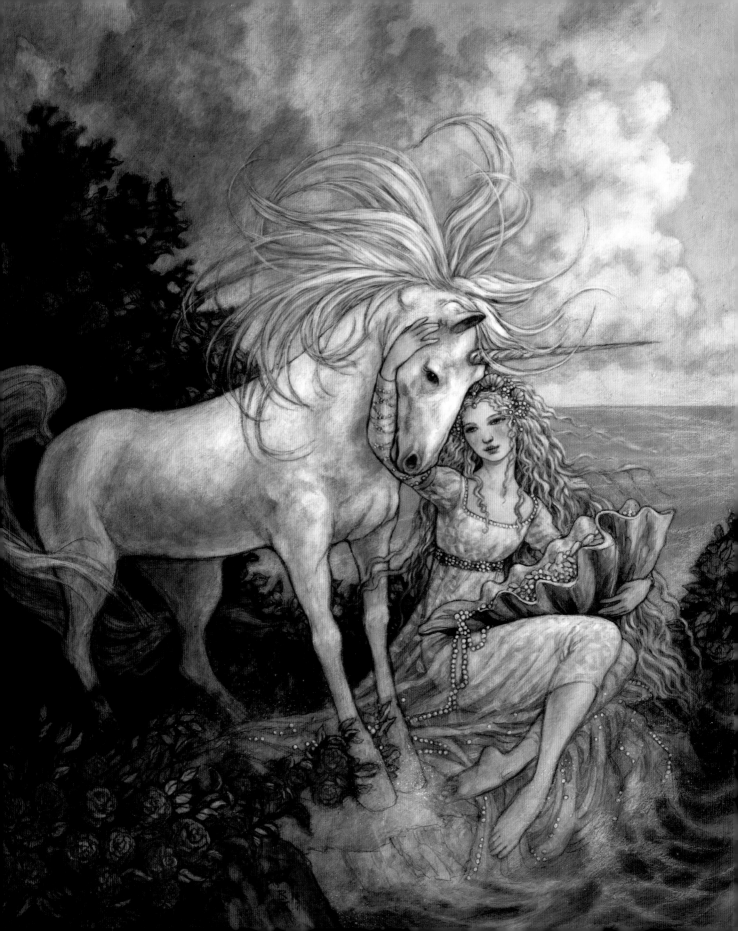

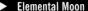
Beauty and the Unicorn
Rebecca Guay
Magazine cover
Cricket Magazine from
Carus Publishing
Gouache on paper
www.rebeccaguay.com

*In traditional folklore, the
unicorn is said to be tameable
only by a virgin woman. A gentle
and pensive virgin has the power
to attract the unicorn, and one
method of hunting it involved
entrapment by a maiden.
Rebecca's painting suggests a
more innocent encounter. "For
me, this is my perfectly pastoral
piece. I wanted to give a sense
of light and the ocean. I love the
affection between these totally
mythical archetypes; a unicorn
and a girl who is a sea maiden;
a nymph representing innocence."*

▶ **Elemental Moon**
Rick Sardinha
Game book cover
Elemental Moon from
Necromancer Games
Oil on masonite
www.battleduck.com

*Rick produced this painting
for the gaming supplement
of the same name. "For this
assignment, I chose to illustrate
a water elemental. I planned
this work around the close
association of the female with
life. The fluid nature of the
quasi-human female anatomy
emphasizes this, as does the
object floating above one of her
hands. It is a loose representation
of the Venus of Willendorf, a
prehistoric fertility symbol."*

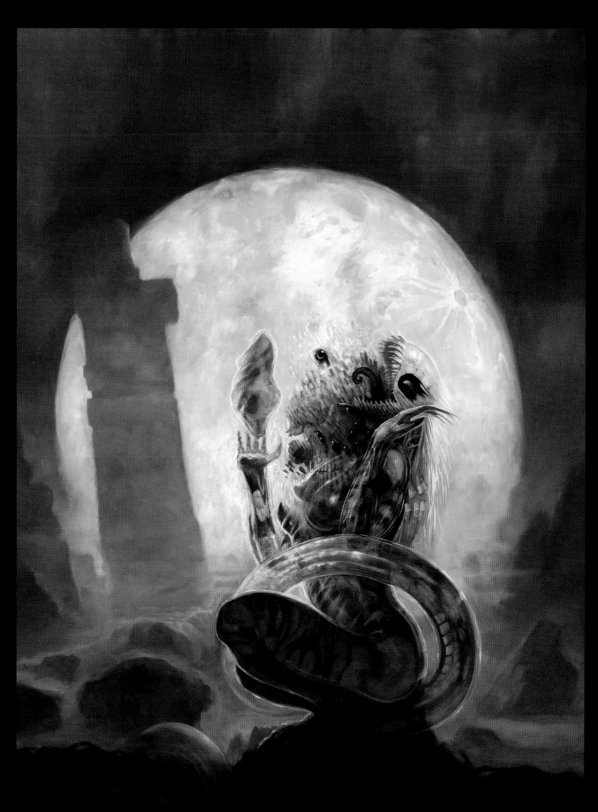

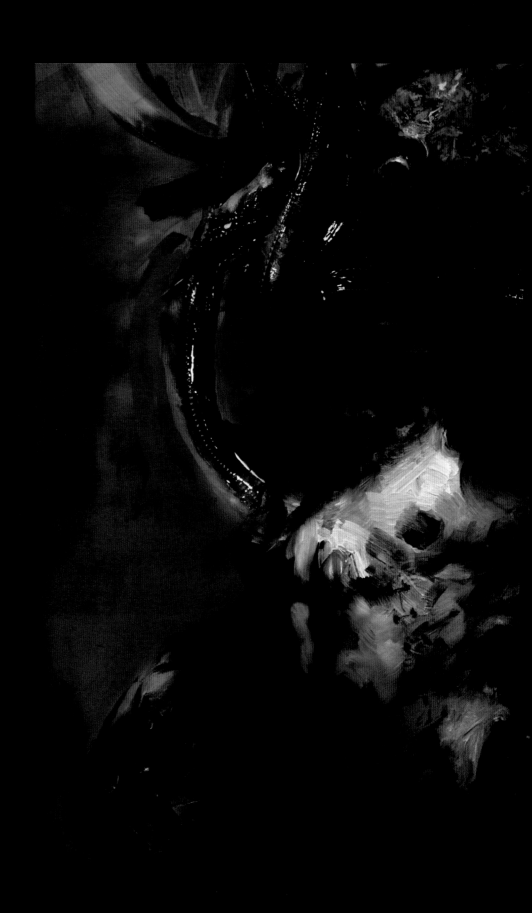

▲ **Changeling**
Matthew Bradbury
Portfolio work
Adobe Photoshop
www.epilogue.net/cgi/database/art/list.pl?gallery=11601

This figure is derived from werewolf folklore, and Matthew explains that he drew influences from films such as Neil Jordan's dark fairy tale, **The Company of Wolves,** *and Ridley Scott's fantasy epic,* **Legend.** *"In most cases when I'm painting, a story evolves in my head alongside the image. In this work, I imagined the changeling girl torn between two worlds; both familiar, both containing loved ones and family. I tried to express something of the sorrow of these two creatures."*

◄ **Male Medusa**
Jason Felix
Portfolio work
Adobe Photoshop
www.jasonfelix.com

In Greek mythology, the Gorgons were female monsters with hair of living venomous snakes. Most popular imagery concerning the Gorgons derives from the Medusa and Perseus legend, but Jason wanted to explore something different. "In mythology, Medusa has always been known as the third sister of the Gorgons, who were transformed into hideous creatures. I've always wondered what a male member of the Gorgon family would look like."

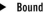

► **Bound**
Ryohei Hase
Portfolio work
Adobe Photoshop
www.h4.dion.ne.jp/~ryohei-h/index.html

With this image of grotesque bondage, Ryohei confronts us with the mystery of what kind of malformed monstrosity could possibly exist within the huge misshapen bulk of this figure's wrapped head. The image is filled with tension, both in the tantalizing enigma of the figure, and through its resistance to the stretched plastic bonds that bite into its pallid flesh. Its hands are balled into tight fists as it tries to tear free.

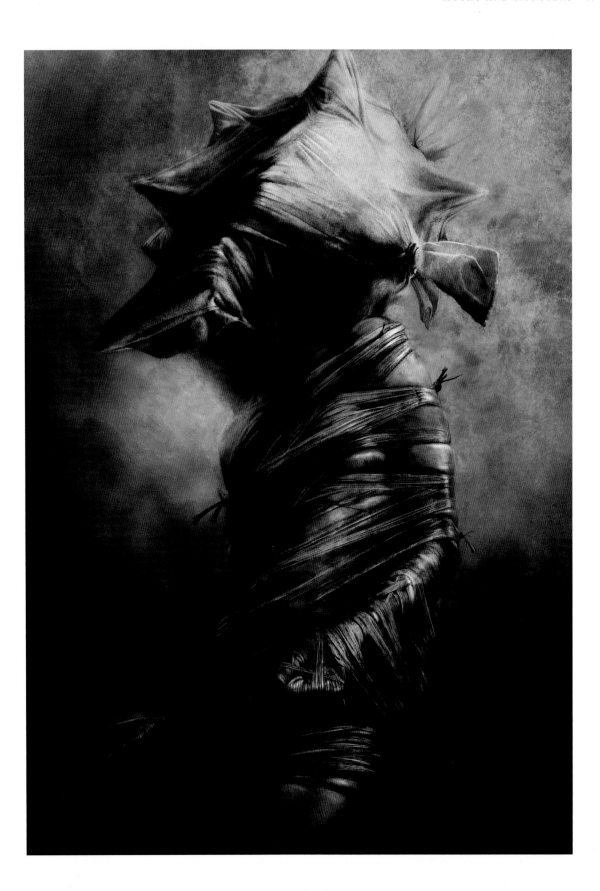

▶ **City of Peril**
Ralph Horsley
Game book cover
Fantastic Locations from
Wizards of the Coast
Acrylic
www.ralphhorsley.co.uk

*A swarming rat horde in a
moonlit urban setting was the
brief for Ralph's painting. "I
decided to go for a low point
of view so that the wererat
antagonists would loom over the
viewer. Along with the off-kilter
horizon line, this helps to create
a sense of menace, and reinforces
the feeling of being inside an
open sewer in the shadowy
depths of the city. The moon acts
as a focal point to draw in the
eye, and it also enabled me to
use back lighting to define the
figures and all those rats."*

▶ **Technical Difficulties**
Patrick Reilly
Portfolio work
Adobe Photoshop and Corel Painter
http://preilly.deviantart.com/gallery

*The idea of gremlins being
responsible for sabotaging
aircraft began in WWII, first
recorded by Royal Air Force pilots.
Mischievous and mechanically
oriented creatures, gremlins
have been depicted wreaking
havoc in* Nightmare at 20,000
Feet, *the classic episode of* The
Twilight Zone, *and in Joe
Dante's* Gremlins *films. Patrick's
portayal is a classic and dynamic
one. "I wanted to combine my
interest in folklore and WWII
by depicting a gremlin attack
on a B-17 Flying Fortress."*

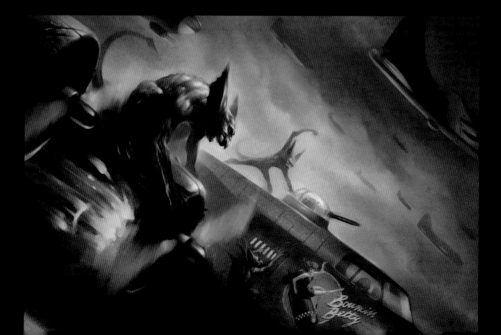

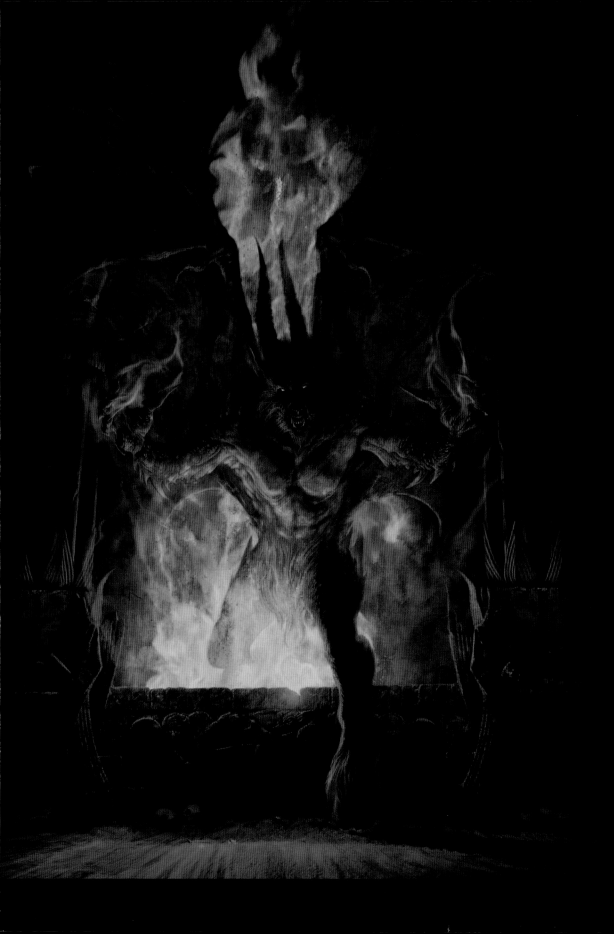

◀ **Spell Breaker**
Martin McKenna
Book cover
Spellbreaker from Wizard Books
Adobe Photoshop
www.martinmckenna.net

*The brief for this cover was to
show a demonic figure stepping
out of a fiery pit. The suggestion
is that this is perhaps a gateway
leading from some infernal
dimension, or maybe an opened
casket that had magically
trapped the creature, from which
it's now breaking free. I wanted
the figure to be dark, almost a
silhouette in places, particularly
the head, to allow the glowing
eyes to stand out.*

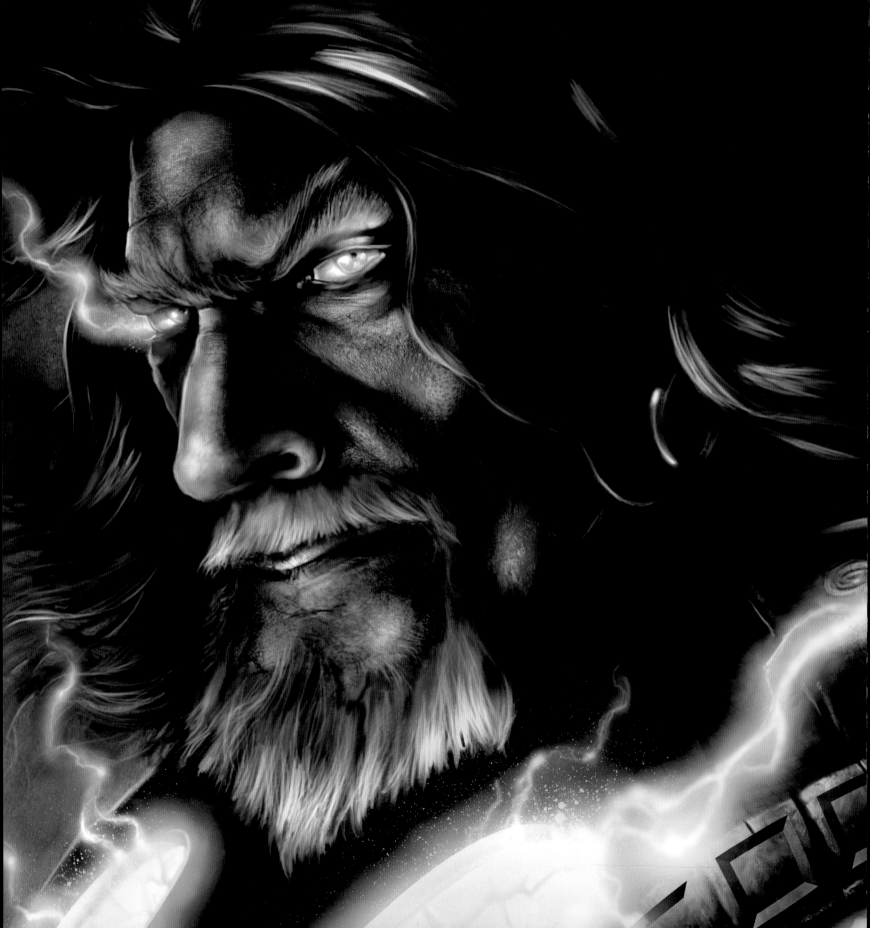

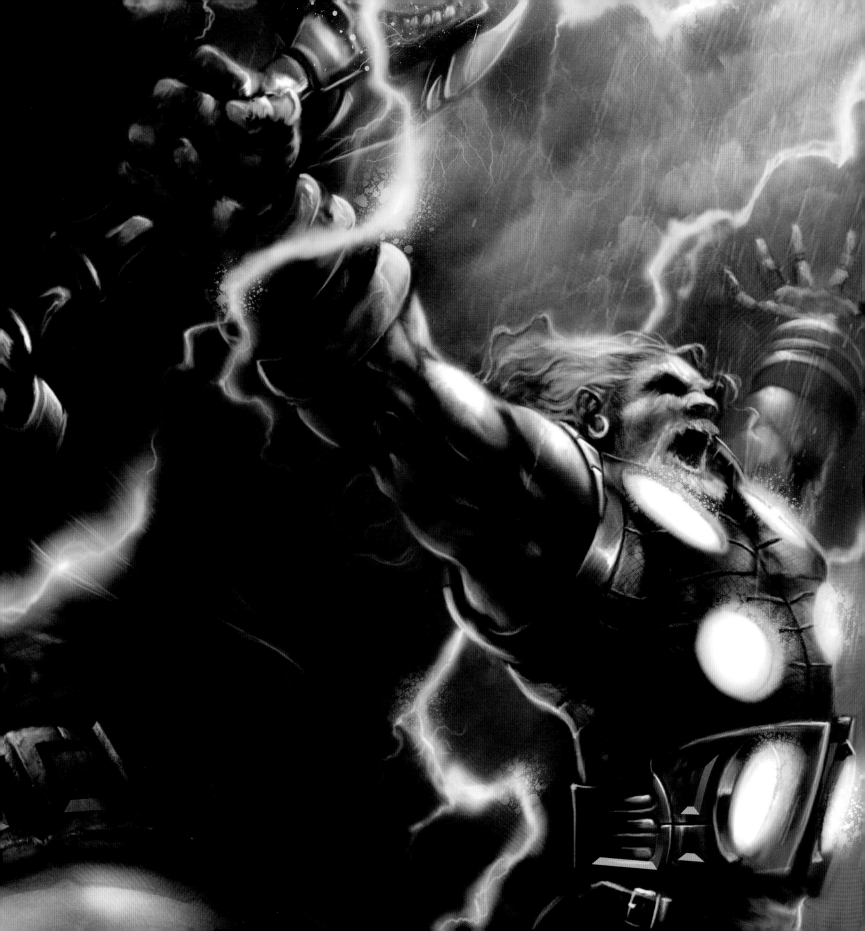

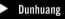 **Thor, Ultimate**
Glen Angus
Game illustration
Marvel Ultimate Alliance from
Marvel, Activision, and Ravensoft
Adobe Photoshop
www.gangus.net

This image was created by Glen
as a character concept and
loading screen for a computer
game. "I wanted to paint Thor
as a weathered and hardened,
larger-than-life figure. I focused
on the hard planes of his face,
and the confident glare in his
eyes. Ironically, in the end, the
client wanted a gentler-looking
Thunder God, one closer to the
current Ultimates comic book
character. I kept this version for
my portfolio because it captures
my first instinct."

▶ **Dunhuang**
Camille Kuo
Portfolio work
Adobe Photoshop
http://camilkuo.com/main.htm

Inspired by a trip to Dunhuang
in China, Camille explains that
she painted this figure without
using the model reference she
normally employs. Painting
freely from her imagination
enabled her to keep the work
spontaneous, and unconstrained
by any reference material that,
in pursuit of tightly detailed
realism, she feels can sometimes
impose limitations upon her
work. The background was
painted traditionally in oils
and scanned.

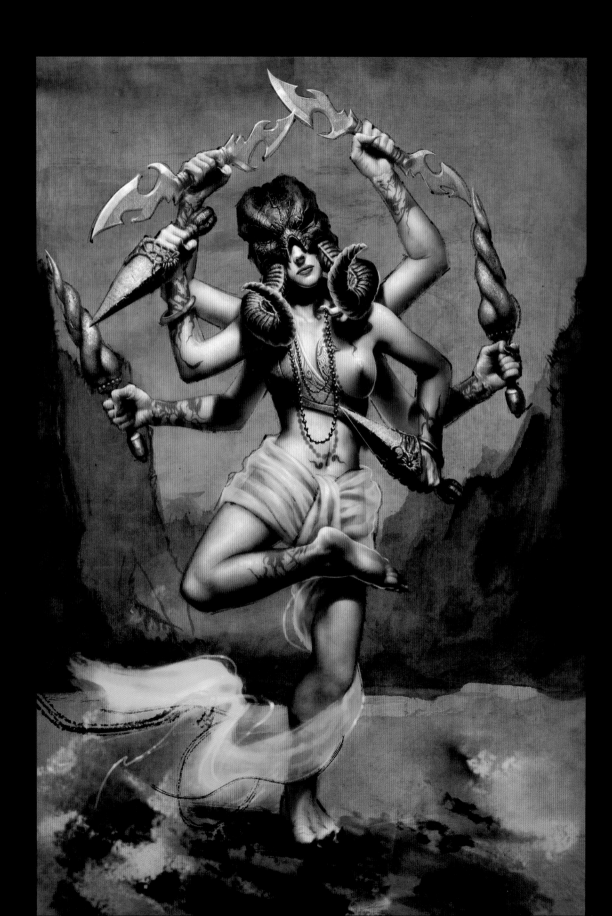

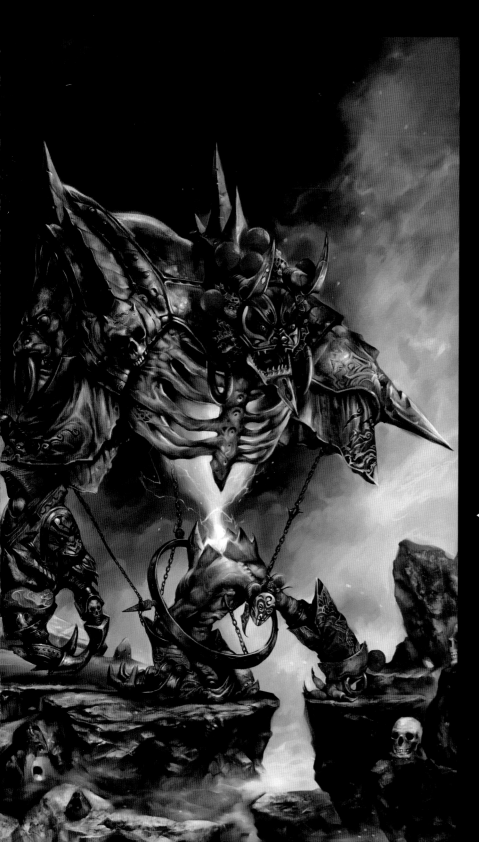

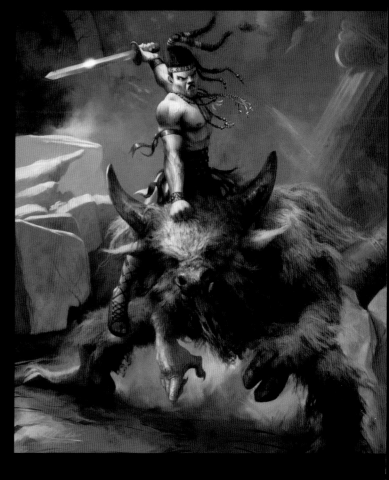

◀ **The Disciplinant**
Kuang Hong
Portfolio work
Corel Painter
www.zemotion.net

Using very traditional painting techniques with Painter, and applying individual brushstrokes to no more than a single layer was a time-consuming process for Kuang. "This is a concept piece. There was a story of a famous Chinese opera actor who was murdered, and this is a manifestation of his soul. The control of the whole entity comes from the white light at its center; the body below and the huge prop on top are merely tools controlled by it."

▲ **Minotaur**
Simon Dominic Brewer
Portfolio work
Corel Painter
www.painterly.co.uk

Simon explains that he has always been fascinated by Greek mythology, and this is his first attempt to depict the battle between Theseus and the Minotaur. "I wanted to portray the Minotaur as being more primal and fearsome than simply a guy with a bull's head, hence the more fundamental combination of human and animal. In Painter I used custom oils, acrylics, and chalk, leaving some areas rough to add dynamism. I also used the slanted viewpoint for a similar effect."

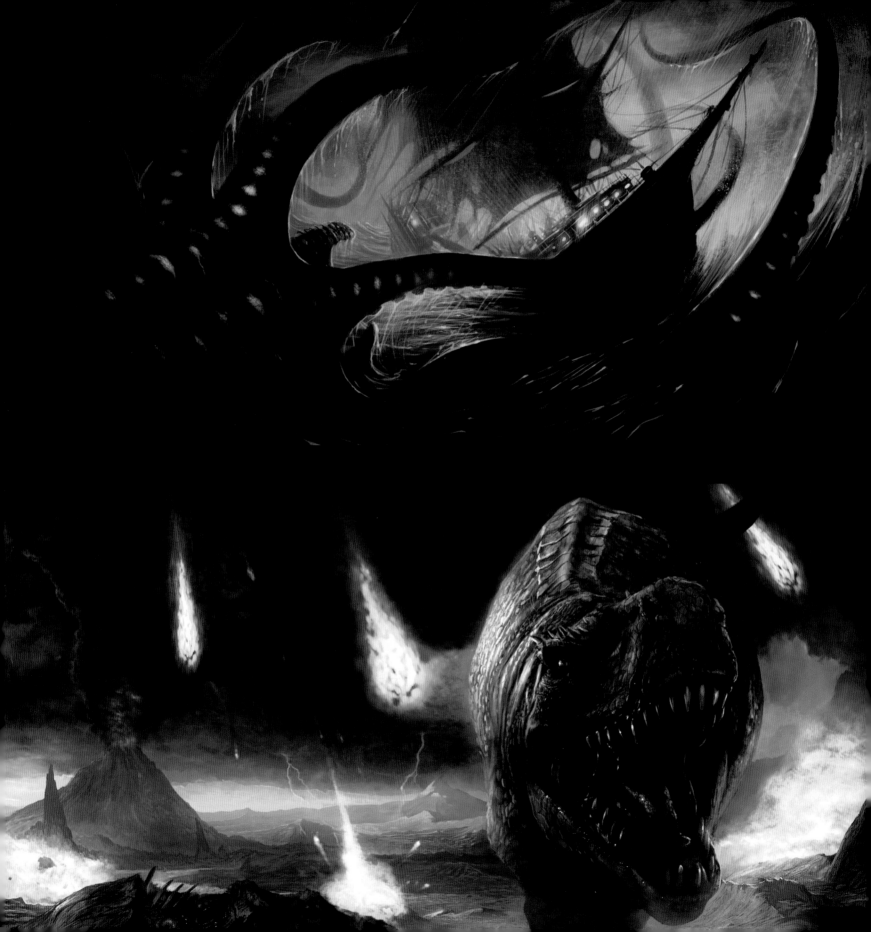

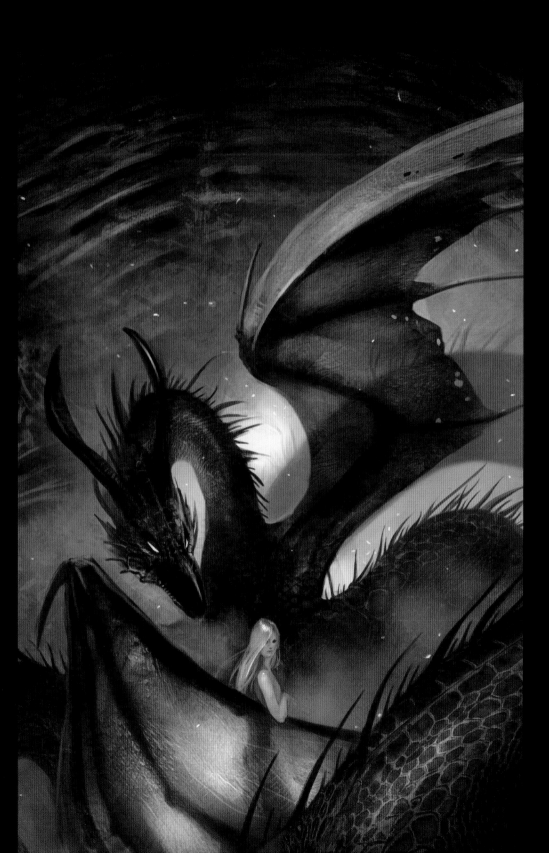

◄◄ **Tales from the High Seas**
Patrick Reilly
Portfolio work
Adobe Photoshop
http://preilly.deviantart.com/gallery

*An atmospheric local pub frequented by
Patrick inspired this piece. "The place had
a very old and creepy nautical feel, with
lime green lighting that really caught my
attention. It was tiny and felt a lot like
being in the belly of an old pirate ship,
and as I was sipping my beer, I expected
a giant tentacle to come crashing in."*

◄ **Prophecy**
Benjamin Carre
Book cover
La Symphonie Des Siecles II: Prophecy
from Pygmalion
Adobe Photoshop
www.blancfonce.com

*In a subterranean lair, this golden dragon
protectively encircles a young woman,
who leans nonchalantly against its wing.
Benjamin has made very effective use of
the warm lighting from behind, to render
the semiopaque quality of the dragon's
membranous wings. The air sparkles with
golden embers, and the ribbed nature of the
cavern walls suggests this might even be the
insides of a far more enormous creature.*

◄◄ **The Last Days**
Matthew Bradbury
Portfolio work
Adobe Photoshop
*www.epilogue.net/cgi/database/art/list.
pl?gallery=11601*

*Matthew's vision offers a glimpse of a hell
on earth in which a doomed Tyrannosaurus
struggles to survive. "Dinosaurs might not
be considered 'fantasy' creatures, but for
me they hold as much fascination as any
dragon of legend, perhaps even more so,
as these giants really did live and breathe.
This image is set at a time after the meteor
impact, which almost certainly brought
about their eventual extinction. I tried
to imagine the harshest of environments,
featuring poisoned skies above volcanic
and geological mayhem."*

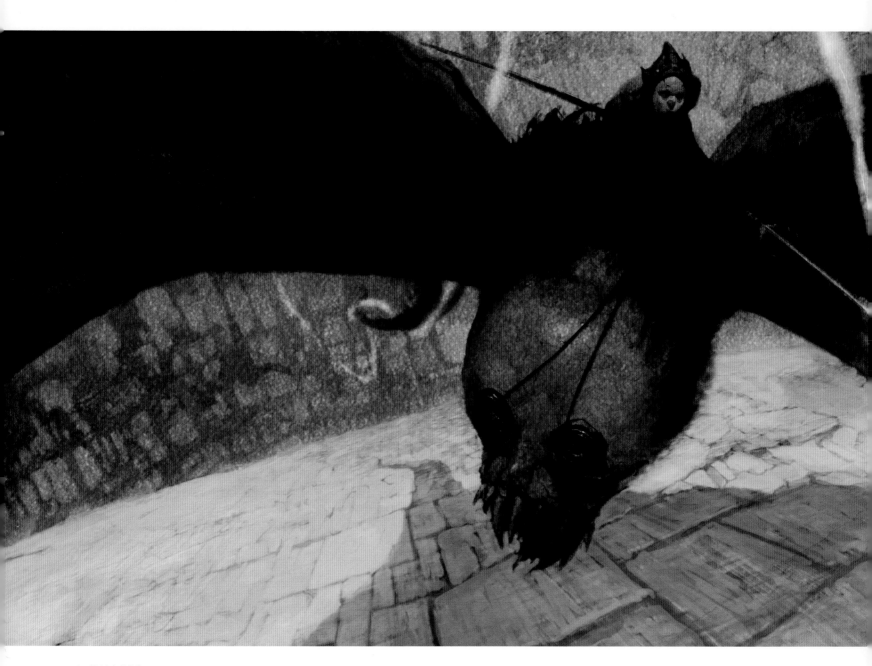

▲ **Voidshriek Spectre**
Anthony S. Waters
Collectible card game illustration
Magic: The Gathering from Wizards of the Coast
www.thinktankstudios.com

This piece started life as a postage stamp-sized scribble sketched in ink, explains Anthony. "I took the doodle into Photoshop and built it up to a detailed value study; first using the Eraser tool, then switching to the Brush tool; the former can be used for a scratchboard effect. I used the Brush for developing the tonal study, which permitted me to get all my values accurate before introducing color. The final stage involved importing textures from various found objects and using them to tint the image."

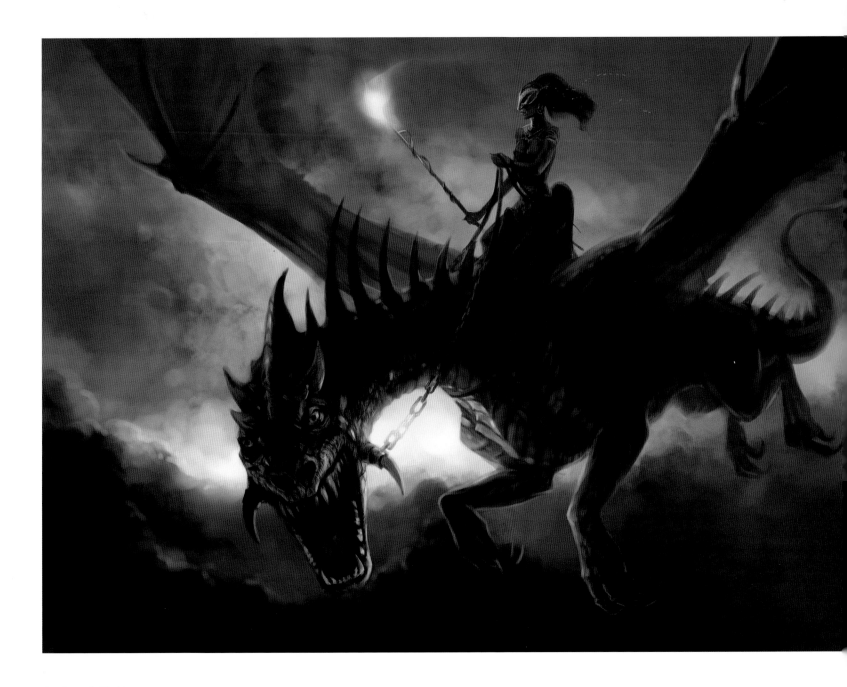

▲ **Dragon's World**
Julia Alekseeva
Collectible card game illustration
Berserk from Fantasy World Publishing, Inc
Adobe Photoshop
http://julax.ru

Julia has depicted a masked female rider, holding her flaming crop aloft as she steers her dragon mount through storm clouds. "In this work, I wanted to convey the power of a mighty dragon, deftly controlled and managed by the spiritual forces of a fragile enchantress. The dark world inhabited by this dragon and its rider is murky, but the skies crackle with magic."

▶ **Mighty Dragon**
Uwe Jarling
Portfolio work
Corel Painter
www.jarling-arts.com

Uwe created this piece for his ongoing Mystical Creatures *series of paintings. "I chose to portray the centralized beast from a low point of view to increase its impact and power, and for focus, I kept the background simple and uncluttered. I love to depict legendary creatures of traditional European folklore and myth. Almost all of my work is created digitally now, but I'm keen to preserve the look of traditional oil paintings."*

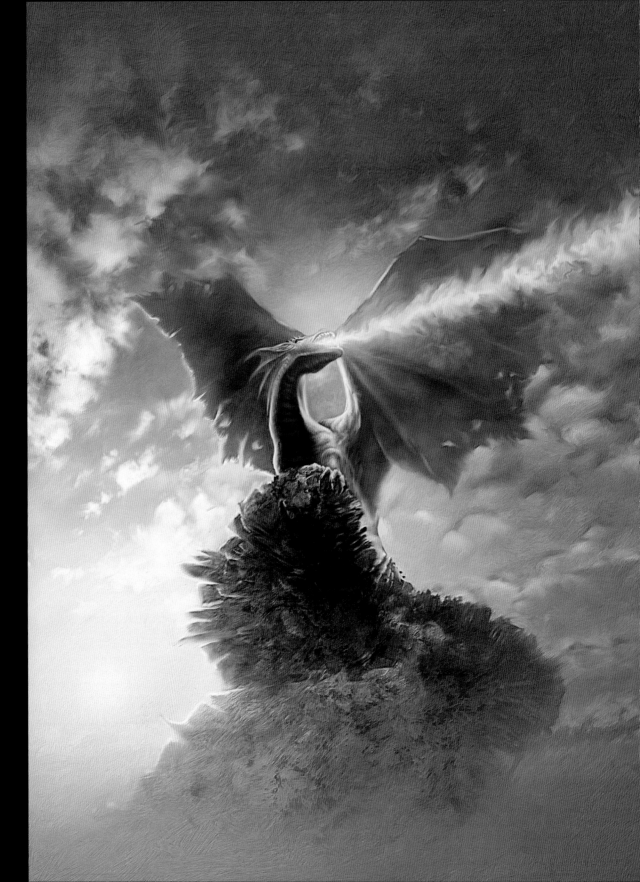

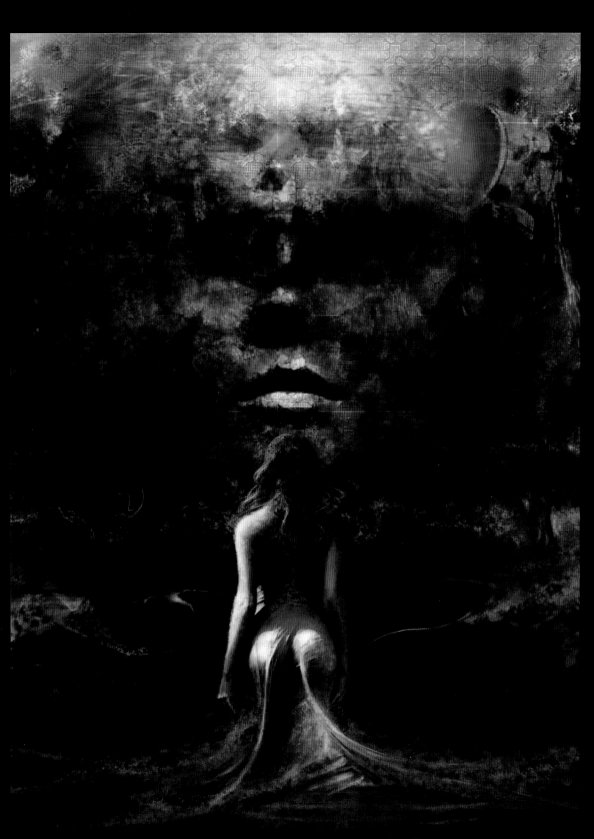

◀ **Crossing The River Styx**
Eric Scala
Portfolio work
Adobe Photoshop and
Corel Painter
www.ericscala.com

*This image, featuring the figure
of a woman wading through
dark waters toward vast faces,
that tower, godlike, among
storm clouds, was one that came
together through a very organic
creative process for Eric. It
wasn't until Eric was finished,
that he finally identified one of
the visuals he'd had in mind,
"I realized it reminds me of
Federico Fellini's film,* La Dolce
Vita, *and the famous scene of
Anita Ekberg standing in the
Trevi Fountain."*

▶ **Tiltadron**
Mike Corriero
Portfolio work
Adobe Photoshop
www.mikecorriero.com

The main focus of this creature concept was to design an asymmetrical giant. To accentuate the asymmetry, Mike decided to substitute one of its legs with an arm, shrinking its other limbs to vestigial forms. The resulting figure appears blasphemously twisted and mutated, but incongruous, landscape features suggest the creature has its origins firmly rooted in nature. The warrior figure provides scale, and wears asymmetrical armor that echoes the form of his titanic beast.

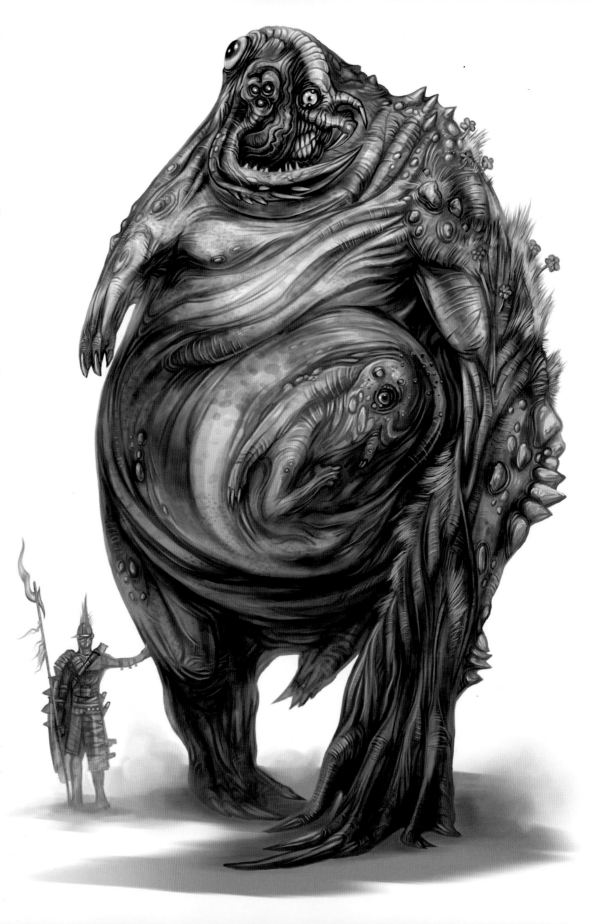

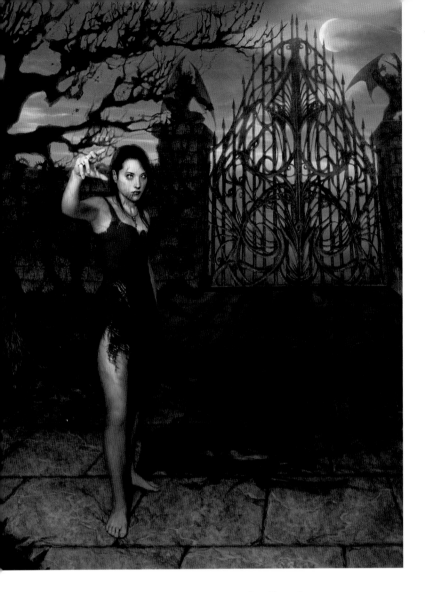

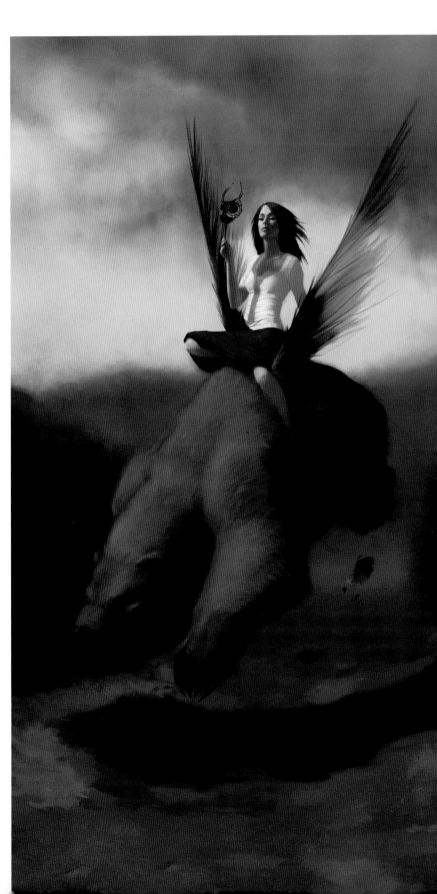

▲ **Cerebrus**
Camille Kuo
Portfolio work
Adobe Photoshop
http://camilkuo.com/main.htm

In Greek mythology, Cerberus was the demon of the pit that guarded the gates of Hades, ensuring that all spirits could enter, but none could return. Traditionally depicted as a monstrous three-headed hound, here we see Cerberus in a much more alluring human form. Camille reveals that she posed for the figure herself, and is shown standing before the hellgate, the key to which hangs on a chain around her neck.

▶ **Honey Queen**
Bryan Beaux Beus
Portfolio work
Corel Painter
www.beauxpaint.com

Bryan found inspiration for this painting in Grimm's fairy tales, as he relates: "To lift a curse, our hero must guess which of three sleeping beauties is a princess. The only clue is that the young princess loved honey. Unable to solve the puzzle, he summons the Honey Queen who turns into a bumblebee, and tastes the sleepers' lips to see which has eaten honey. I've shown the Honey Queen hurrying to the castle upon her flying bear."

▶ **Claw Clan**
Kerem Beyit
Portfolio work
Adobe Photoshop
http://kerembeyit.gfxartist.com

*Proud members of this leonine
warrior clan pose beneath
their tribal banner. Kerem has
provided the figures with subtle
but distinctive indications of
individual character. Each
warrior wears his mane slightly
differently, with personal touches
including plaits. A neat visual
connection has been made
between the creatures and the
medieval lion, rampant heraldic
devices just visible on their armor.*

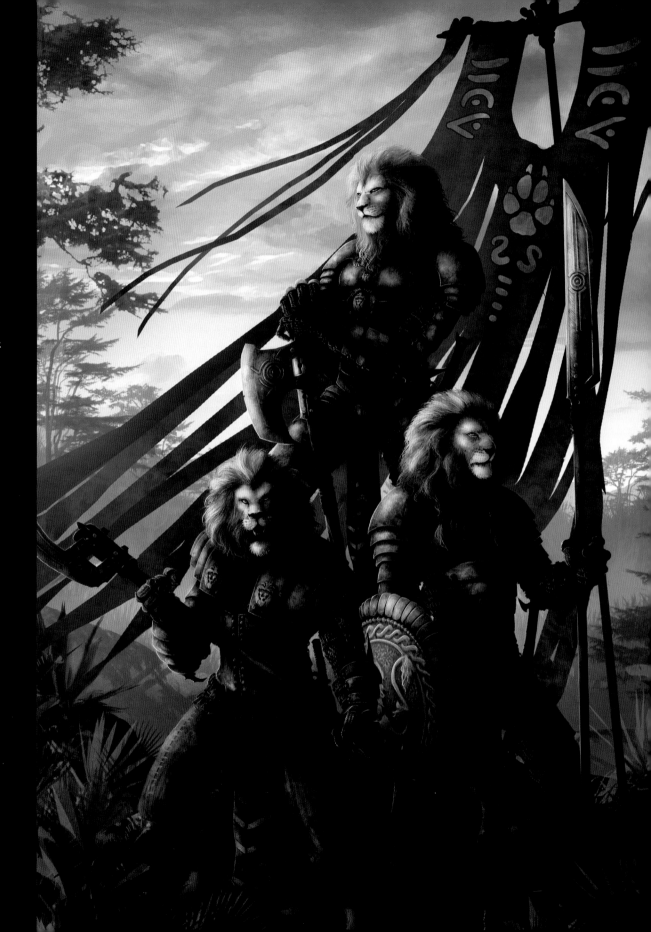

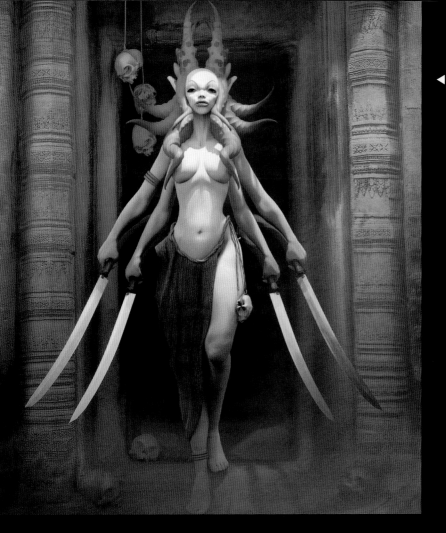

◀ **Dead End**
Pascal Blanche
Portfolio work
Autodesk 3ds Max and
Adobe Photoshop
www.3dluvr.com/pascalb

*Heavily influenced by the
stop-motion creatures of fantasy
film special effects pioneer Ray
Harryhausen, Pascal created
this mythic monster. As Pascal
says, "Ray Harryhausen is one
of the masters of fantasy that
made me the artist I am today."
The architectural details in
the background were derived
from photographic reference
material of the Angkor temples
in Cambodia.*

◀ **Morphogenesis**
Simon Dominic Brewer
Portfolio work
Corel Painter
www.painterly.co.uk

*This represents one of Simon's
more surreal fantasy settings,
which he describes: "We see a
portal between two worlds,
and that portal maintains
the integrity of each world
by changing whatever comes
through it. In the scene, the
many-legged alligator is being
morphed into many smaller
porcupine creatures, and the
tropical birds are merging into
a single forest-dwelling, flying
animal. Even the trees change,
as they grow from one world
into the next."*

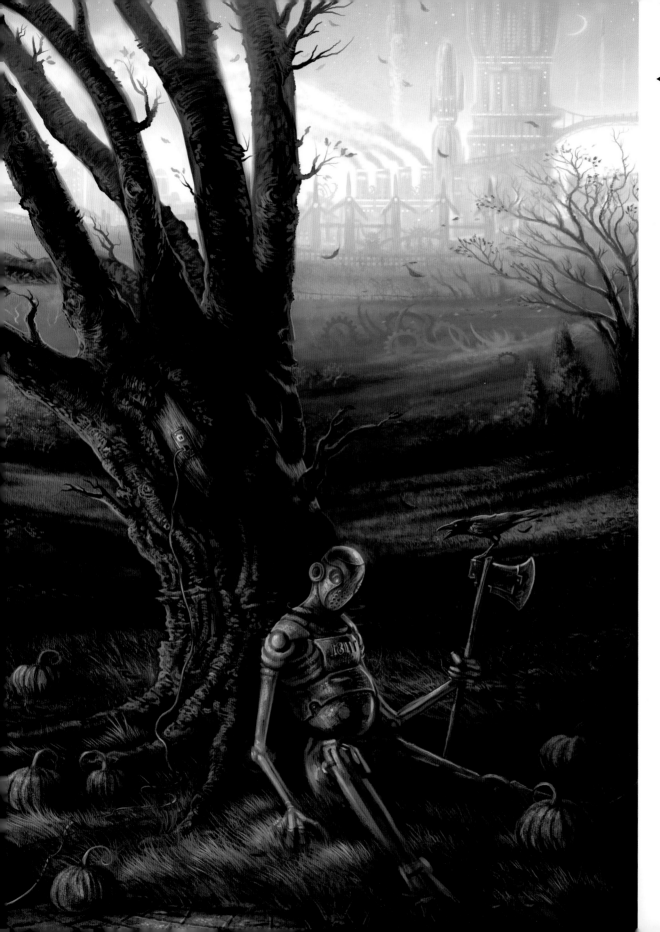

◀ **Keeper of the Fields**
Mike Corriero
Portfolio work
Adobe Photoshop and
Corel Painter
www.mikecorriero.com

*The collapse of an industrialized
society is glimpsed in this fall
scene. Mike gives us more of
his story: "The Keeper was
once a hard-working machine
that watched over the fields
and crops, but it has now been
abandoned. Low on energy
and slowly rusting away, it sits
watching the crows that mock it.
This melancholy robot figure is
also a small nod to the Tin Man
in* The Wizard of Oz.*"*

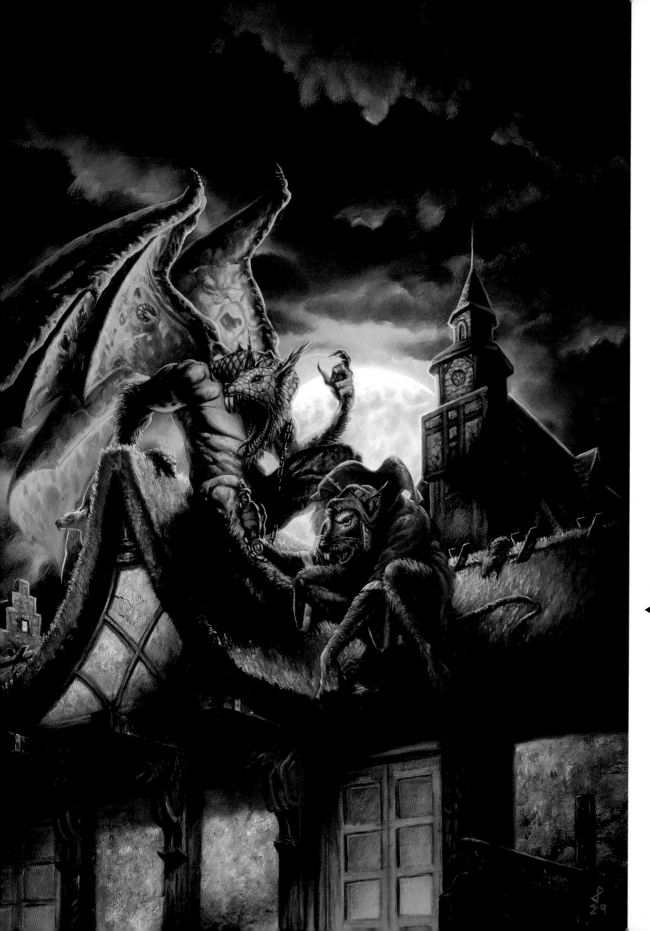

◀ **Wererats**
Jim Pavelec
Game book cover
Complete Guide to Wererats
from Goodman Games
Oil on paper on masonite
www.jimpavelec.com

*The U.S. gaming company
Goodman Games commissioned
Jim to produce this book cover,
and he chose to depict nocturnal
were-creatures prowling on city
rooftops by the light of a full
moon. "The art director is really
generous about giving artists
creative freedom, so I was able
to do pretty much whatever I
wanted with this piece."*

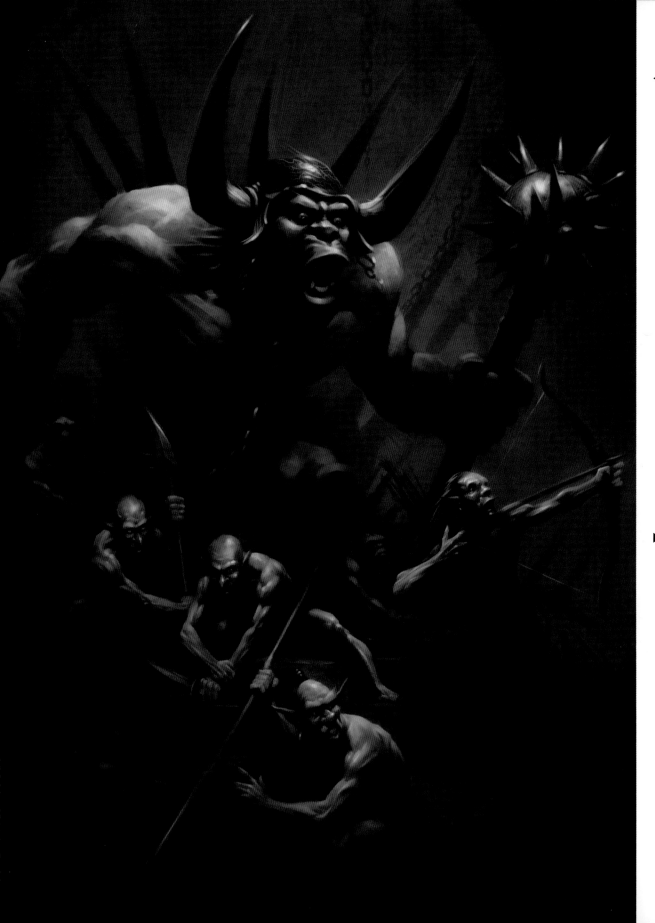

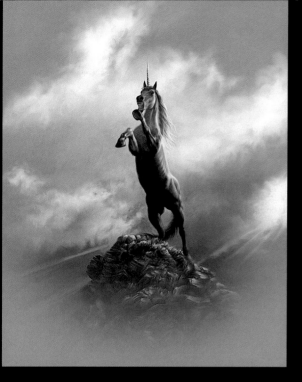

◀ **Majestic Dignity**
Uwe Jarling
Portfolio work
Corel Painter
www.jarling-arts.com

One of an ongoing series of paintings showcasing mythical creatures, Uwe has captured the free spirit of a unicorn in this picture. "I wanted to show the unicorn as prominently as possible, so I chose to have it rearing up on a hilltop. The low viewpoint helps to make the animal more impressive."

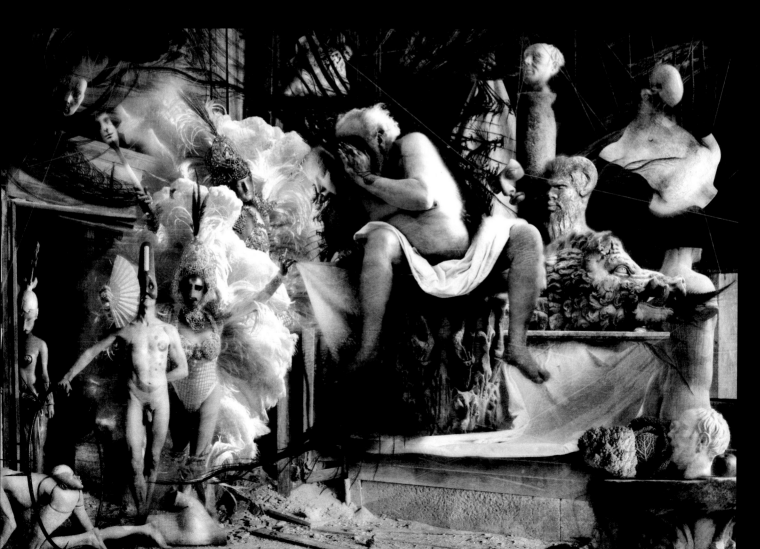

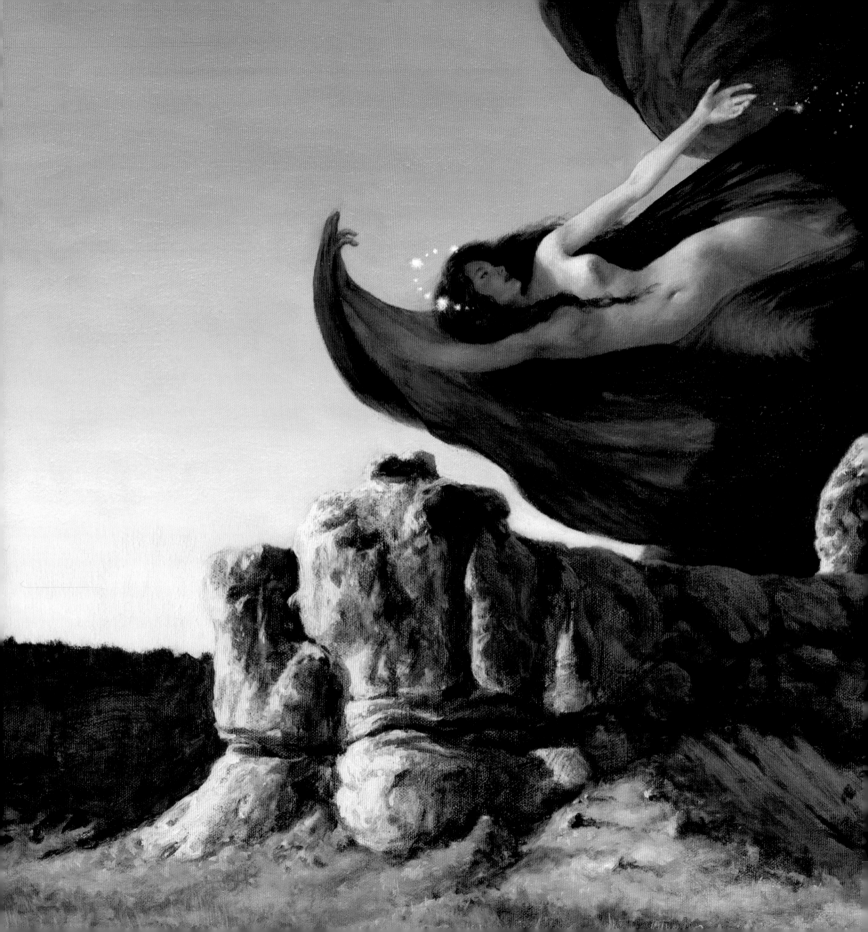

CHAPTER 4

SIRENS AND SEDUCTRESSES

Night
Richard Hescox
Portfolio work
Oil on canvas
www.richardhescox.com

This painting incorporates strong use of allegory, as Richard divulges: "I make use of the human form to symbolize and personify some aspect of nature, and this is one of a series of paintings I am working on in which I am exploring the grandeur and mystery of the landscape, and the natural forces that perform upon that stage.

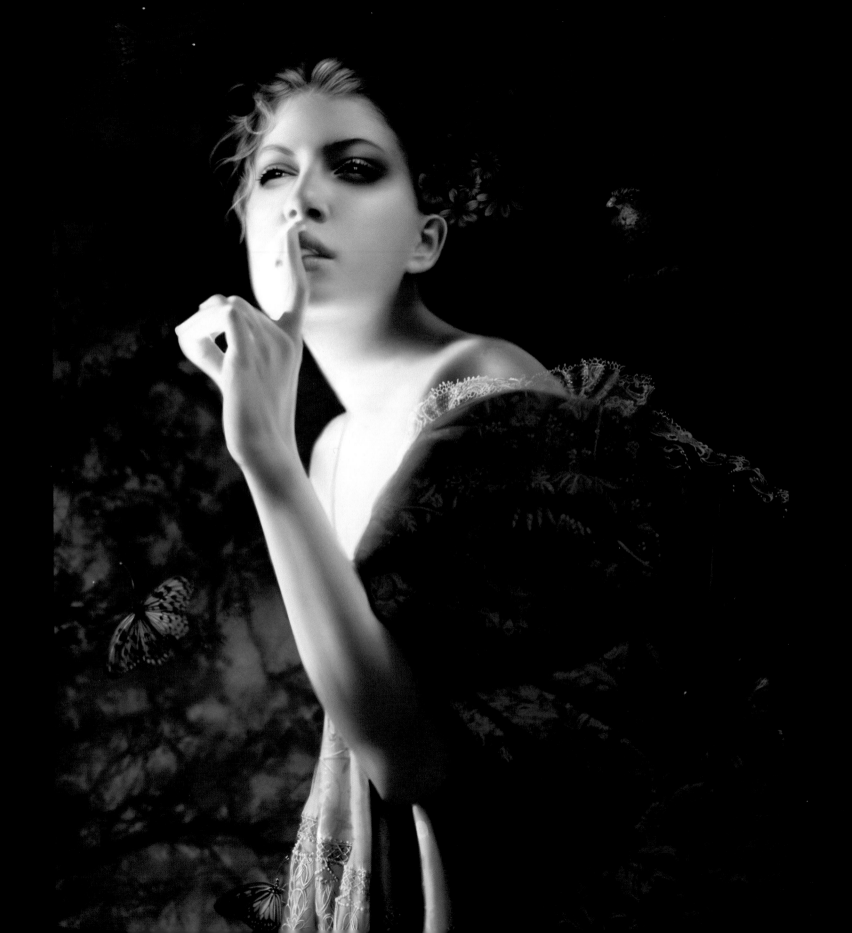

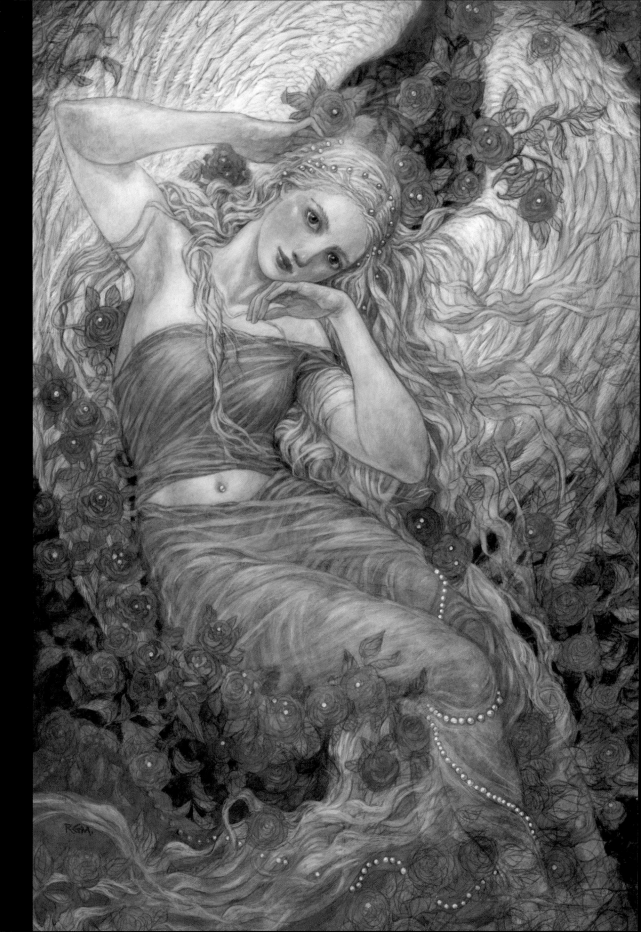

Surprise
Melanie Delon
Portfolio work
Adobe Photoshop and
Corel Painter
www.eskarina-circus.com

*Asyllia is an enchantress, and
she is featured in one of
Melanie's stories that recall
traditional Russian folklore.
"Asyllia is the queen of the forest,
she takes care of the land, and
protects it with her magic. But
she is also mischievous, and
she often plays tricks on the
hapless, local peasant people
who stray into her forest realm.
Fortunately, they know that
Asyllia isn't evil, so they are not
afraid of her, but they respect
her protective powers."*

Angel of First Love
Rebecca Guay
Game illustration
Angel Quest from
Angel Quest, Inc
Oil over gouache on panel
www.rebeccaguay.com

*Rebecca describes how this
painting contains the themes
of love and passion that she
finds forever appealing. "I
wanted to paint a portrait
that would feel like the face of
love, and the embodiment of
falling in love. I wanted her
to be sensual, yet innocent,
wide-eyed and absorbing, while
maintaining a distant air. She
is complete in her confidence
and strength, and, although
an angel, entirely earthly."*

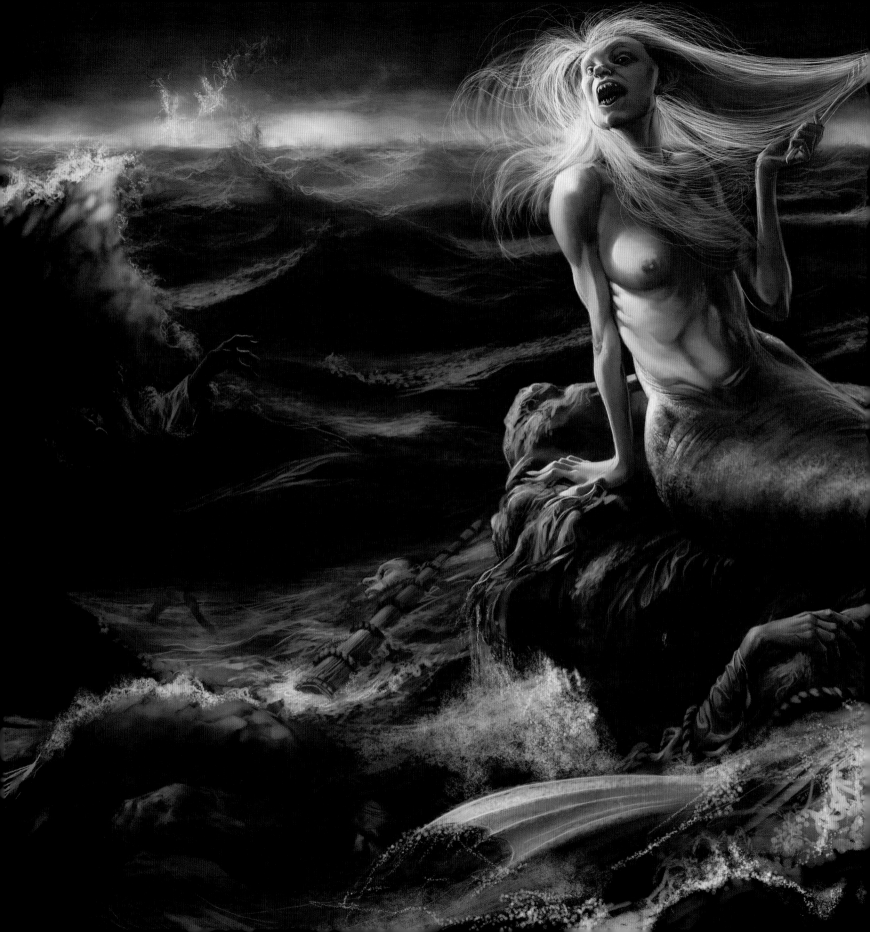

◀ **Siren Song**
Nick Harris
Portfolio work
Corel Painter

*Dividing this scene into fore, mid,
and background, to keep control over
the tonal values, Nick then blocked
everything in using the oil pastel variant
in Painter, and applied shadows with
digital tinting brushes. "I added detail,
such as pattern interest, to the siren's
tail using the Large Chalk variant with
swirling paper textures. It all looked too
bright and cheery, so I applied a blue
Multiply layer and painted glows and
glints into it with a light orange hue."*

▼ **Day Dreamer**
Tony Hayes
Portfolio work
Autodesk 3ds Max, Adobe Photoshop,
and e frontier Poser
www.my-art-gallery.co.uk

*Tony's intention for this piece was to
create a restful, placid image. "I enjoy
creating pictures that get the viewer
thinking, and I offer no clues as to how
or why she is there. The basic 3D scene is
little more than a rectangular wall with
a tube set into it, built and textured
in 3ds Max. The cloth was created by
photographing a bed sheet, and using
pillows under it to simulate the shape
of the sleeping character's body."*

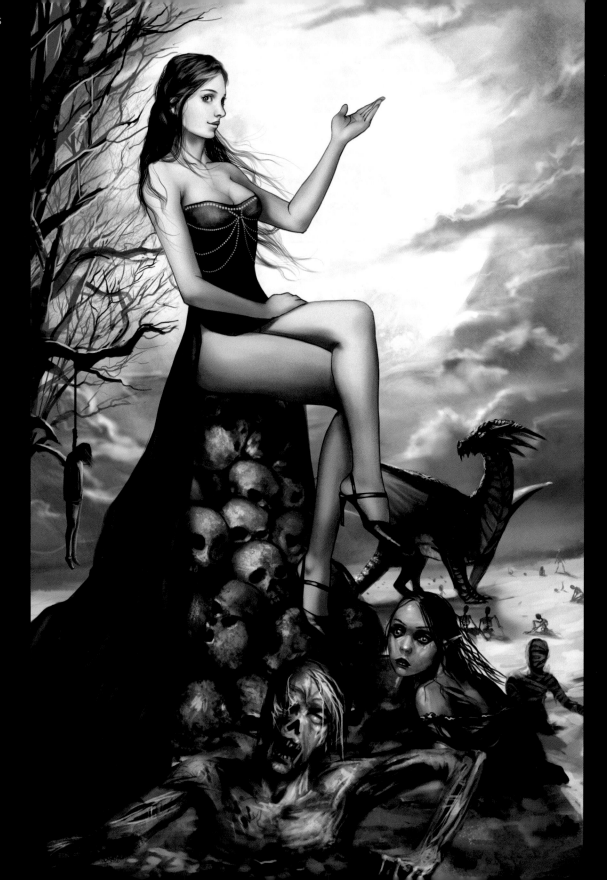

▶ **Black Dandy**
Linda Tso
Book cover
Hotu Publishing
Adobe Photoshop
www.stickydoodle.com

To paint this book cover, Linda
needed to depict a necromancer
who could raise the dead to join
the legions of her zombie army.
As Linda describes, "I thought it
would be interesting to contrast
a cheerful-looking and attractive
girl with dark horror elements.
For this painting, I finished a
detailed grayscale tonal image
first, then tinted it with color
on separate layers."

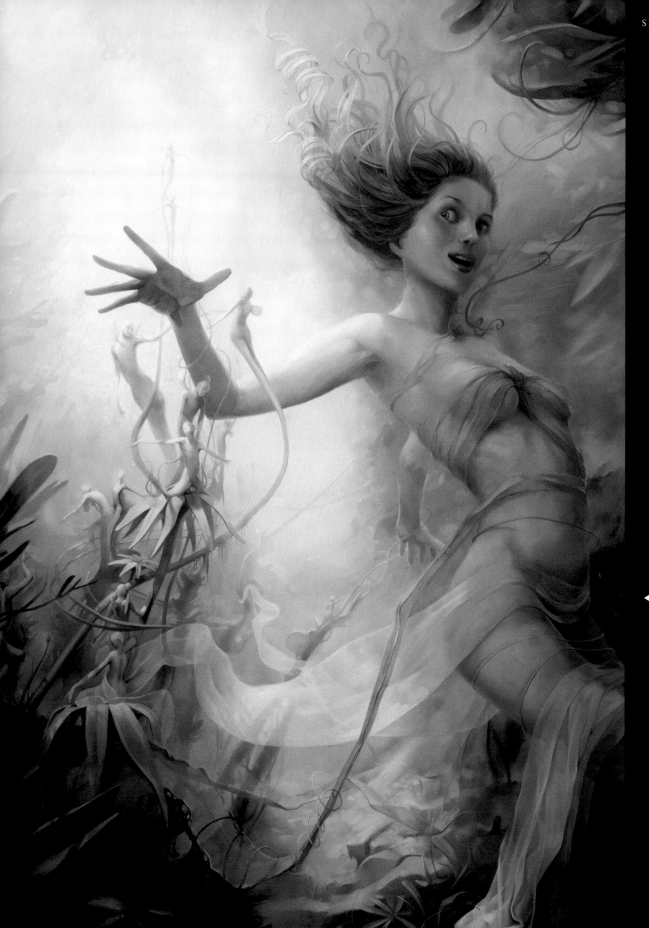

◀ **Backdoor to Luxuriance**
Michael Zancan
Portfolio work
Oil on canvas
http://zancan.fr

*Michael reveals that the word
"luxuriance" had been repeating
in his head for days like a
leitmotif, and that the most
natural response for him was to
externalize it in paint. "To enable
a brighter light to fall upon the
hand, the whole painting had to
be plunged in a subtle penumbra.
After working out the body
language with a live model, I
tried to describe in the girl's face
an expression of joyful surprise,
mixed with a hint of worry."*

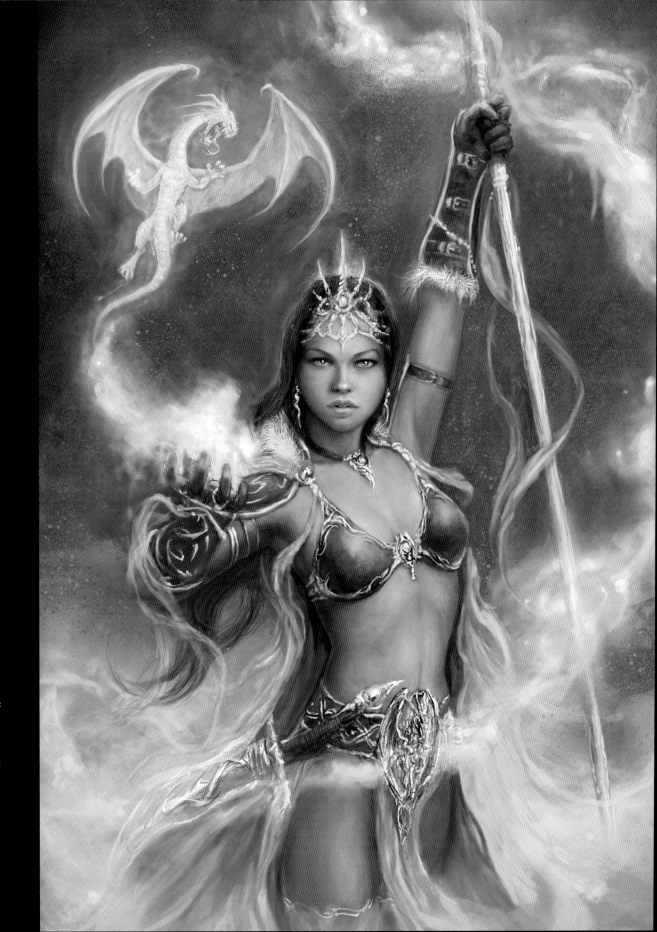

Flames of Magic
Sacha "Angel" Diener
Portfolio work
Adobe Photoshop
www.angel3d.ch

In this painting, Angel has portrayed his sorceress character; Elfborn, a dragon woman and mistress of elemental magic. "I've imagined that in ages past there were people able to manipulate the very essence of what surrounds us. Controlled by mind and soul, the spiritual energy of nature manifested and became what was known as the "flames of magic." This is a sketch I colored fast and loose, trying to retain the dynamic movement and raw power of the initial sketch."

As Holy as They Come
Felipe Machado Franco
Portfolio work
Adobe Photoshop
http://finalfrontier.thunderblast.net

Felipe feels it's important to maintain his output of personal work, in addition to commissions from clients. "My usual process is to start with a photo shoot; in this particular case, a nude model because I intended to dress her digitally; this is the best way to create clothing that really fits the form. I created each piece of armor separately and assembled them along her limbs. Working on a grayscale version of the image, I finally added lighting, color, and texture."

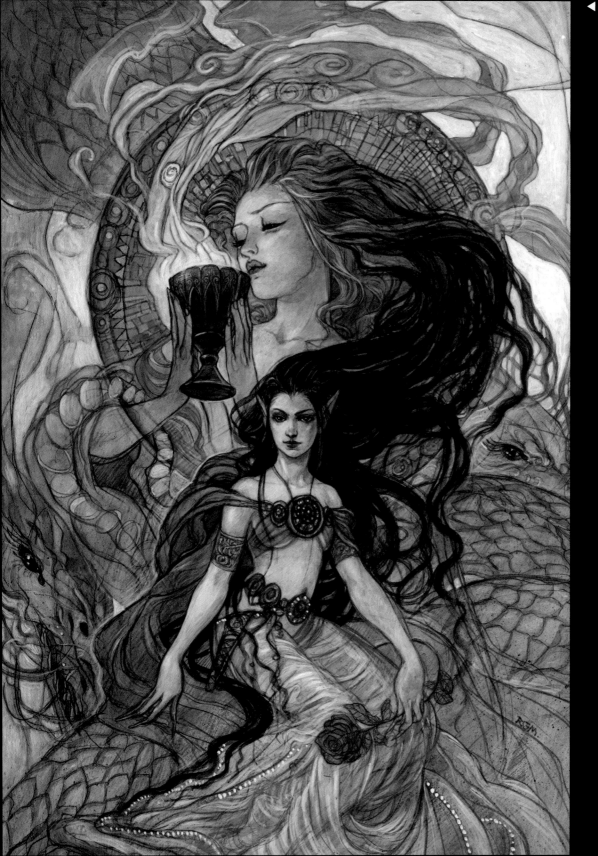

◀ **Mev**
Rebecca Guay
Private commission
Pencil and gouache on paper
www.rebeccaguay.com

This was a rare private commission accepted by Rebecca. "I agreed to paint this because I felt very connected to the strength of the character; I've always loved warrior women. She is beautiful and strong, and went through fundamental, life-altering transformations, that appealed to me on many levels. To pursue art is an all-encompassing daily endeavor of passion. It's a glorious journey, full of narcotic-like highs and lows, and I'm most successful when I feel that I've given some important part of myself to the image."

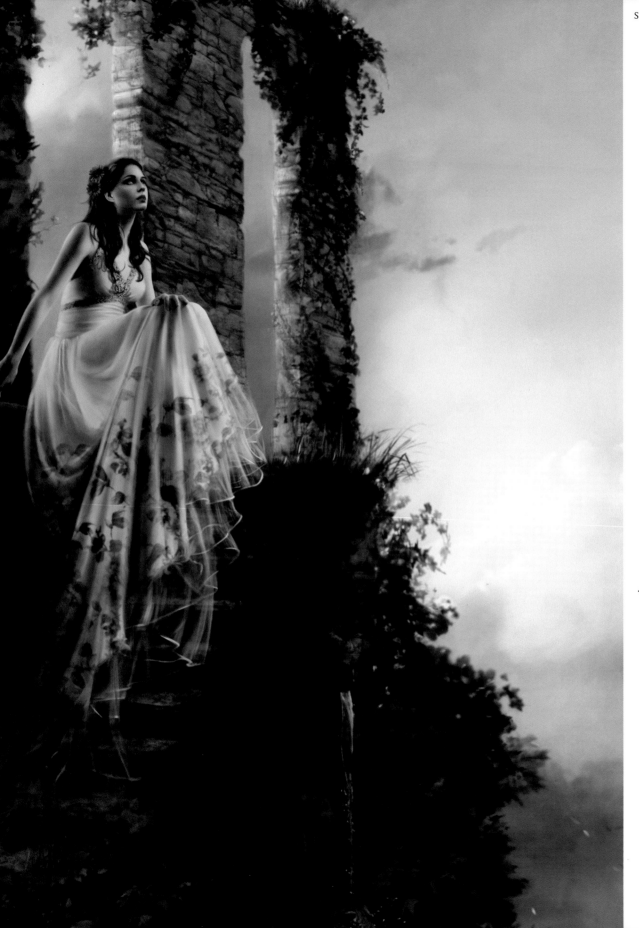

◀ **What I See**
Melanie Delon
Portfolio work
Adobe Photoshop and
Corel Painter
www.eskarina-circus.com

*This romantic, yet mournful
scene illustrates a sad tale
described by Melanie: "Naery
was just a child when her
parents were killed during an
attack on their city. The king of
this land saved her and raised
her as his own daughter. Years
have passed, and despite all of
the king's love, she always feels
alone. Sometimes she lingers in
the ruin of her parents' home,
remembering her childhood."*

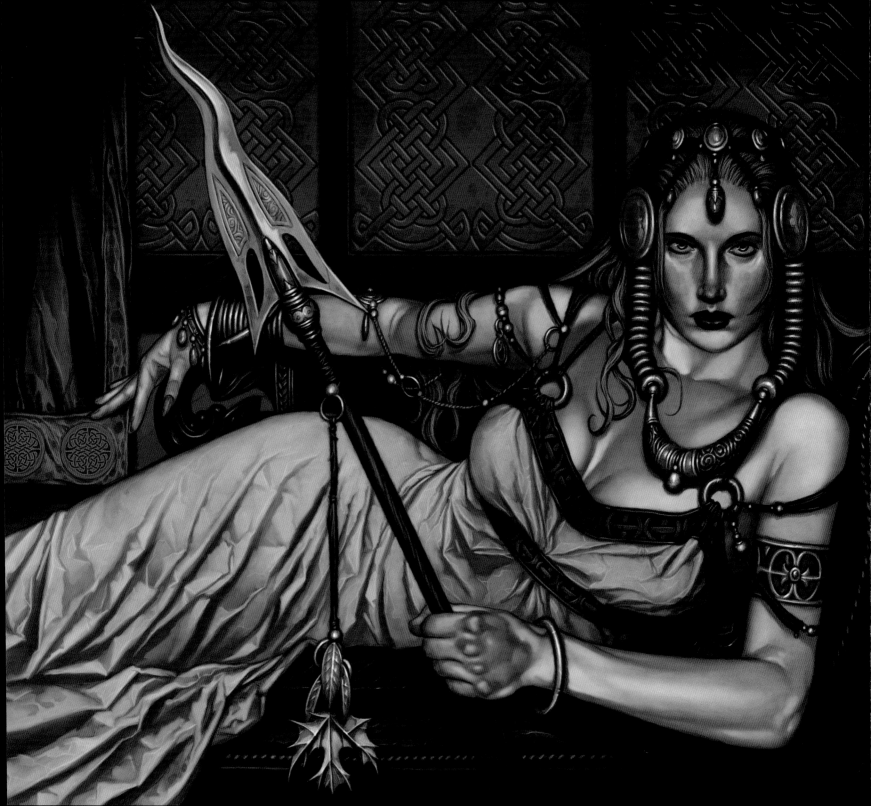

Benrig Medb
R. K. Post
Collectible card game illustration
Anachronism for the History Channel
Adobe Photoshop
www.rkpost.net

Medb is queen of Connacht in the Ulster Cycle of Irish mythology. Her father was Eochaid Feidlech, the High King of Ireland. The cycle consists of about 80 stories, the centerpiece of which is a battle in which Medb invades Ulster at the head of a huge army. R. K.'s portrait of Medb features closely observed Iron Age jewellery and weapon designs, and he adds, "This is one of a few pieces that I have done based on historical figures, although Medb is a bit more on the mythical, folklore side of things."

Lady of Shalott
Yvonne Gilbert
Portfolio work
Colored pencil
www.yvonnegilbert.com

Yvonne was inspired by a romantic poem by Alfred, Lord Tennyson. The poem, with its Arthurian subject matter, is loosely based on a story from Thomas Malory's Le Morte d'Arthur, *concerning Elaine of Astolat, a maiden who falls in love with Lancelot but dies of grief when he cannot return her love. The poem was particularly popular among artists of the Pre-Raphaelite movement, who shared Tennyson's interest in Arthurian legend, and their style is echoed in Yvonne's artwork.*

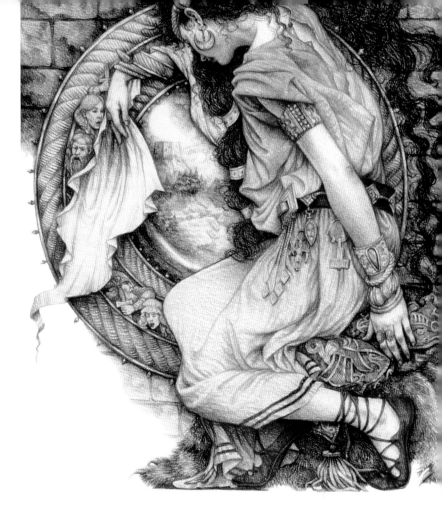

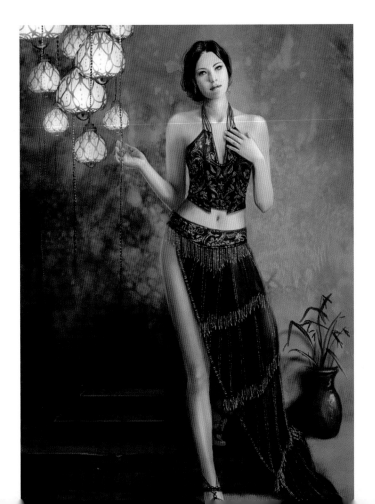

Liante
Linda Tso
Private commission
Adobe Photoshop
www.stickydoodle.com

This was a commissioned portrait, and an image for which Linda worked closely from reference material, as she explains further: "Reference was provided by the client, showing a figure from the waist up. It was fun to try and paint the character that was, by description, a vain and ruthless 'villain with a mask of charm.' The rich, purple-brown costume, with the elaborate gold decoration, was designed with this in mind."

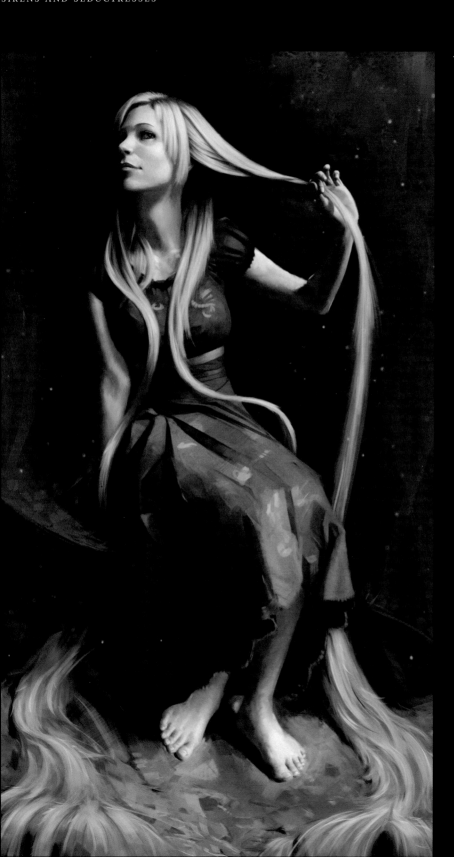

◄ **Rapunzel**
Bryan Beaux Beus
Portfolio work
Corel Painter
www.beauxpaint.com

"Rapunzel, Rapunzel, let down your hair, so that I may climb th golden stair," is the famous line from this traditional German fairy tale, recorded by the Brothers Grimm. First published in 1812, as part of Children's and Household Tales, *its plot has been widely referenced and parodied in popular culture ever since, and has been illustrated in many styles throughout countless collections of fairy stories. Bryan's portrayal shows Rapunzel running her fingers through her golden tresses.*

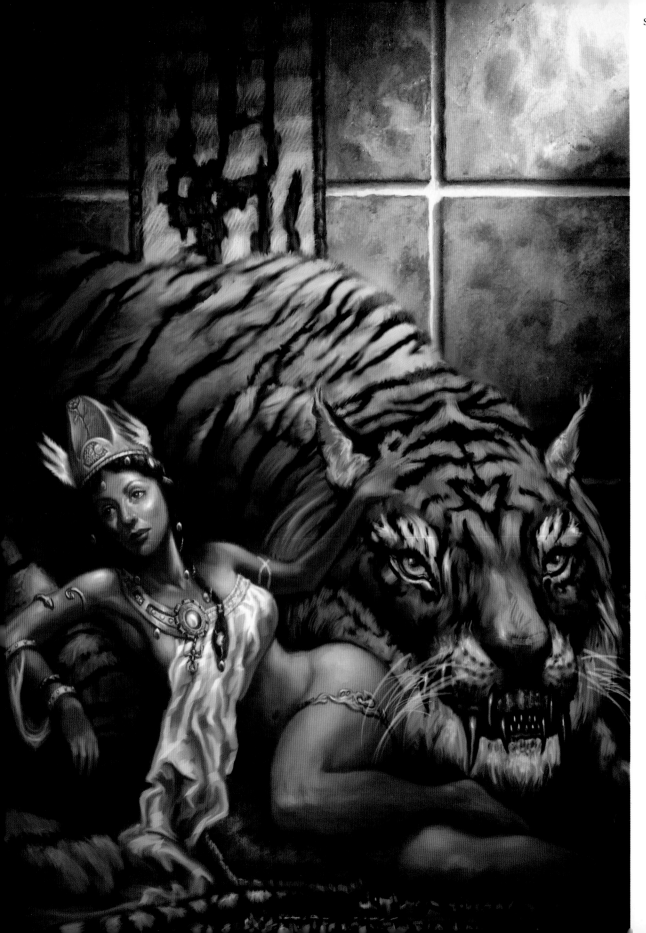

◄ **Olive Skinned in Cobalt Fur**
Jim Pavelec
Magazine cover
Heavy Metal magazine
Oil on paper and Photoshop
www.jimpavelec.com

This piece was created for Heavy
Metal *magazine, and for Jim it
was a particularly memorable
commission. "I got the
opportunity to meet one of my
earliest artistic influences, Kevin
Eastman, who is editor-in-chief
of* Heavy Metal. *He asked me to
do the piece for him, which was
a special honor for me. I started
the painting in oil on paper, but
then moved into Photoshop to
finish the piece."*

◀ **Awakening Maro**
Anthony S. Waters
Collectible card game illustration
Future Sight from
Wizards of the Coast
Adobe Photoshop
www.thinktankstudios.com

*Anthony's assignment was to
create a magical incarnation of
nature, called a "Maro" in the
Future Sight universe. "The
Maro is waking up from a long,
apocalypse-induced slumber. How
you use light goes a long way
toward defining the emotional
content of a piece. The same can be
said of color. I used strong, high-
key greens on his face to suggest
this emergence from hibernation."*

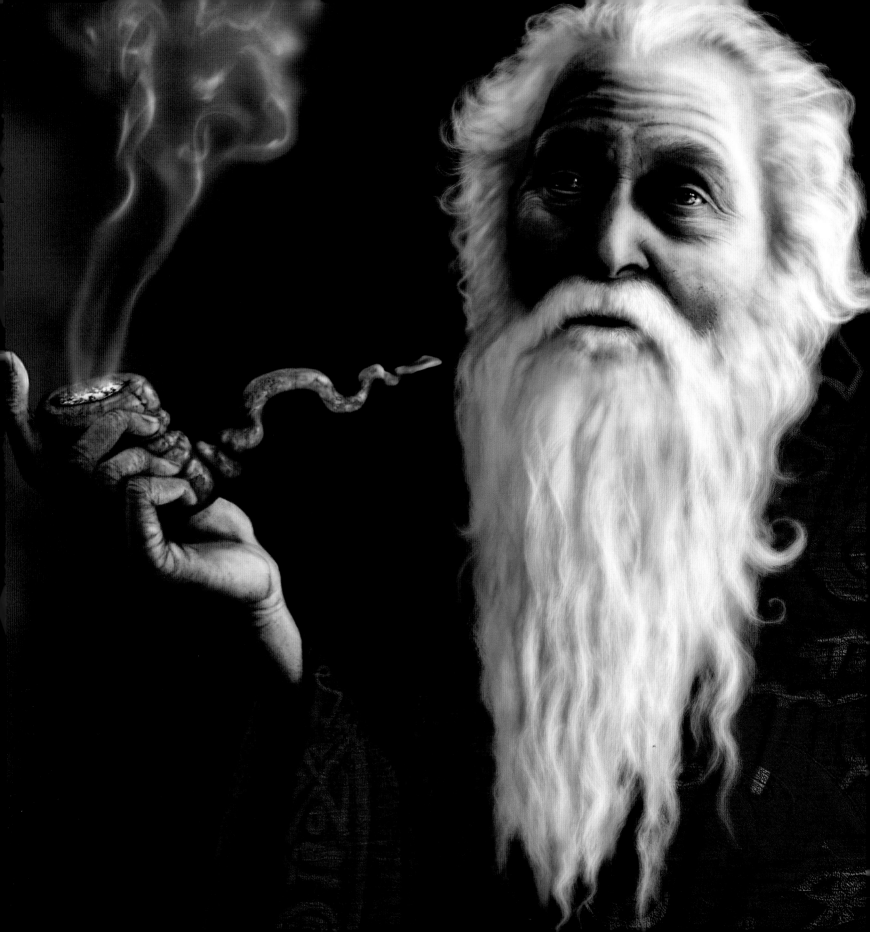

Sorcerer
Emily Hare
Portfolio work
Colored pencil and
Adobe Photoshop
www.emilyhare.co.uk

For this portrait, Emily used one of her neighbors as inspiration and reference. "He had a 'twinkle in the eye' that was ideal for an old wizard! I did most of the painting in Photoshop, incorporating textures here and there to add character, and took photos of burning incense for reference when painting the smoke. I wanted to give the impression of a magician who had been a bit of a rascal in his day, now enjoying a quiet pipe between incantations."

◀ **Blood Inside**
Sam Araya
Game illustration for White Wolf
Publishing
Adobe Photoshop
www.paintagram.com

Sam was inspired by the film Wolf, *and says the idea of something feral bursting from within a quiet office worker really struck a chord. "This picture marks another attempt at telling a story with geometric shapes. The graphical elements describe the character's mindset, and make fairly obvious reference to lycanthropy. The piece was originally commissioned as an illustration depicting the internal struggle of werewolves in an urban setting."*

▶ **Blue Queen**
Martin McKenna
Book cover
The Key to Rondo from
Scholastic/Omnibus Books
Adobe Photoshop
www.martinmckenna.net

This image, a detail from a much larger digital canvas, was delivered to the client in fully editable layers. This was to enable the cover design to introduce graphical elements between the layers, meaning that the book's logo, for example, could be positioned behind the figure. As a result, this isn't quite a fully realized composition. Only the figure of the queen, holding her captive pet, has been rendered in detail.

▶ **The Pig Walker**
David M. Bowers
Portfolio work
Oil on wood

Reminiscent of work from the 18th century portrait and landscape painter, Thomas Gainsborough, this surreal vision contains a sobering undertone. David reveals, "Urban populations are more divorced from their food supplies than ever before. There is total ignorance of how farmers raise the food that magically appears wrapped in plastic, canned, or frozen in our local grocery stores. As long as the Thanksgiving turkey appears on time, nobody thinks about how vulnerable we all are if something breaks the chain of supply."

▶ **Shadow's Edge**
Jeff Anderson
Portfolio work
Adobe Photoshop

Jeff explains that this new image features a reworking of characters from a graphic novel that he drew several years ago. "I painted a new portrait of this somber character wearing the hat, and for the background, I added and reworked some existing imagery from the comic. I tend to work in basically the same way as if I'm using traditional media; I do all my rough pencil sketches on layout paper, but I then scan it and paint digitally."

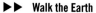

▶▶ **Walk the Earth**
Felipe Machado Franco
Album cover
Silent Force from AFM
Photoshop
http://finalfrontier.thunderblast.net

Ideas for this album cover came from its title, and from Felipe's creative meetings with the band. "For the earth, I used photos I'd taken from a plane, and gave them a sphere effect. I introduced basic tones of blue, and some focal points in purple. Finally, I worked on the character's details and jewelry, which were simple flat shapes to which I added bevel and emboss to give them volume."

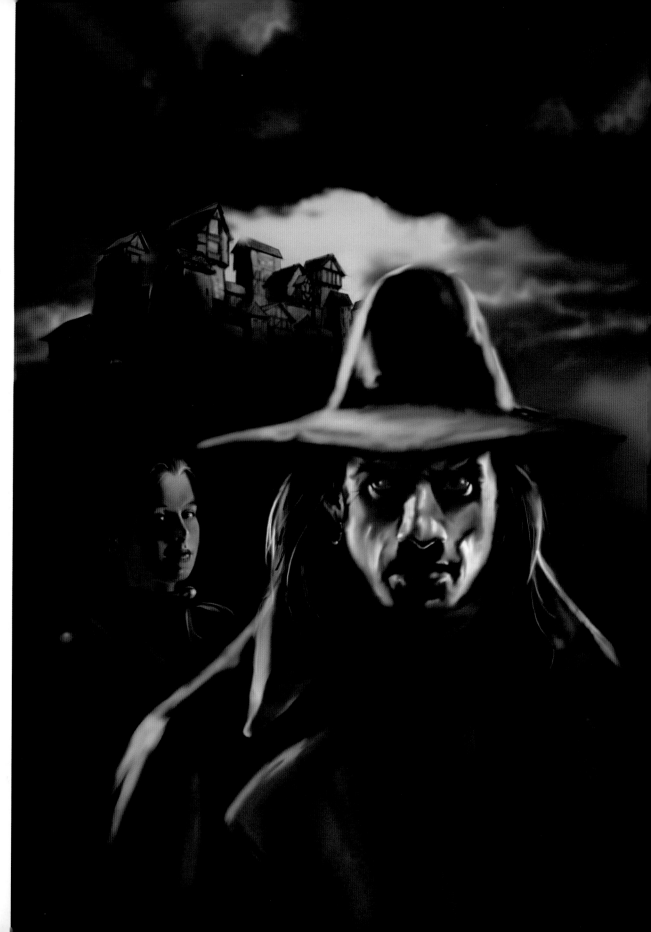

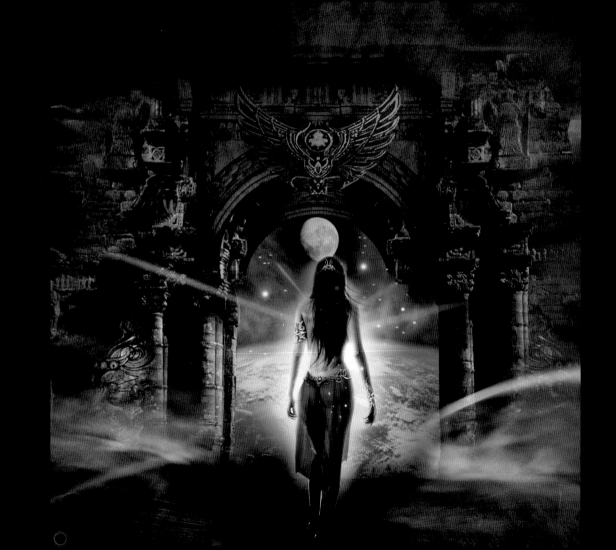

▲ **Cura dell'Incanto in Chiave Minore
(Cure for Enchantment in a Minor Key)**
Alessandro Bavari
Exhibition commission
26th Guitar Festival of Cordoba from the Municipal
Institute of Artes Escénicas
Adobe Photoshop
www.alessandrobavari.com

*This triptych serves as a metaphorical expression
of the power of music, as Alessandro explains: "As
an instrument for the sharing of a common feeling,
music has a universal value. Here the guitar becomes
an extension of the mind and body. Aligned with
the fundamental elements of nature, the musician
becomes a demiurge with dramatic powers. The
pathos that is inspired in those who listen is not
only sweet and melancholic, but also profound."*

▶ **Merlin**
Yvonne Gilbert
Portfolio work
Colored pencil
www.yvonnegilbert.com

*Wizards have appeared in myths, folktales, and
literature throughout recorded history. Magicians are
common characters in works of fantasy literature and
role-playing games, drawn from figures in mythology
and folklore — perhaps none more so than Merlin the
magician, the wizard featured in Arthurian legend.
Born the son of an incubus and mortal woman, Merlin
inherited his powers from his strange birth, but here
Yvonne has depicted him deep in arcane study.*

► **Mystica**
Felipe Machado Franco
Album cover
Axel Rudi Pell from SPV
Adobe Photoshop
http://finalfrontier.thunderblast.net

This recording artist was very specific about the visuals to be created for his album cover, as Felipe relates: "Axel Rudi Pell sent me a simple line drawing he'd made showing all the elements and basic composition. I began work on the background of mountains. I then made the skull towers, cave, and boat. I worked in detail on each figure in separate files, for which I photographed myself in different poses wearing a cloak."

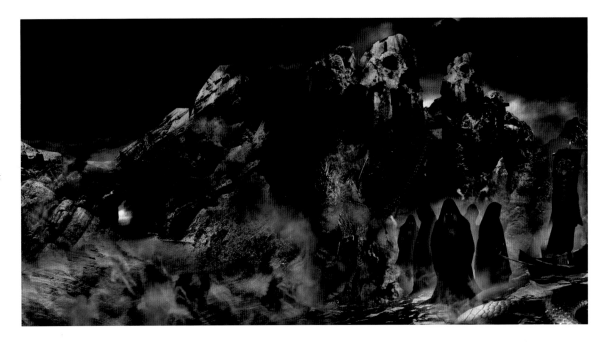

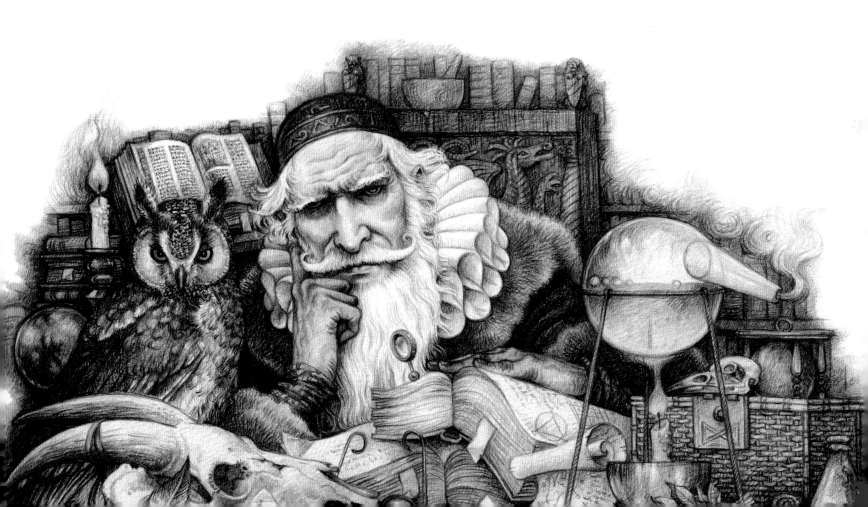

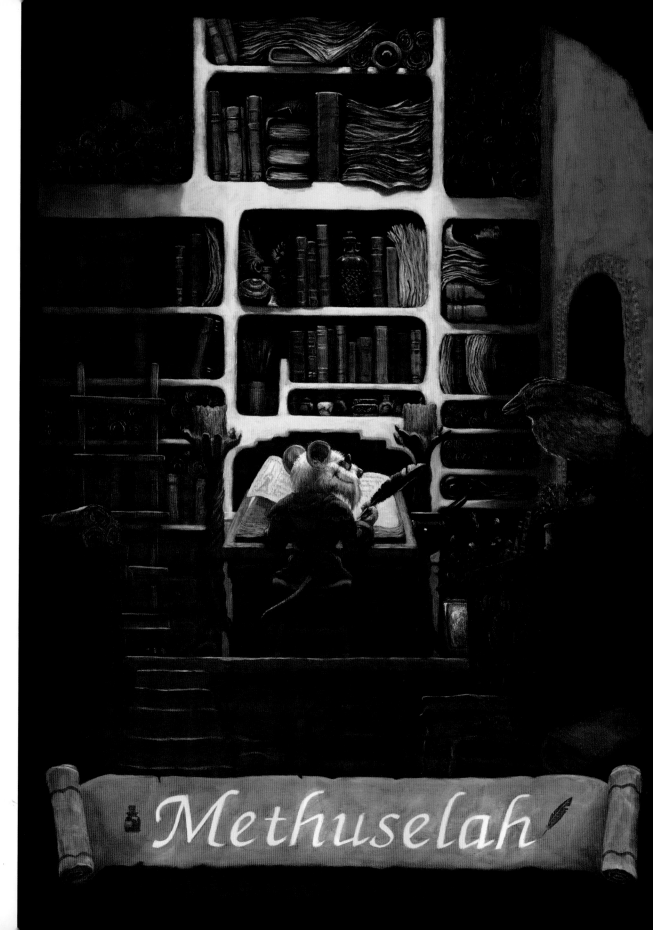

▶ **Methuselah (Gift of Tongues)**
Rick Sardinha
Portfolio work
Oil on masonite
www.battleduck.com

This is a painting that was inspired, explains Rick, by the Redwall books of Brian Jacques. "I really love the books because they combine my love for wildlife with fantasy, on a really fun level. The central figure of this work is Methuselah, an ancient mouse at Redwall Abbey, a sort of patriarch and recorder of events. He is the only mouse with the gift of tongues, meaning he can talk to any other creature, though he stops at snakes and doesn't like foxes."

▶ **Garga's Concern**
Matt Gaser
Portfolio work
Adobe Photoshop and Ambient
Design ArtRage
www.mattgaser.com

This whimsical image provides us with a snapshot of the surreal hustle and bustle of a bizarrely cosmopolitan city of the imagination. "In this painting, I wanted to show an everyday scene in a fantasy world where strange beings, large and small, live together with humans. In my personal work, I strive to create images of wild invention that capture a moment as if you are seeing a still from a film."

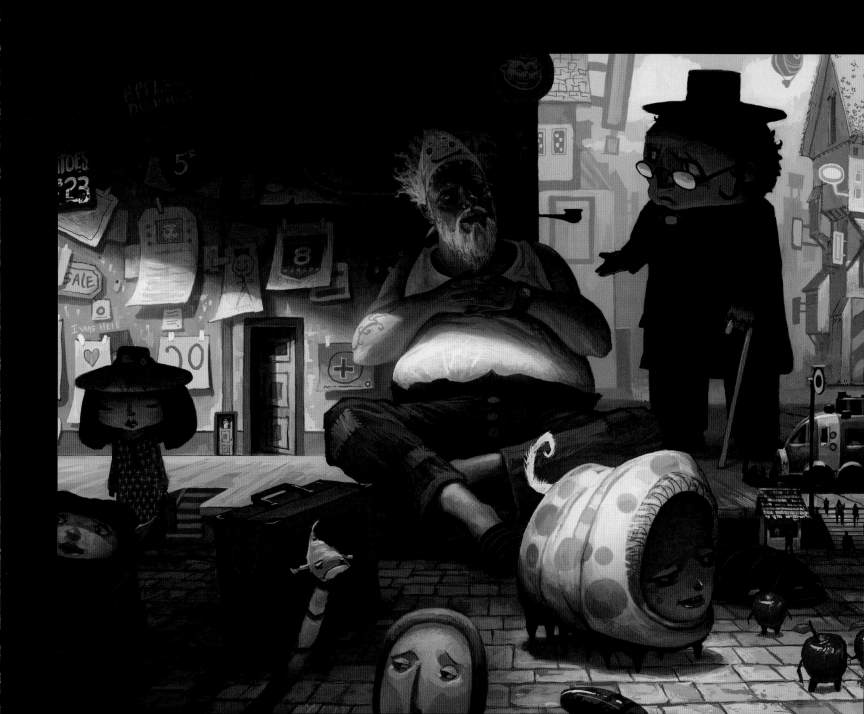

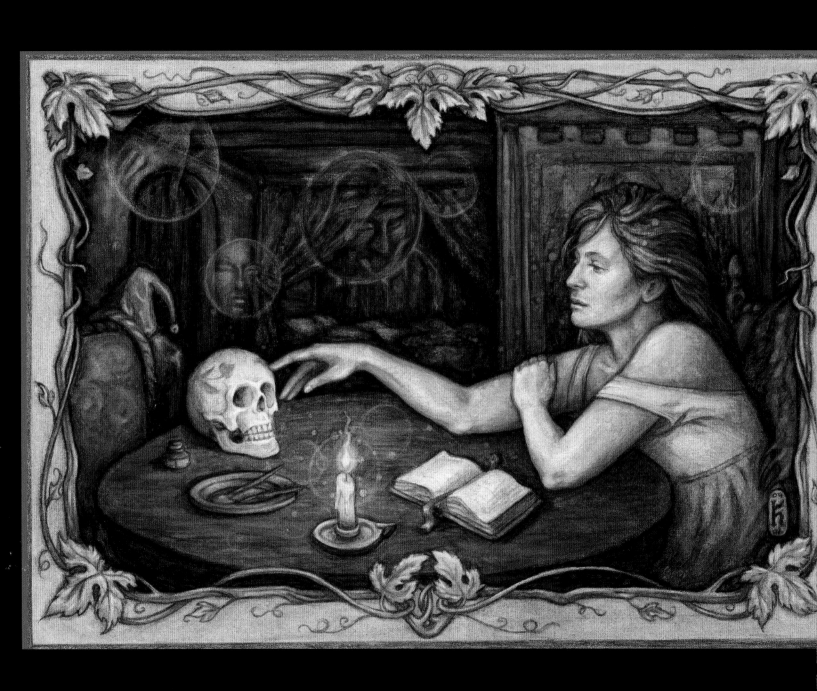

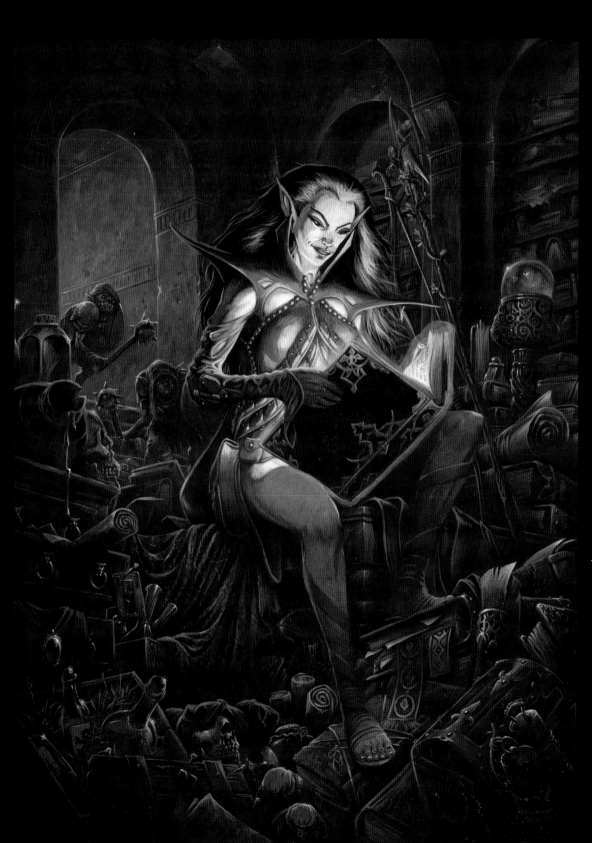

◀ **Mialee Prepares Her Spells**
Ralph Horsley
Book illustration
Shattered Gates of Slaughtergarde from Wizards of the Coast
Acrylic
www.ralphhorsley.co.uk

An elf studies a spell book in an abandoned library, while goblins creep up behind her. "I wanted to convey the magical nature of the book and make Mialee the focus, so I chose a contrasting color scheme. The yellow appears bold against the blue-purple, and uses the lightest values. After this initial impact, the viewer's eye will then wander into the background to pick out the goblins. This hopefully achieves a balance between impact, and reward for closer attention."

◀◀ **A Fool's Love (Alas)**
Karen Ann Hollingsworth
Portfolio work
Watercolor and pencil on canvas
www.wrenditions.com

Karen was inspired by a deliberate triple misquote from Shakespeare's Hamlet; *"A lass, poor Yorick! She knew him well." Karen explains, "The lady's bedchamber alludes to their relationship; the hat and the painting's title refer to Yorick as court jester. The decoration on the skull was influenced by an ossuary in which women's skulls were painted with flowers and men's with laurel or ivy, a motif I incorporated into the border."*

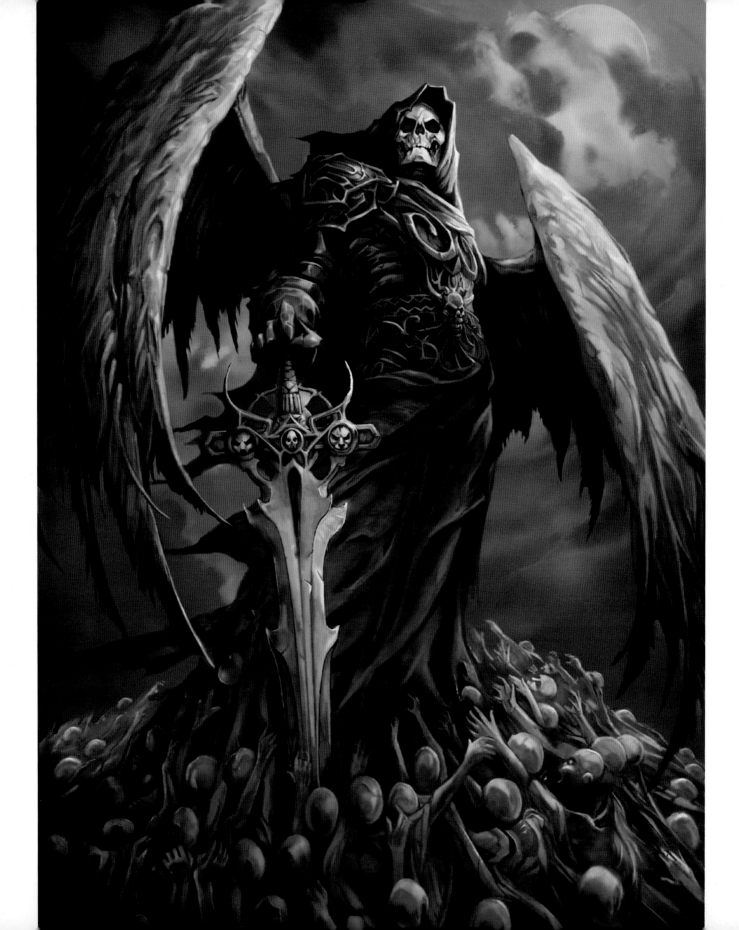

◀ Angel of Death
Abrar Ajmal
T-shirt and poster for
Skulbone USA
Adobe Photoshop
www.aaillustrations.com

*Abrar explains that inspiration
for this powerful figure came
to him when he was working
for a miniatures company
that, at the time, were
producing a game about
angels. "As luck would have
it, I soon had the opportunity
to develop the concept when I
was commissioned to produce
artwork with a strongly gothic
theme. The idea was to represent
the figure of Death with a slight
twist. What if, for some people,
he is a symbol of salvation rather
than just one of dread?"*

▶ Death and the Serpent of Caol
Kieran Yanner
Portfolio work
Adobe Photoshop
www.kieranyanner.com

*Much of Kieran's work utilizes
a technique similar to that
of matte painting: using
photographs in collage or
montage, then combining
this with digital paint, and
sometimes acrylic or oil. "I
adopted this fast technique
to meet ever-tightening
deadlines, and I stuck with it
because it achieved the look
that I wanted. This piece relied
much more on painting than
photomontage. I'd always
wanted to paint a mysterious
cloaked figure, and this is my
realization of that desire."*

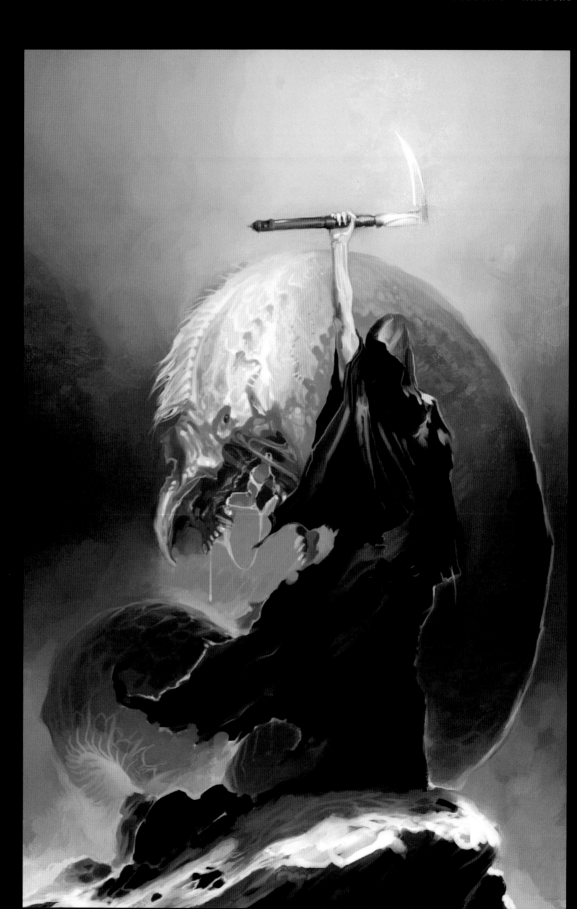

▶ **The Tongues of Fire**
Sam Araya
Game illustration for White Wolf
Publishing
Adobe Photoshop
www.paintagram.com

*Achieving a balance, or complete
dissonance, between abstract
forms and the human figure
is something that has always
interested Sam, he says. "The
same can be said about the
interaction between painting
and elements of photomontage.
This piece represents a small step
toward what I want to achieve in
my future work; the integration
of my formal study of graphic
design with my self-taught
approach to illustration."*

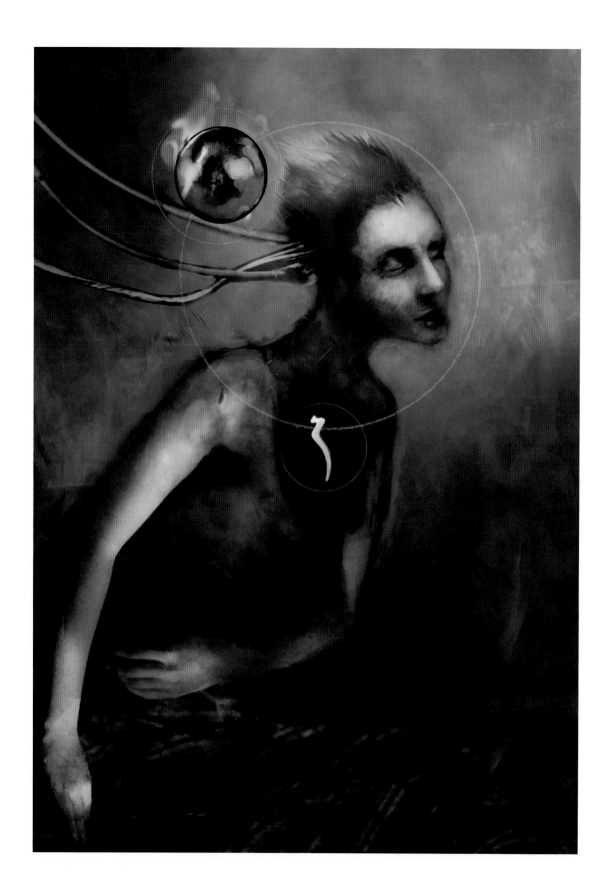

◀ **Stages of Life**
David M. Bowers
Portfolio work
Oil on panel
www.dmbowers.com

*This beautifully painted, and
subtly eerie, composition is
laden with symbolism, which
David helps to interpret: "Little
girls learn their mothering
skills from playing with dolls.
It is the dolls that teach them
about life. Their dolls mimic
birth, adolescence, maturity,
and old age; life's full circle. This
imitation of real life has existed
for thousands of years, and
will continue into the future."*

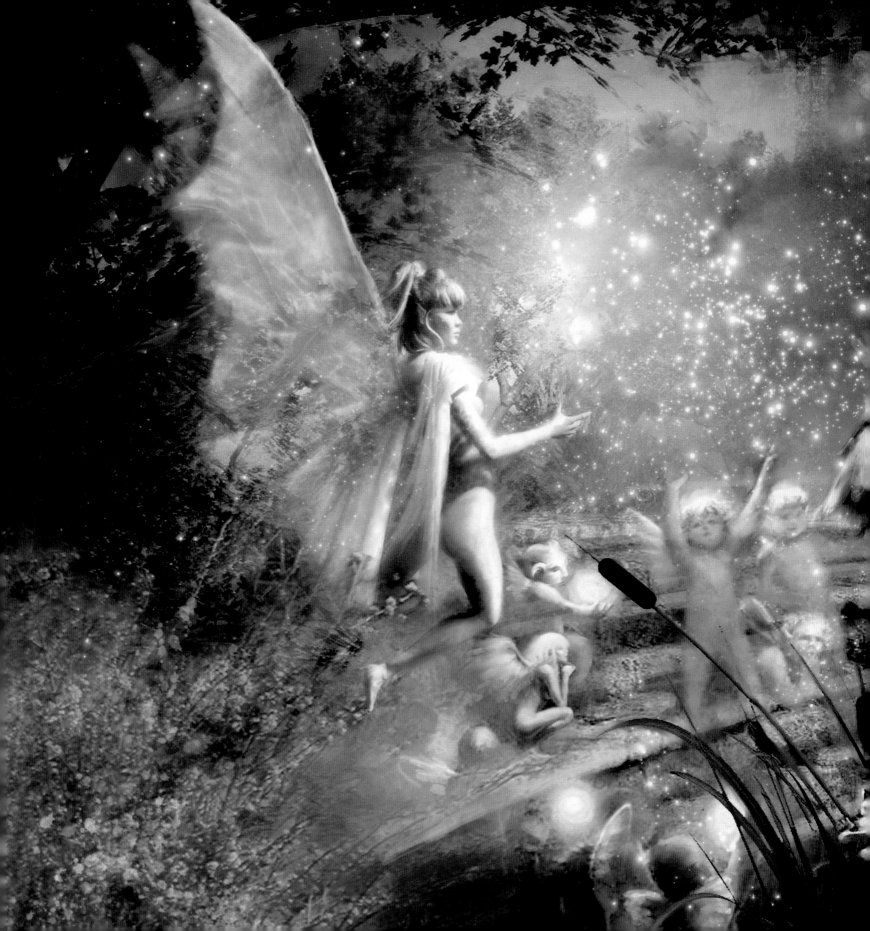

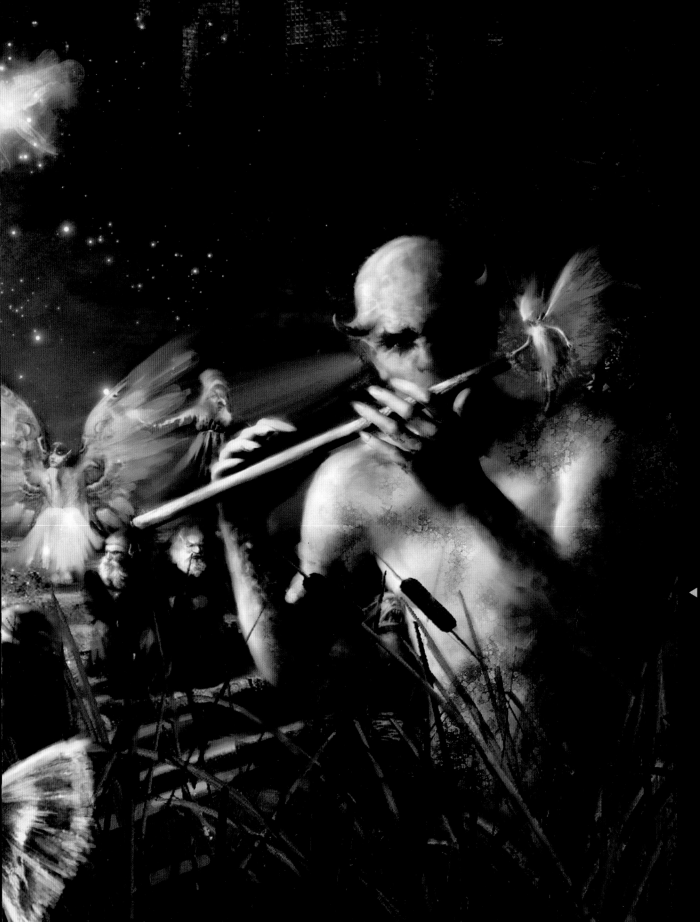

CHAPTER 6

FAIRIES AND FEY FOLK

◀ **Little People Parliament**
Eric Scala
Book illustration
Little Big from Terre de Brume
Adobe Photoshop and Corel Painter
www.ericscala.com

*In Eric's picture we spy upon
a gathering of fairy folk in
a modern city park at night.
"The idea was to create a scene
depicting a parliament for the
little people. The good fairy
creatures are lit in the brighter
area of the group, while in the
dark are the more mischievous
ones. After creating the
background landscape, I added
the characters one by one; my
intention being to give the image
the look of a traditional painting."*

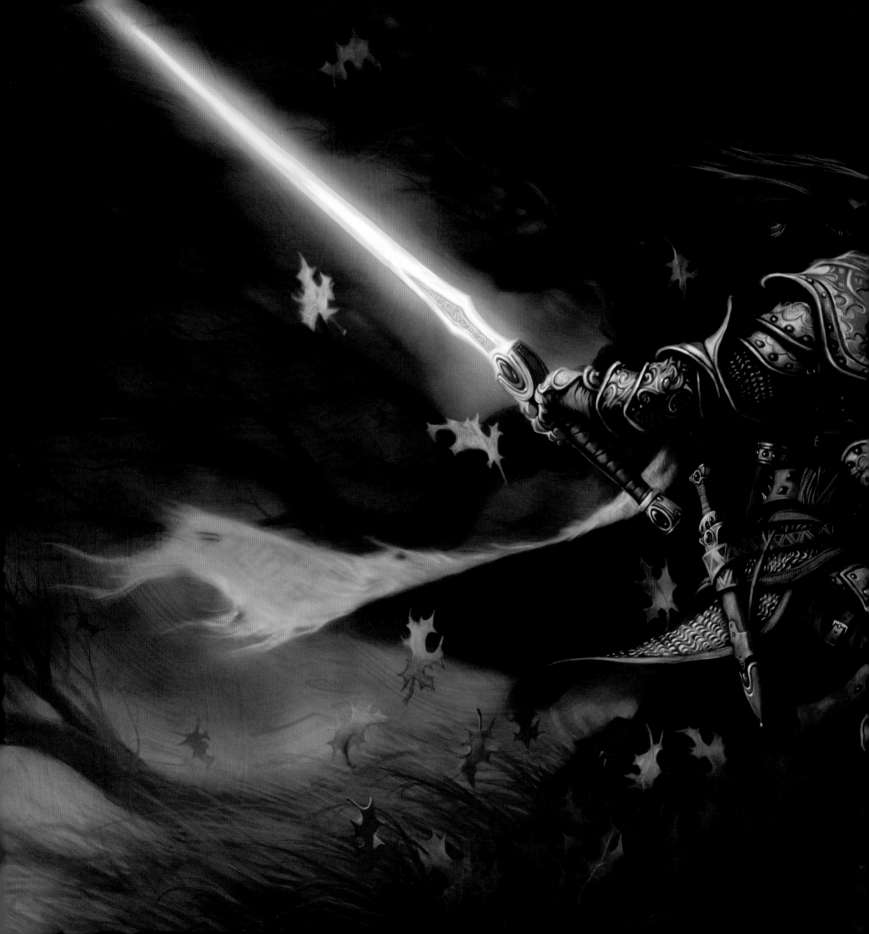

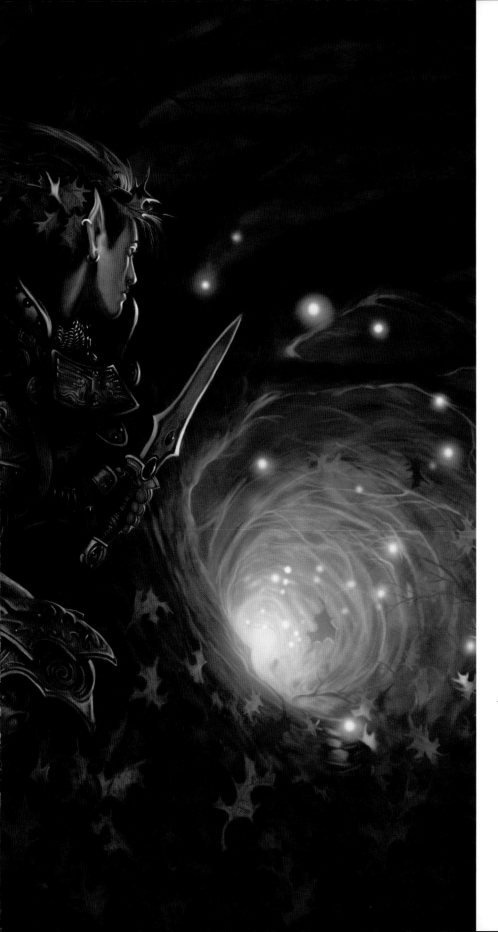

◄ **Zephyr's Tomb**
William O'Connor
Portfolio work
Adobe Photoshop
www.wocillo.com

A composition intended to illustrate movement, the sweeping design is accentuated by the blowing leaves and armor detailing. William reveals more: "When I am composing images, I constantly try to simplify my designs. Although there is a great deal of detail in this painting, the overall design is very simple. Texture is the concentration of this piece. Metal, leaves, wood, sky, and flesh; all of the forms in this composition are defined by their texture."

▶ **Peter Pan in Scarlet**
Tony DiTerlizzi
Book cover
Peter Pan in Scarlet from
Margaret K. McElderry
Gouache on board
www.diterlizzi.com

*This re-imagining of a classic
character was understandably
a tough challenge for Tony.
"Many people have preconceived
ideas of how certain literary
heroes should appear. The
trick here was to design
the character in a way that
acknowledges what has come
before, while at the same time
pushing the character's design
forward for a new audience."*

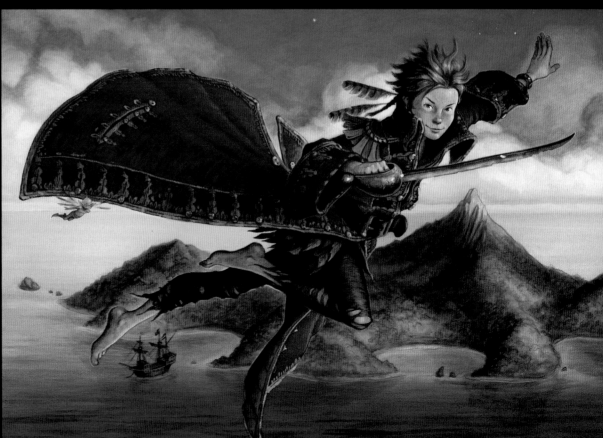

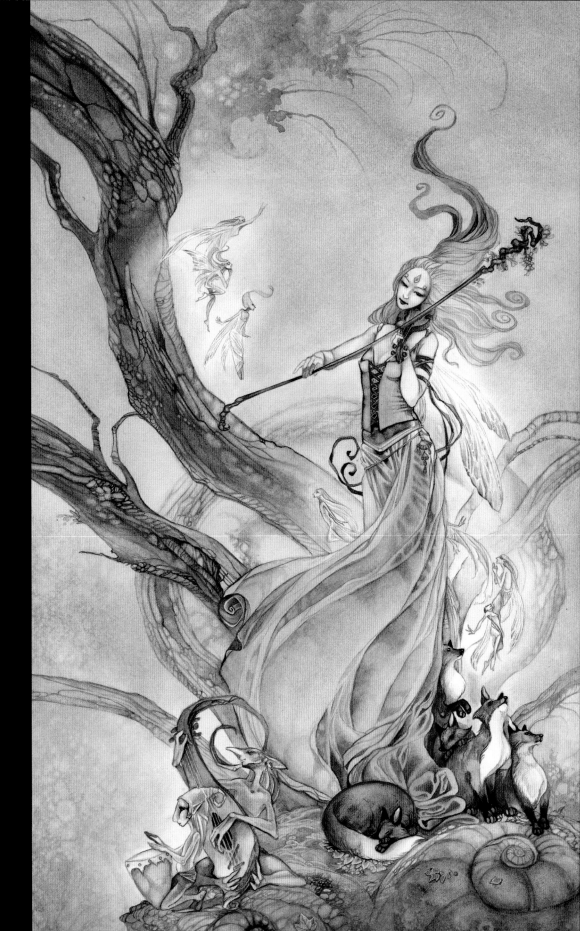

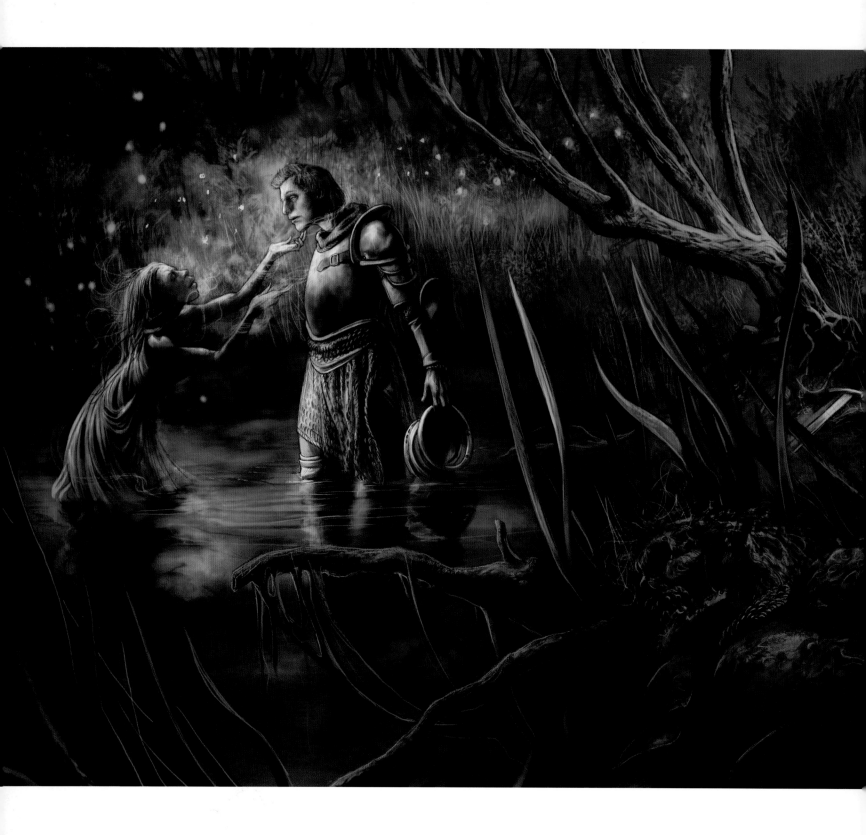

The Enchanting
Nick Harris
Portfolio work
Corel Painter and
Autodesk Sketchbook Pro

Nick is heavily inspired by the
style of Victorian painters, and
the Pre-Raphaelites. "I come from
a traditional art background,
and treat digital art in the
same way. After importing this
drawing from Sketchbook Pro, I
added a base color, and worked
into it with the oil pastel variant
to establish some tonal values.
This gave me something to place
washes of color over to bring to
life the lights and darks."

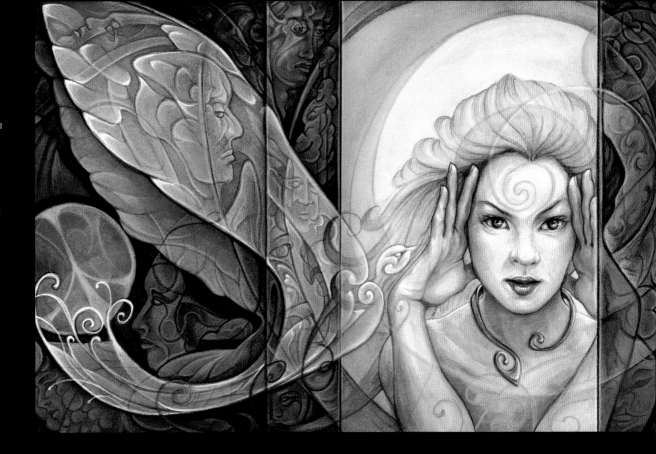

Old World Leprechaun
Tony DiTerlizzi
Book illustration
*Arthur Spiderwick's Field Guide
to the Fantastical World Around
You* from Simon & Schuster
Gouache on board
www.diterlizzi.com

This is one of Tony's favorites of
the 30-plus plates he produced
for the centerpiece of The
Spiderwick Chronicles books.
"I like it because it captures a lot
of philosophy behind the series;
to take traditional, classic, and
trite fantasy characters, and
reinvent them through character
design. This piece pays homage
to not only my fantasy influences,
like Arthur Rackham and Brian
Froud, but to classic illustrators
like Norman Rockwell."

Imagine
Karen Ann Hollingsworth
Portfolio work
Watercolor and pencil
www.wrenditions.com

Two distinct methods were used while working
on this picture, as Karen reveals; "One style
is very controlled, composing a tight pencil
drawing using reference. The second approach
I use is extremely spontaneous, finding shapes
within a watercolor wash using colored pencils.
It's very meditative, like imagining shapes
in clouds. The sweeping dove form suddenly
emerged while using this second technique."

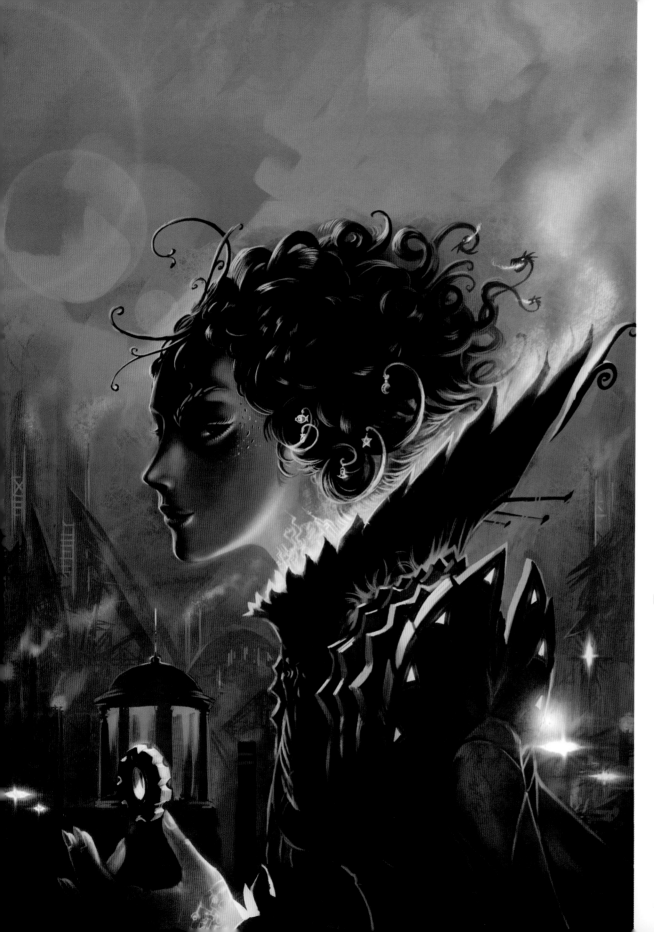

◄ **Goddess of Industry**
Jian Guo
Magazine illustration
The Magazine from Sci-Fi World
Corel Painter
http://breathing2004.gfxartist.com

At first glance, this Arcadian figure appears to have only organic flowing forms echoing nature, whereas in fact, Jian has portrayed the physical embodiment of technology and industry. The circuitry-laced fiery glow within the character's leaf-like collar and cuff, are representative of the blast furnaces of a steel mill, while details of her costume suggest roller chains, and other mechanisms. Most symbolic of all is the gear wheel hovering in her grasp.

► **A Fascinating Bloom**
Soa Lee
Promotional image for
Legend Footwear
Autodesk 3ds Max and
Adobe Photoshop
www.soanala.com

Soa Lee's glossy characterization of this glamorous, modern fairy, was designed to appear in an advertisement for women's shoes. "It's a spring morning, and Christina the fairy, who fell asleep in a garden of red flowers, has been woken by dawn's sunlight. She unfolds her wings with a beautiful whirl of color, while red petals open wide and sparkling pollen starts to dance."

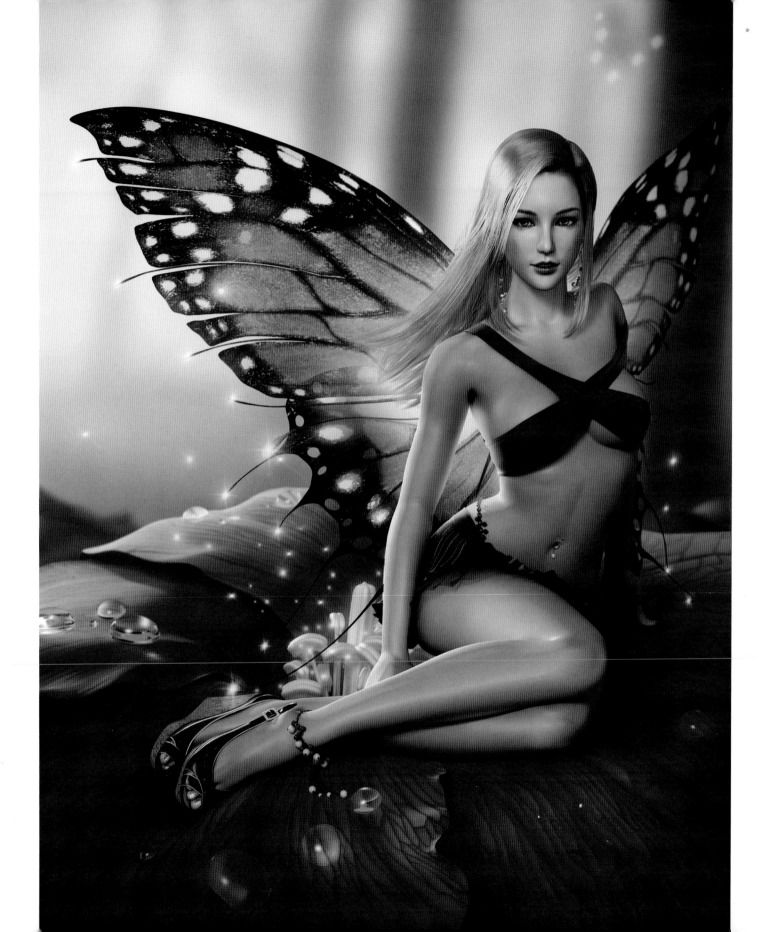

▶ **Daniel**
Kieran Yanner
Portfolio work
Adobe Photoshop and
Corel Painter
www.kieranyanner.com

This painting was developed by Kieran from a series of sketches, and finally brought to fully rendered fruition. "Originally, the composition had a crowd of upward reaching arms in worship of this fallen angel. I later made changes to this when a client requested printing rights to the piece, but wanted it in a slightly different context and format. I agreed and altered the piece as seen here, but the original version can still be viewed on my website."

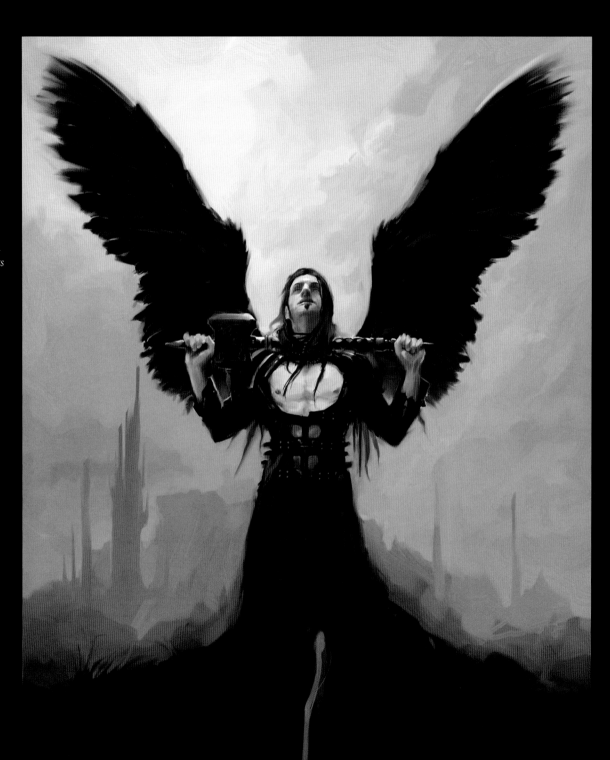

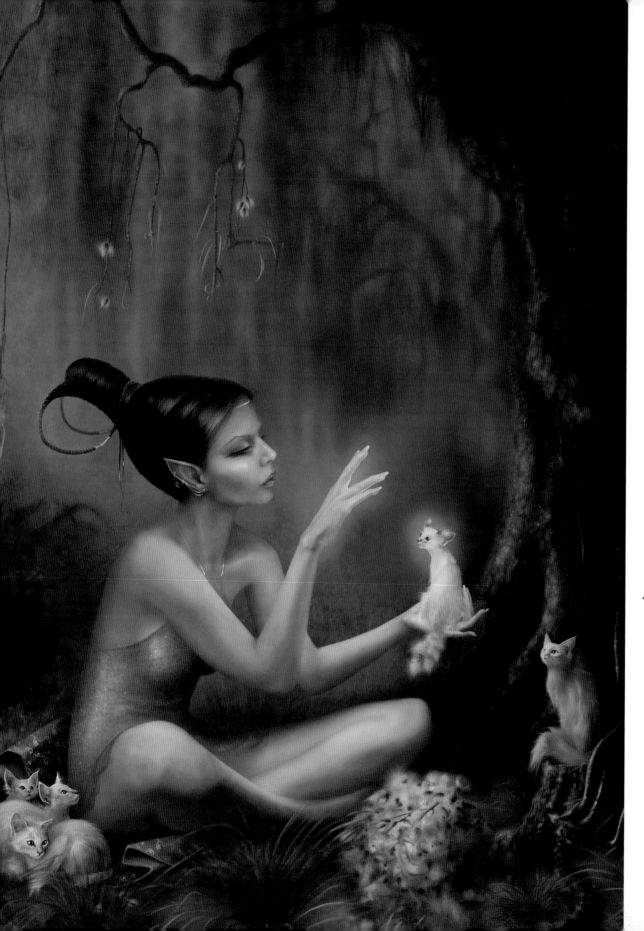

◄ **Lovecats**
Benita Winkler
Portfolio work
Adobe Photoshop
http://eeanee.com

*Benita has shown this
enchanting fairy witch sitting
beneath a weeping willow
tree, as she uses her magical
powers to conjure delicate feline
companions out of the tree's
catkins. Catkins, or aments,
are slim, cylindrical flower
clusters without petals. Many
other trees, including oak,
birch, hazel, and chestnut,
also bear catkins, which, in
ancient folklore, are said to
contain magical properties.*

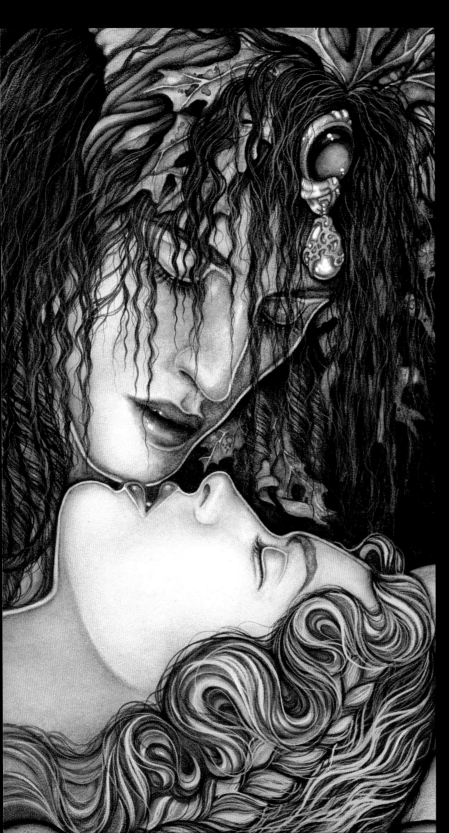

◀ **Kiss**
Denise Garner
Portfolio work
Watercolor
www.towerwindow.com

This piece, as Denise reveals, is actually a fragment of a larger watercolor painting. "Difficulties with the original composition, prompted the cropping of the piece. Since there was a high level of detail within the area of the picture that I finally used, I still see the piece as being a successful painting."

◀ **Shell Fairy**
Roberto Campus
Book illustration
The Secret World of Fairies
from Silver Dolphin
Adobe Photoshop
www.robertocampus.com

The fairy in this painting was made into a small figurine to be included with The Secret World of Fairies, *and Roberto tells us more: "My daughter, Gwendolyn, posed for this fairy character. The art director on the job had a lot of creative input, especially concerning the costume, but I'm happy with how it turned out."*

 ▶ **Angelic Corruption**
Kevin Crossley
Portfolio work
Adobe Photoshop
www.kevcrossley.com

Here, Kevin depicts a once celestial character, now dissolute; her skewered arms alluding to her newly found deviancy. "This picture is my first foray into the world of clichéd female fantasy figures. Surprisingly, hardly anyone notices her pierced arms. Photos of ferns and trees were incorporated into the background, using filters and blending modes. I made extensive use of Photoshop's Brush tool as well as the Dodge, Sponge, and Burn tools."

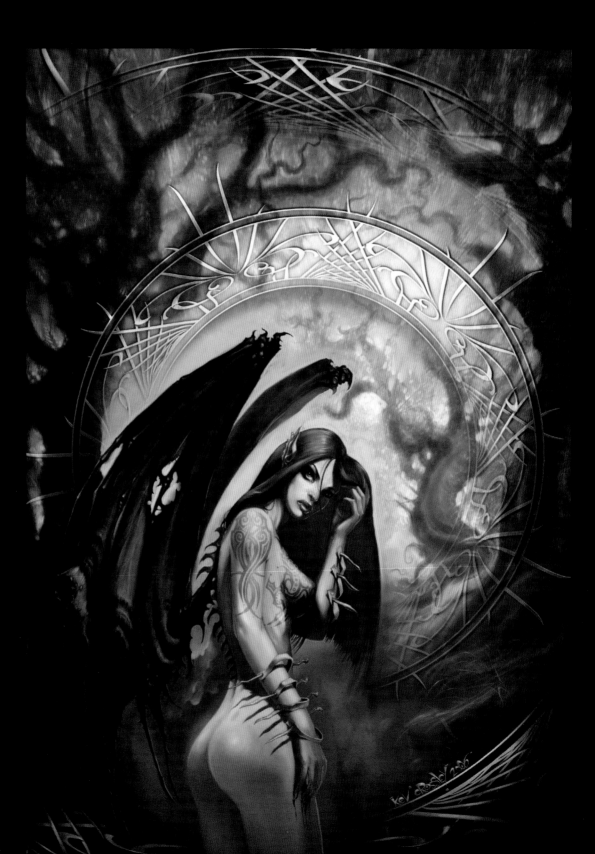

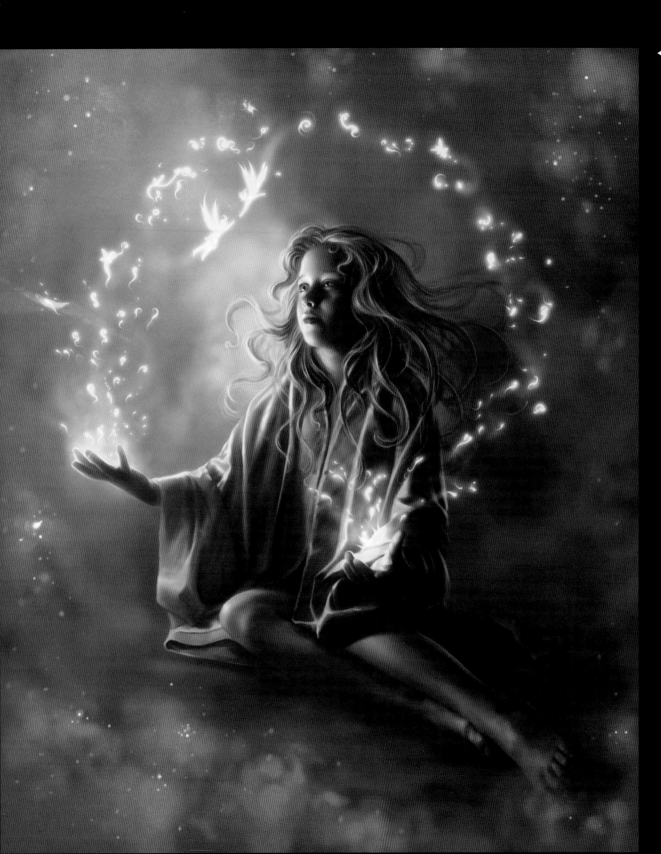

◄ **Little One**
Roberto Campus
Album cover
LuxaAeterna by Aquaria
Oils and Adobe Photoshop
www.robertocampus.com

This is one of the pieces that Roberto is most proud of, and it originally took him only three hours to put together. "There was an art contest and I didn't have anything to submit, so one evening I rushed to my desk and after rummaging through the fairy-inspired photo references I have of my daughter Gwendolyn the concept came to mind. The final image was ready in the blink of an eye. I didn't win the contest, but this slightly revised version of the image was later used as an album cover."

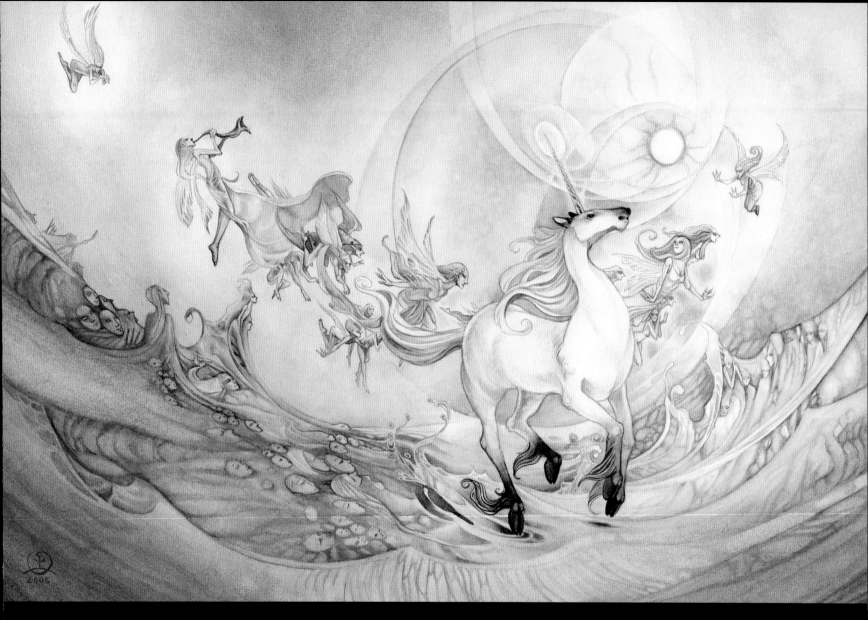

▲ **Skimming the Surface**
Stephanie Law
Portfolio work
Watercolor
www.shadowscapes.com

The unicorn is a legendary creature, whose power is exceeded only by its mystery. Though the modern popular image of the unicorn is that of a horse, the traditional unicorn has a billy-goat beard, a lion's tail, and an antelope's cloven hooves. Stephanie has shown her unicorn magically cantering, lightly across ocean waves. "Unicorns are said to have been born from the sea. They are creatures of light, air, and sea foam, and they are wild as the ocean."

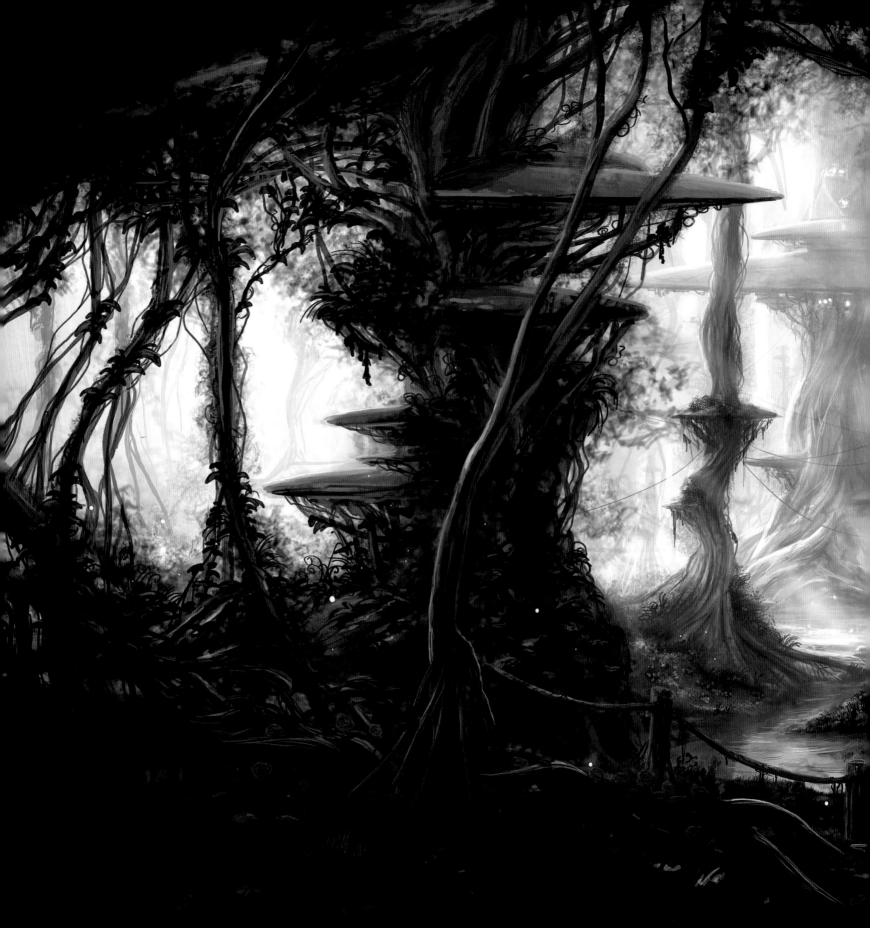

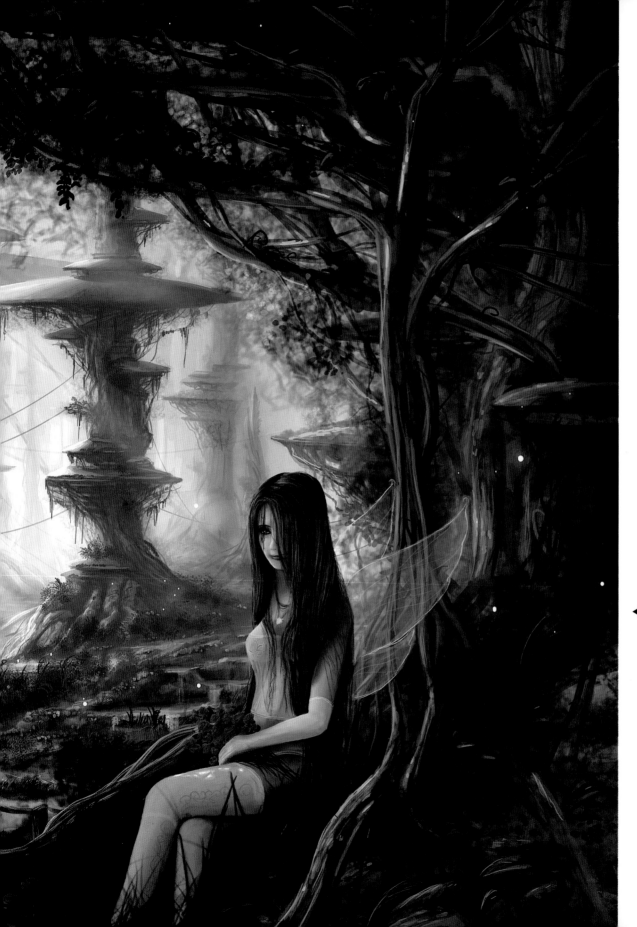

◄ **Rose River**
Marcel Baumann
Portfolio work
Adobe Photoshop
www.marcelbaumann.ch

*Developed from the rough sketch
of a fantasy forest, Marcel enjoyed
the process of painting without
a clear concept in mind, his only
plan being to create a romantic
scene. Each stage of the composition
developed organically; the design,
shapes, and lighting being rendered
instinctively. "It was easy to alter
the mood in Photoshop very
quickly by changing the colors and
brightness, which each time took
the work in a new direction."*

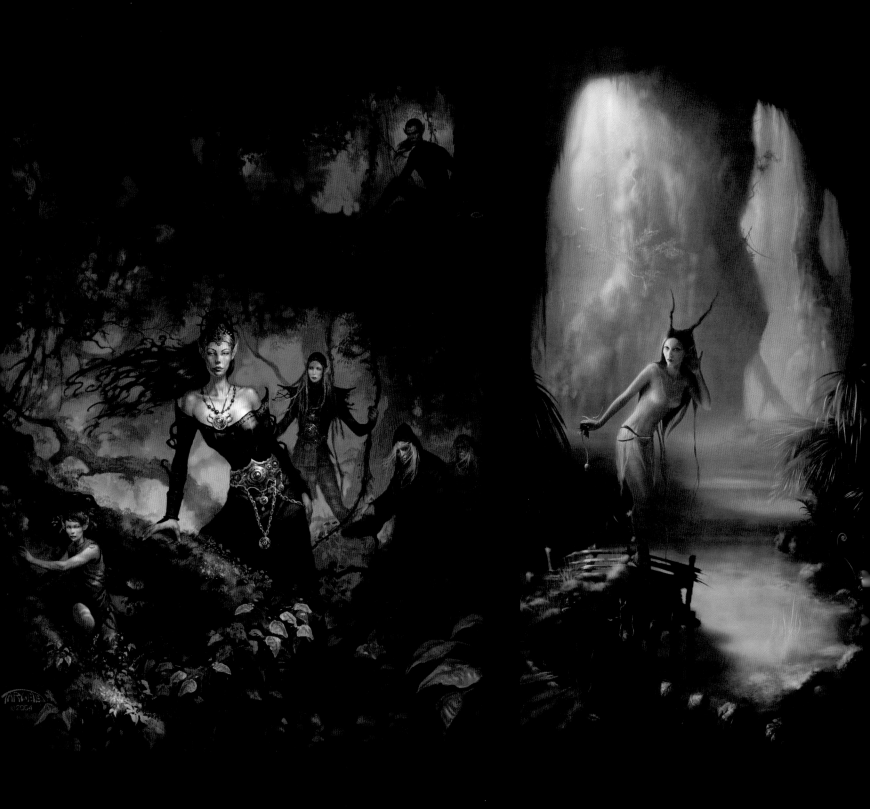

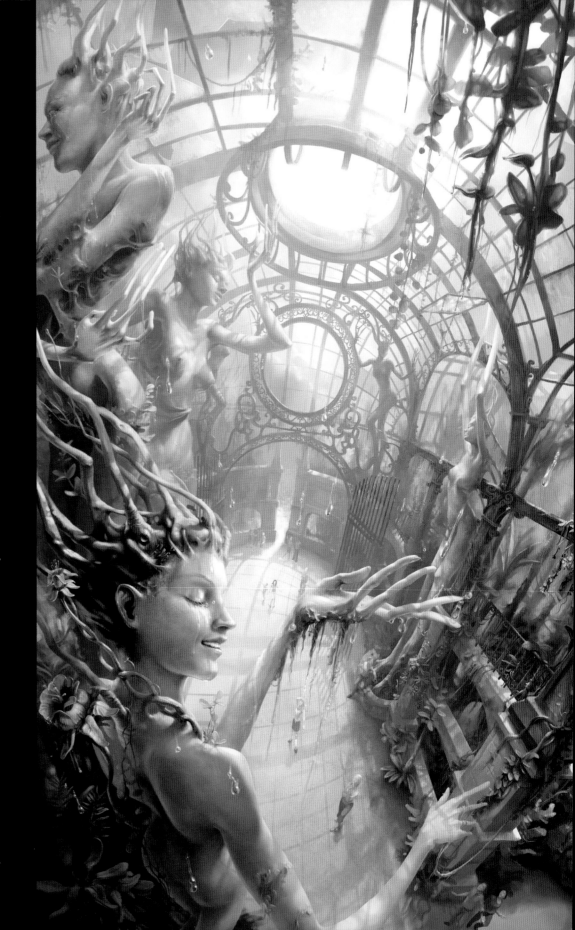

Fair Folk
J. P. Targete
Book cover
Fair Folk from Bookspan/SFBC
Adobe Photoshop
www.targeteart.com

In J. P.'s painting, we catch a glimpse of elves in a
dark forest. "I created this piece for an anthology
from Bookspan, who are also the Science Fiction Book
Club. Depicted in the painting is an elf from each of
the stories in the anthology. I wanted to give elves a
darker edge here because too many fantasy images
depict them superficially. Some of the stories in the
anthology have a sinister feel to them, so I reflected
that in my painting."

Faydrums
Benita Winkler
Portfolio work
Adobe Photoshop
http://eeanee.com

In Benita's crepuscular green swamp, a fairy
creature delicately cups her ear to listen, perhaps for
sounds of slumber. The signs are that she inhabits
the realm of sleep and dreams, as the plant she
holds in her other hand is an opium poppy, symbol
of Morpheus. In Greek mythology, Morpheus is the
principal god who shapes our dreams, and from him,
the drug morphine derives its name, based on its
dream-inducing power.

Garden of Giants
Michael Zancan
Portfolio work
Autodesk 3ds Max and Adobe Photoshop
http://zancan.fr

The scene in this painting, presents a metaphor
for that intense and rare feeling of crying for joy,
Michael explains: "Creating this has been like going
on a long, epic adventure. Several preliminary
studies of the main characters were drawn on paper.
The building, inspired by Art Nouveau architecture,
such as the Grand Palais in Paris, was designed and
rendered in 3D. This gave me a reliable perspective
base for the initial drawing, onto which I painted the
scene digitally."

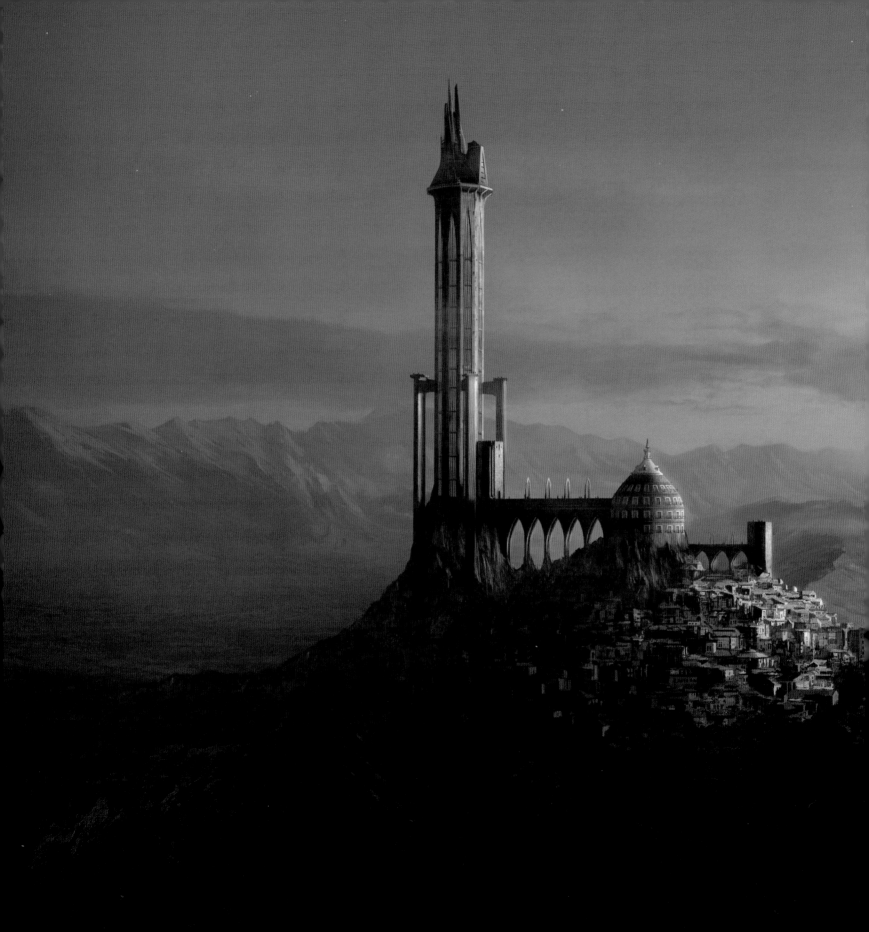

CHAPTER 7
SCENES AND SETTINGS

◄ **Spring Sunset**
Andreas Rocha
Portfolio work
Autodesk 3ds Max and
Adobe Photoshop
www.andreasrocha.com

*This image was the first serious
attempt at a matte painting for
Andreas. "It took me three days to
complete, starting with a couple
of sketches. I created a basic model
in 3ds Max with some textures
applied, which I then brought
into Photoshop. I painted over the
3D render, incorporating a lot
of photographic elements, until
everything came together. I've
always had a great fascination for
sweeping, fantasy landscapes, that
immerse the viewer and engage
the imagination."*

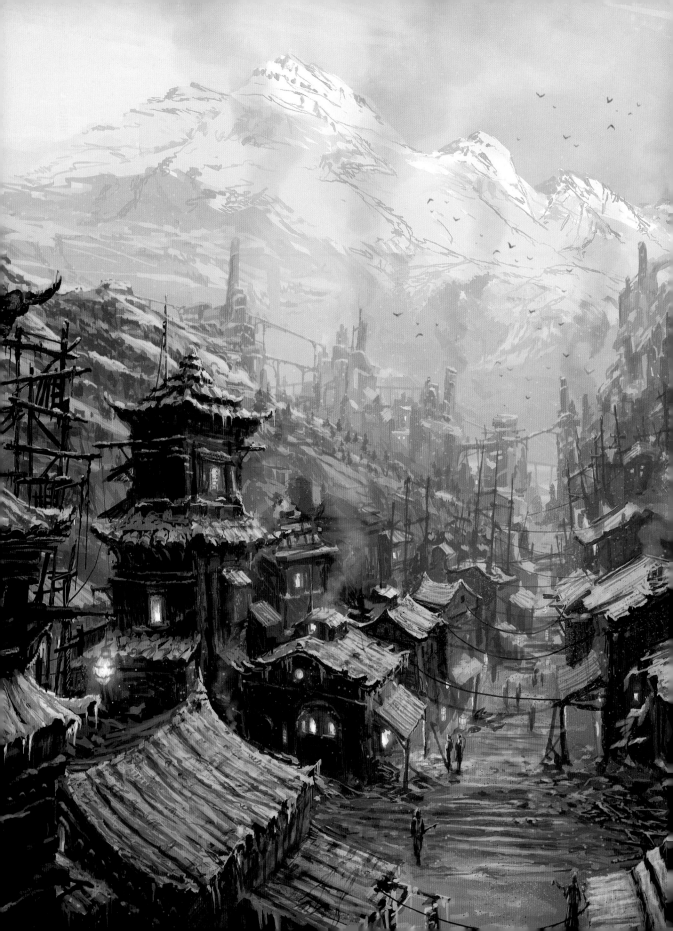

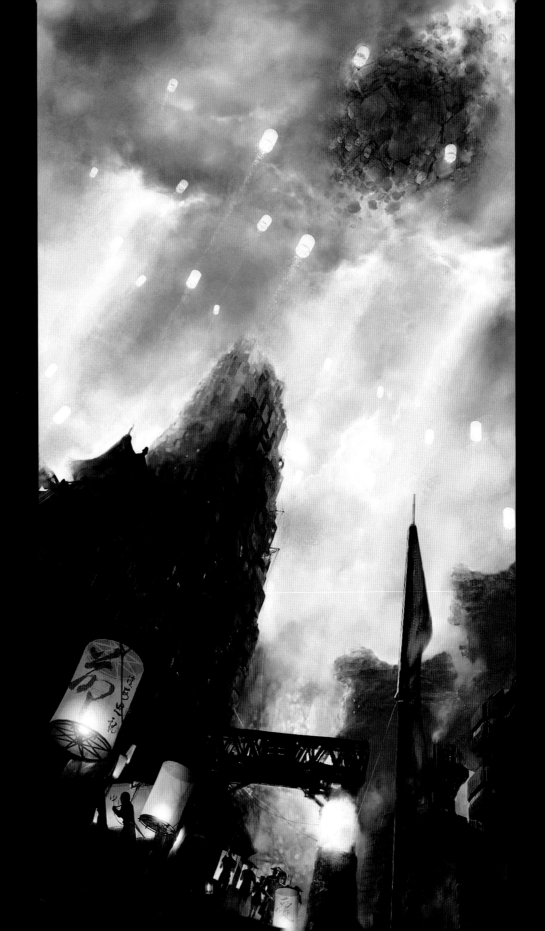

◀ **Chinese Winter**
Raphael Lacoste
Portfolio work
Adobe Photoshop
www.raphael-lacoste.com

*Having a strong background in 3D graphics,
Raphael explains that he wanted to paint
something entirely in 2D for practice. "I painted
this during the winter, when I was inspired by the
cold Canadian climate. I enjoyed the perspective,
working on the foggy houses and roofs to make
everything organic, rather than straight and
obvious. The pencil is better than 3D software to
create this kind of composition. There is a subtle
steampunk mood to it, with factory structures just
visible in the distance."*

 The Journey
Michael See
Portfolio work
Adobe Photoshop
http://michaelzhsee.cgsociety.org/gallery

*Michael depicts a festival of lights, behind which
lies his cautionary tale. "The inhabitants of this
world remember the earth through stories of a
once-beautiful place. Environmental disaster
caused by man meant that the earth could no
longer sustain life. The human race prolonged its
existence by travelling to harsh planets on which
colonists make desperate attempts to fashion lives
like those remembered from home. Although the
earth is dead to them, people pay homage to her
by offering up to the heavens these lanterns of
light, hope, and mourning."*

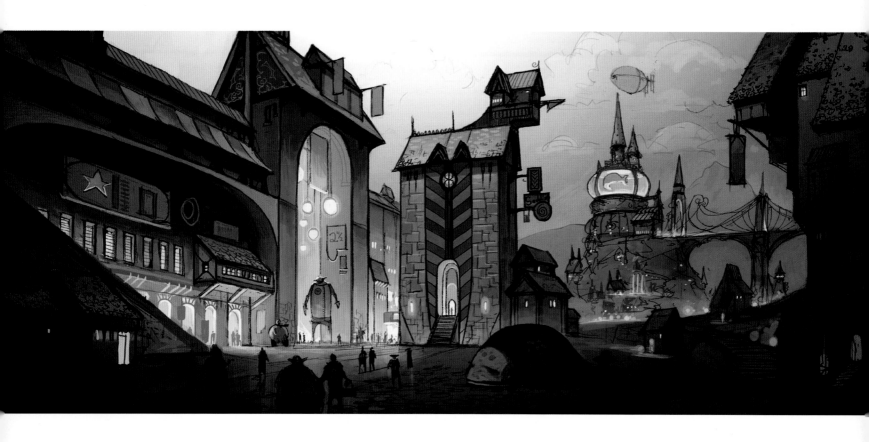

▲ **Amphibula**
Matt Gaser
Portfolio work
Adobe Photoshop
www.mattgaser.com

Another of Matt's wonderfully fanciful realms, where he enables
his imagination to run free in the creation of delightfully
impossible architecture, and in glimpses of this town's whimsical
citizenry. Like all the best fantasy art, this makes you want to step
in and explore. Particularly notable in this scene is the brilliant
aquarium castle on the hill. Matt says, "Here I wanted to create a
painting of a busy city in a world where beings of all shapes and
sizes live together."

▶ **Locke Lamora**
Benjamin Carre
Book cover
Les Mensonges de Locke Lamora from Bragelonne
Adobe Photoshop
www.blancfonce.com

In this image, we journey into an extravagant city; a shimmering
and exaggerated alternative Venice. We observe the complexity of
its maze-like architecture, in the company of the somewhat piratical
figure standing on the quayside. But we're also allowed to dive into
the deep, murky waters. Benjamin split the composition into a cross-
section, enabling us to catch a glimpse of the extraordinary, submerged
metallic infrastructure supporting the ancient streets, houses, and
bridges towering above.

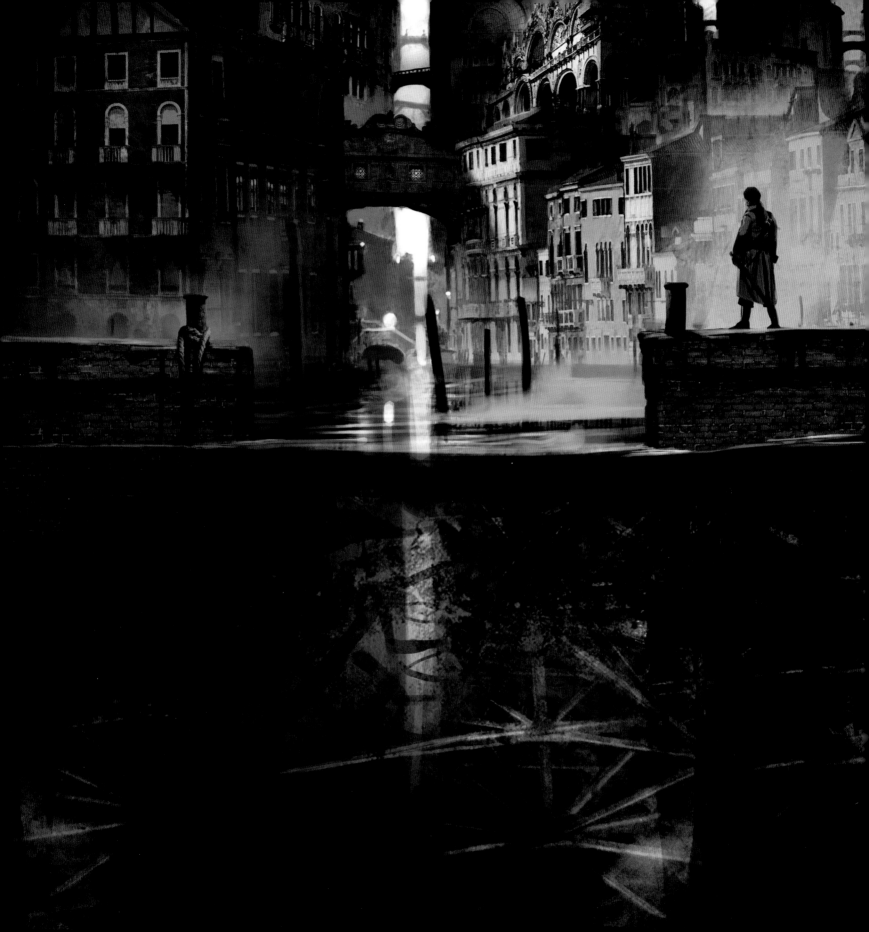

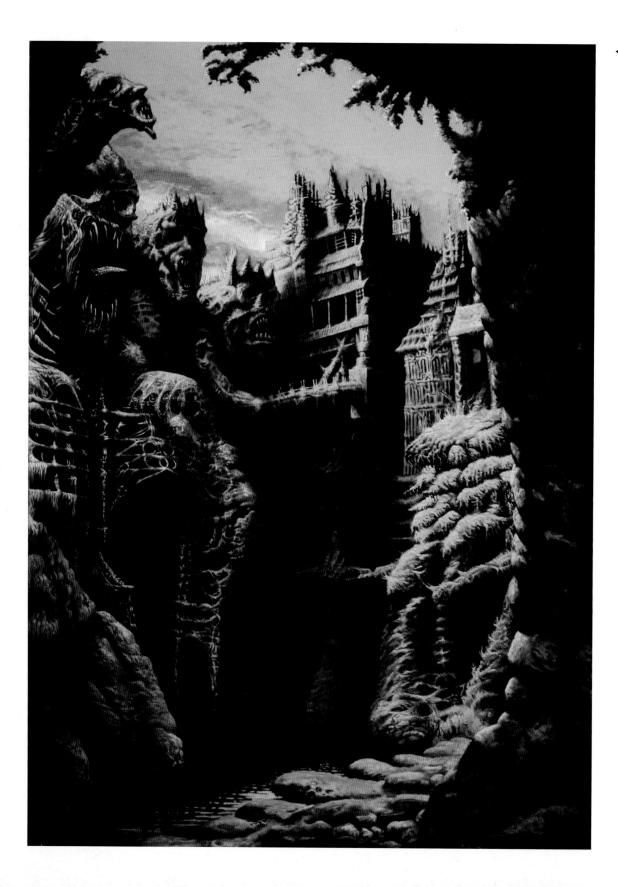

◄ **After a Long Silence.....**
Tony Hough
Portfolio work
Oil pastel, acrylics and
Adobe Photoshop
www.tonyhough.co.uk

Tony's goal was to depict beauty arising from wreckage and decay left by humankind. "In this lonely future vista, long after mankind has gone, nature moves back in, to reclaim the landscape. To create this piece, I used a mix of media, initially an oil pastel and airbrush sketch on art board. It was then sealed and painted over with acrylics. The completed painting was then digitally photographed and heavily modified in Photoshop."

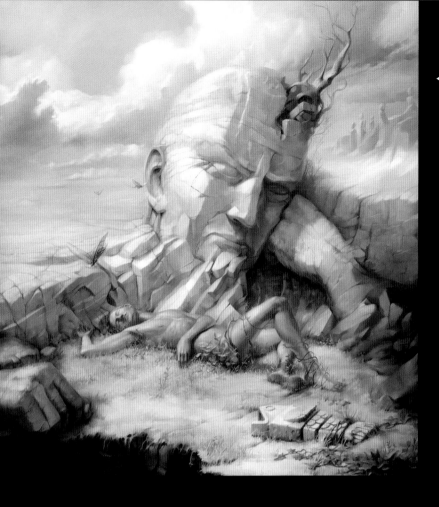

◀ **Purple-spattered Memories**
Michael Zancan
Portfolio work
Oil on canvas
http://zancan.fr

*The basic subject matter
Michael wanted to explore in
this painting was the duality
and symbiosis between the body
and the mind. "It started out
as a simple sketch drawn on a
train; a good example of how an
artist's mood and experiences
can influence a painting, all
the way through the creative
process. Each little detail, such as
the carving in the rocks, or the
purple butterflies, voices its own
worry, making the scene, as a
whole, a surreal, silent yell."*

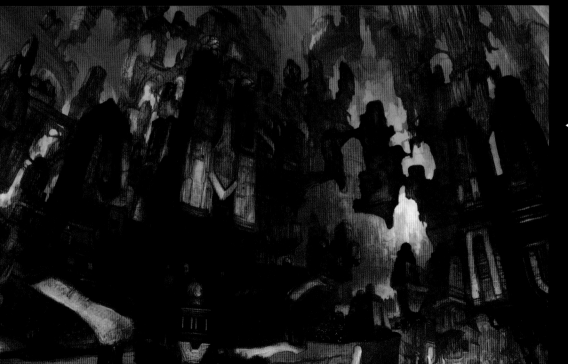

◀ **Ravnica Mountains**
Anthony S. Waters
Collectible card game illustration
Ravnica from Wizards of the Coast
Adobe Photoshop and
Corel Painter
www.thinktankstudios.com

*Anthony produced a total of five large
environment paintings for the* Magic:
The Gathering, Ravnica *project.
"This piece, showing the gigantic
growth of factories that form the
mountains on this world, was by far
the hardest to complete. It remains
one of the most densely detailed pieces
I've ever created."*

▶ **The Broken Orrery**
Paul Bourne
Portfolio work
Daz Bryce and Corel Paint Shop Pro
www.contestedground.co.uk

A heliocentric device, showing
the relative positions and
motions of heavenly bodies, this
orrery illustrates an unknown
solar system. As Paul describes,
"I always liked the idea of
ancient civilizations and archaic
technology, the purpose of which
having been long since forgotten.
That's what this image presents;
an ancient orrery built by some
long-dead civilization, rusting
and undiscovered; its secrets
soon to be lost forever."

▶▶ **Citta' di Sodoma: Ritratto
di Pastore con Idolo
(City of Sodom: Portrait
Of Shepherd with Idol)**
Alessandro Bavari
Portfolio work
Adobe Photoshop
www.alessandrobavari.com

Rich in metaphor, Alessandro's
work explores themes of
decadence and deviancy. "Sodom
was one of the two forbidden
and damned cities, where
people happily lived in a total
absence of morality. Devoted
to vice and lust, every kind of
perversion was part of everyday
life. To create my work, I have a
habit of taking photographs of
everything wherever I go; people
and animals, objects, landscapes,
and architecture. I accumulate
these materials and catalog
them for later use."

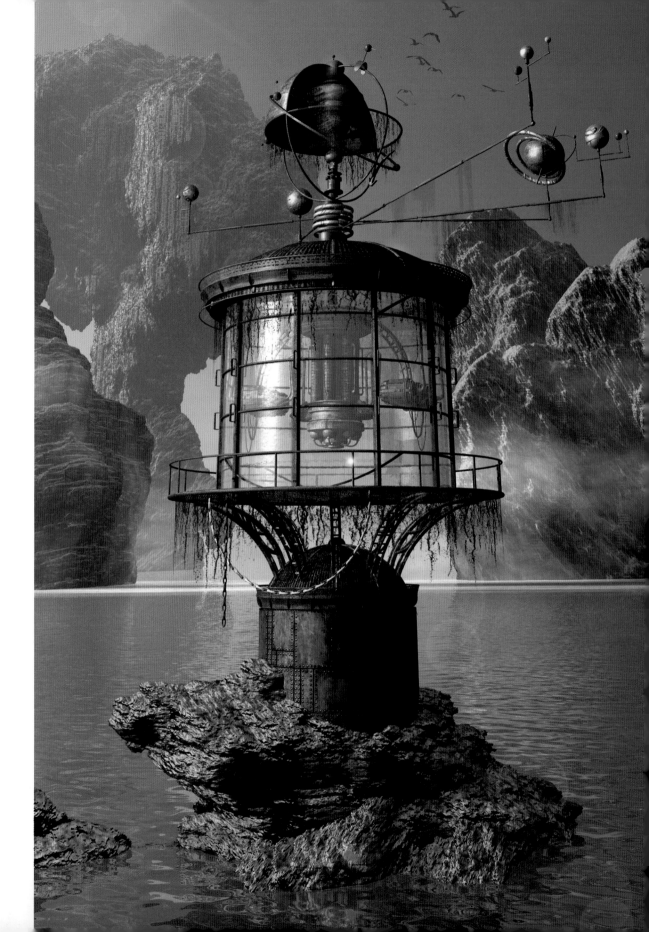

▲ **Water Valley**
Marcel Baumann
Portfolio work
Adobe Photoshop
www.marcelbaumann.ch

*Some of botany's tranquil forms sparked
Marcel's imagination when creating this
idyllic pastoral landscape. As he explains,
"Beautiful plants, their shapes, and how
they looked in sunlight, inspired me to try
creating a calm and dreamlike natural
environment. I decided to use a verdant
valley, with waterfalls as my main theme,
creating a natural amphitheatre, and
suggesting how the water had formed
this place over time."*

▲ **Pirates**
Patrick Reilly
Portfolio work
Adobe Photoshop and Corel Painter
http://preilly.deviantart.com/gallery

*A delightfully crepuscular seascape, which,
with its murky night scene swathed in
damp fog, recalls the spectral green-tinged
paintings of the Victorian artist John
Atkinson Grimshaw. Patrick elaborates,
"I've been a longtime fan of popular folklore,
whether it's sea monsters, gremlins, or, in
this case, tales of ghost ships sailing the high
seas. This image depicts an old ghost ship
returning to port, long after it was thought
to have been lost at sea."*

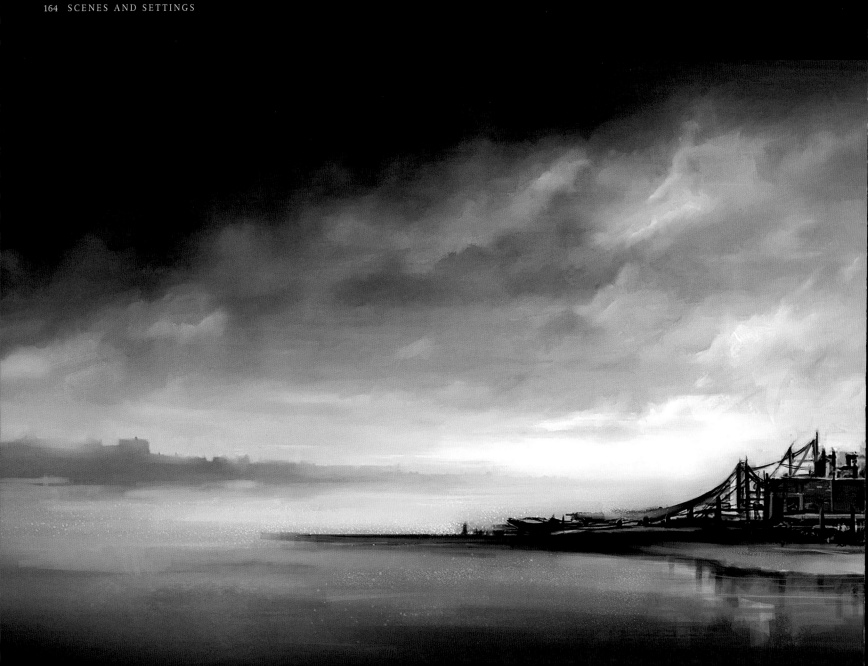

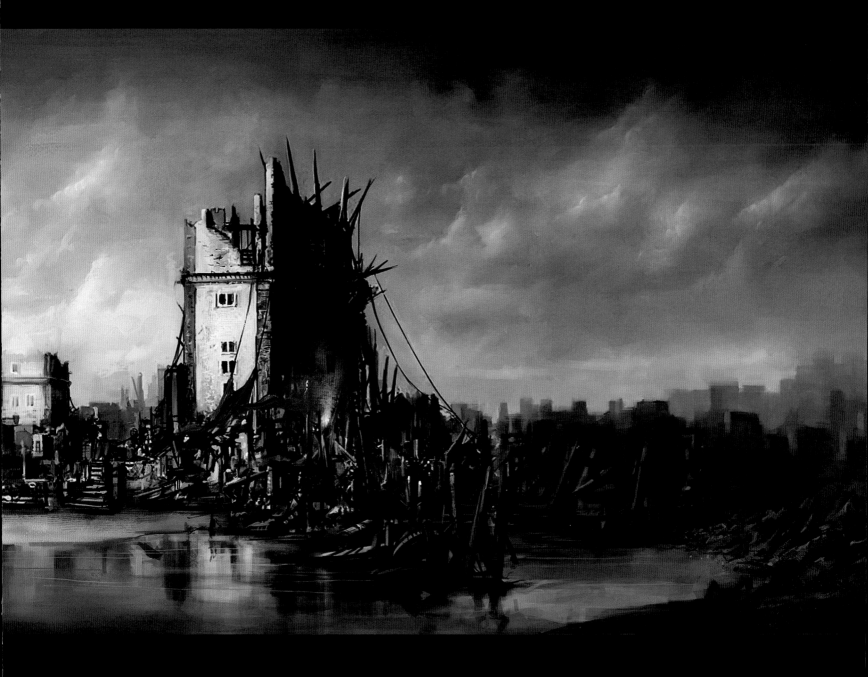

▲ **Home**
Andreas Rocha
Portfolio work
Adobe Photoshop and Corel Painter
www.andreasrocha.com

*For this painting, Andreas was inspired by the Torre de Belém, a major landmark in Lisbon. He has
captured a monochromatic air of solitude; cold, but with the glowing fire providing a warm focal point.
"I've always loved rainy coastal environments. This took me about a day to complete in Photoshop, with
a lot of help from Painter, to achieve those 'wet and rainy' brush strokes of the green-gray colors that are
so characteristic of heavy thunderstorms."*

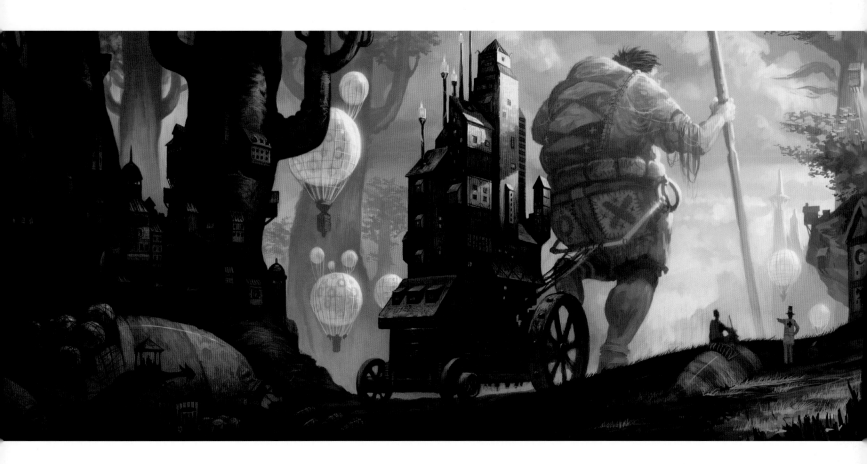

▲ **Gluba Vanderhon the Giant**
Matt Gaser
Portfolio work
Adobe Photoshop
www.mattgaser.com

A panorama that's delightfully playful in its use of scale, this is a scene set at what first appears to be a fairly intimate level, but which soon reveals layers of worlds within worlds, containing many miniature tableaux. "In this painting, I wanted to show a wide shot of a grand fantastical moment like nothing anyone has seen before. Once I finished the piece, it spawned an entire personal project that I've continued to develop into a storyline."

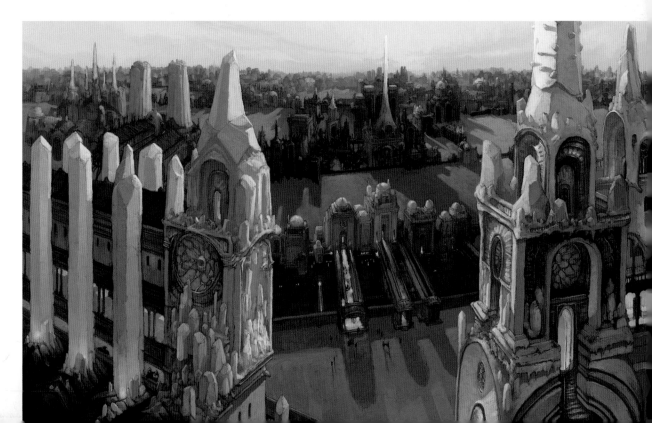

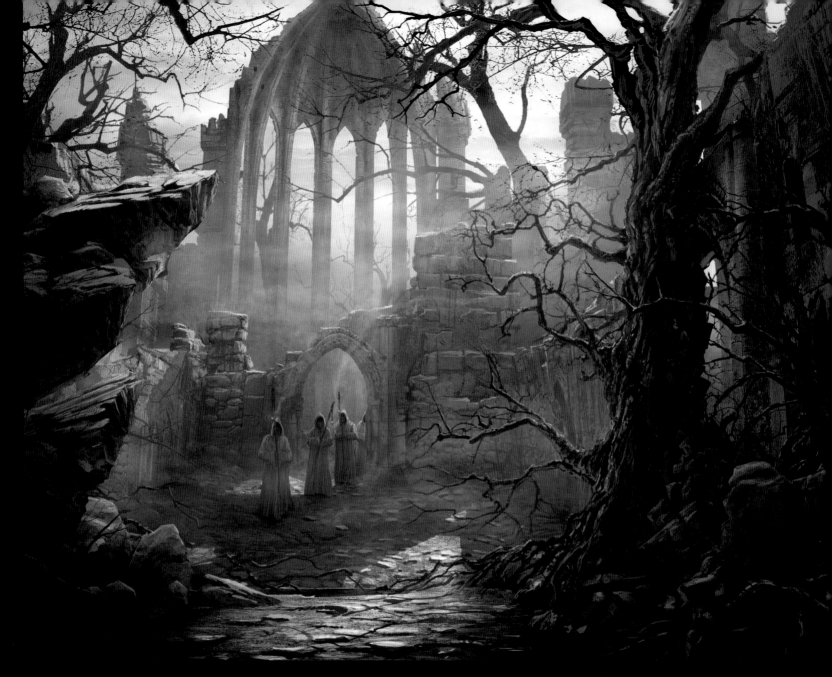

◄ Ravnica Plains
Anthony S. Waters
Collectible card game illustration
Ravnica from Wizards of the Coast
Adobe Photoshop and Corel Painter
www.thinktankstudios.com

The work of famed French comic artist, Moebius, was very much on
Anthony's mind as he designed the Ravnica city structures, and he
reveals more about their concept. "Most of the people of Ravnica live
far below the surface levels. Those who rule the world get to cavort
at the very top. These elite are the only ones to regularly experience
undiluted sunlight, and they make the most of it, channeling and

▲ Path to the Gothic Choir
Raphael Lacoste
Portfolio work
Autodesk 3ds Max and Adobe Photoshop
www.raphael-lacoste.com

Raphael was inspired by Caspar David Friedrich's painting
Abbey in an Oak Forest for this picture. "I'm quite a romantic
artist and I love 19th century paintings. Between realism and
stylization lies a fascinating way of depicting reality that's very
dramatic and theatrical. I love to work on atmosphere and moods,
and here I hope you can smell the smoke and feel the mist of a
humid early morning. I created very simple shapes in 3ds Max,

◀ **Cannot Prevent**
Ryohei Hase
Portfolio work
Adobe Photoshop
www.h4.dion.ne.jp/~ryohei-h/index.html

*Amid this miserable crowd of hunched figures, shambling under their
umbrellas through a downpour, one woman stands, detached and upright,
her entire head alight in a sudden spectacular blaze. This incendiary motif
in Ryohei's symbolic image represents ignited anger and passions bursting
free from within this frustrated proletarian, no longer able to countenance
the bleak thronging procession of her dreary, city commute.*

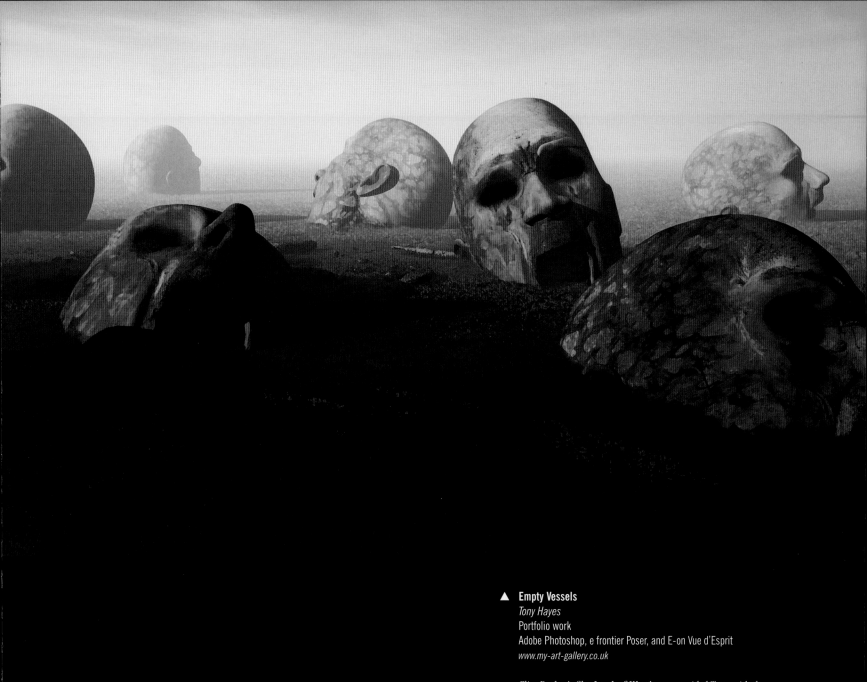

▲ **Empty Vessels**
Tony Hayes
Portfolio work
Adobe Photoshop, e frontier Poser, and E-on Vue d'Esprit
www.my-art-gallery.co.uk

Clive Barker's film Lord of Illusions, *provided Tony with the inspiration for this image. "My intention was to create a stark, barren desert, littered with gaunt empty heads; a hellish place. I adjusted the lighting to give long, dark shadows, and black mouths and eyes, which reinforce the impression of the heads' emptiness. This is one of the few images that turned out exactly as I had envisaged, showing how simple ideas can be effective."*

► Ravnica Forest

Anthony S. Waters
Collectible card game illustration
Magic: The Gathering from
Wizards of the Coast
www.thinktankstudios.com

Anthony developed the
environment for this card-
based fantasy game. "I got to
participate in all aspects of
production on Ravnica, and
illustrated its gigantic city.
Certain parts of the city are
dedicated to hydroponics, which
are shown in this painting. This
piece was a true pleasure to
do, in every respect. I wanted
to suggest a simultaneously
artificial and organic space;
the architecture reflecting the
shapes of the trees that they are
designed to shelter."

▲ Lancelot's Secret

John Garner
Portfolio work
Oils and acrylic
www.shadowsofthunder.com

John drew upon his love of
Arthurian legend as the
inspiration for this piece. "It
was created with many layers
of acrylic paint as a base. An
airbrush was used to add the
highlights and atmospheric
effects. Once the acrylic paint
was dry, oil washes were used to
deepen and enhance the colors.
No digital effects were used in
the creation of the painting."

► Goondabar Discovery

Matt Gaser
Portfolio work
Ambient Design ArtRage and
Adobe Photoshop
www.mattgaser.com

Here, we enter a landscape
dominated by mysterious
constructions of colossal size.
Matt explains further; "Scale is a
theme I've noticed creeping into
my work a lot over the years.
Perhaps it's the epic nature of
the subject matter that attracts
me. For this painting, I wanted
to tell the story of a traveller who
finds a robot leaving its post
and walking, after being locked
in stone for thousands of years.
What happens next, I leave up to
the viewer."

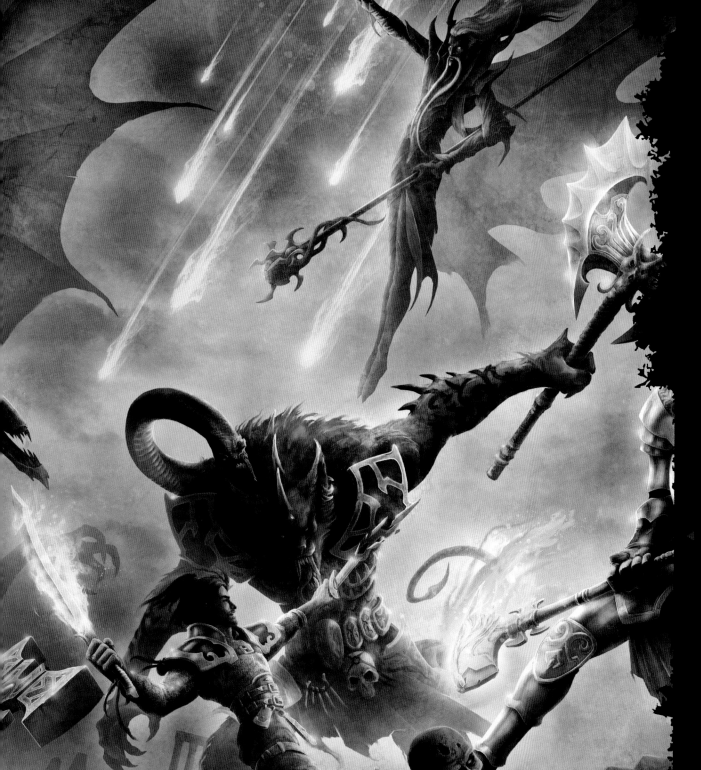

◄ The Battle of Four Armies
Jason Engle
Promotional image for
a miniatures company
Adobe Photoshop
www.jaestudio.com

"For Jason, this was one of the
most complex and challenging
works. Designed to show as much
detail for them as possible,
it was printed at a full page
format. During the six-month
schedule for the piece, Jason
worked on it alone, and for many
months it was rendered
each battle is remarkably more
precise elements to make
these, and it is a product to
light it could enhance motion
of every one from to and the
scene it added."

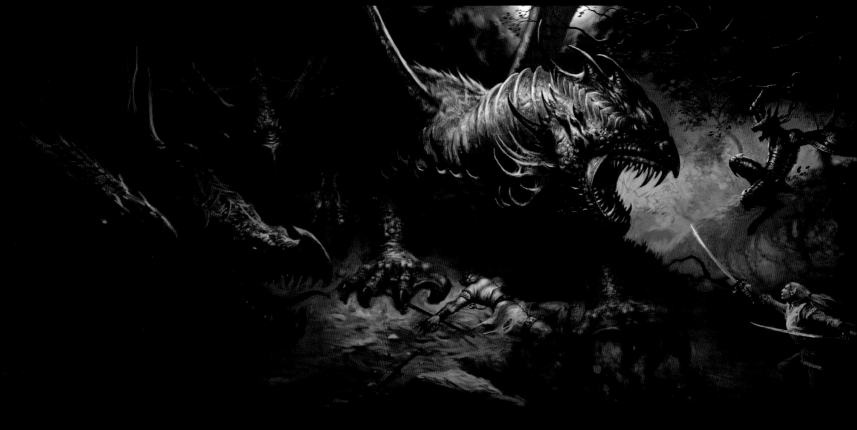

▶ **The Night of Dissolution**
Kieran Yanner
Book cover
Ptolus series from Malhavoc Press
Adobe Photoshop
www.kieranyanner.com

Kieran tells us about the creation of this fight between good and evil. "I began with a model photo shoot. I enjoy photo sessions that encourage the model to really act out a character and create expressive poses. This has tended to work better for more somber pieces, rather than action scenes, and, curiously, I've found it is hard to get female models to frown. I decided to use a green color scheme for this piece, leaving the comfort zone of my usual palette."

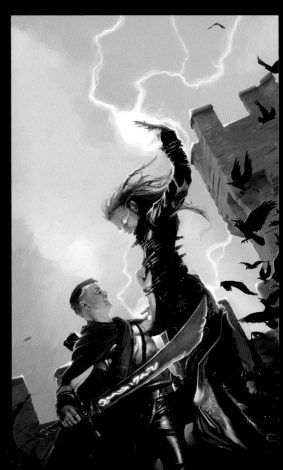

◀ **Arcana Evolved**
J. P. Targete
Game book cover and novel cover
Arcana Evolved from Malhavoc
Press
Adobe Photoshop
www.targeteart.com

*To begin this piece, J. P. created
a detailed drawing, but this had
its drawbacks, as he explains:
"The under-drawing made the
painting very easy. The snag
was that it couldn't evolve
much because I'd shown it to
my client for approval. I still
enjoyed working on it and I
wanted to express a sense of
epic drama unfolding before
the viewer. The letterbox format
lends itself to such epic scenes.
Composition, along with form
and light, are controlled to
enhance drama and action."*

▶ **Untitled**
Ryohei Hase
Portfolio work
Adobe Photoshop
*www.h4.dion.ne.jp/~ryohei-h/index.
html*

*In this dark fantasy painting,
Ryohei shows a young sword-
wielding Japanese warrior
surrounded by towering,
lycanthrope horrors. The artist
captures the moment just before
his boy hero, already slashed
and bloody, begins his desperate
battle in earnest. Werewolves
and shape-shifters are common
in folk tales from all over the
world, and Japanese folklore
features many creatures that are
part-animal and part-human,
including the capricious fox
creatures, Kitsune.*

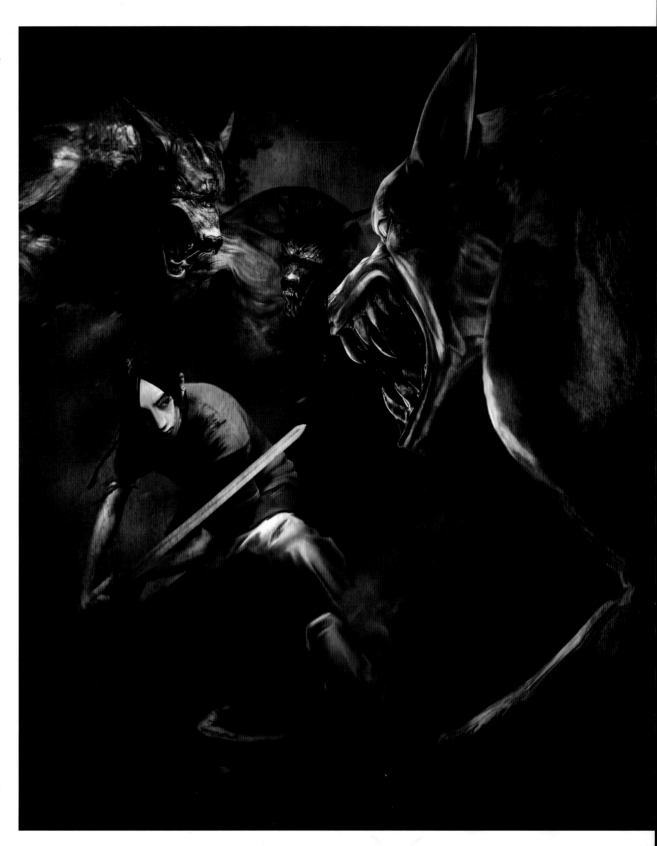

▶ **Pirates**
Abrar Ajmal
T-shirt and poster for
Skulbone USA
Adobe Photoshop
www.aaillustrations.com

*Recalling the art of the notorious
EC horror comics of the 1950s,
Abrar has depicted a band of
bloodthirsty skeletal cutthroats.
EC's classic comic books revelled
in a gruesome joie de vivre, with
grimly ironic fates meted out to
many of the stories' protagonists.
"I really enjoyed working on this
piece. The client wanted a pirate
picture with a horror theme.
With relish, I sat down to work
with two of my favorite genres,
and produced this piece of
deliciously grisly fantasy horror."*

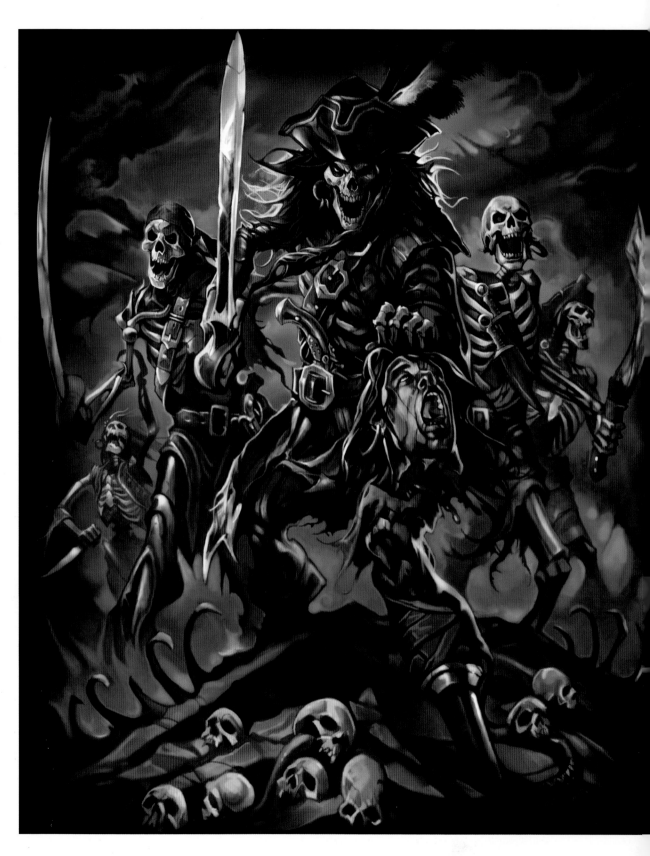

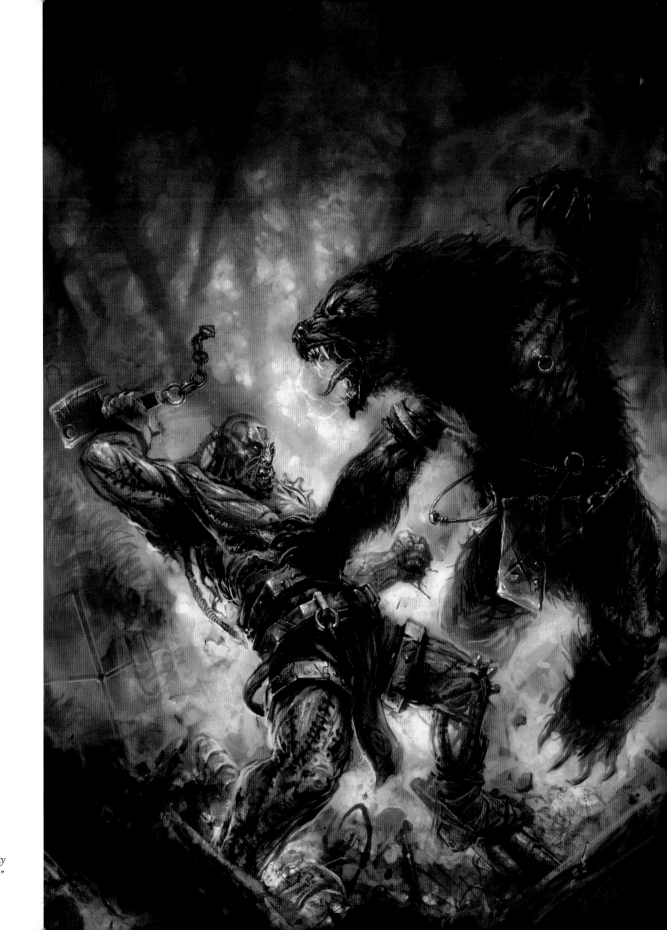

► **Meatman vs. Werebear**
Michal Ivan
Game book cover
Adobe Photoshop
http://perzo.cgsociety.org/about

*For this Czech role-playing
game cover, Michal has depicted
two of the monsters that are
featured in the book; here
seen locked in brutal combat.
"Meatman is a monster inspired
by the Frankenstein creature; its
muscular form sewn together
from dead tissue, and brought
to life by magicians, while the
grizzly Werebear is a bloodthirsty
half-man, half-bear lycanthrope."*

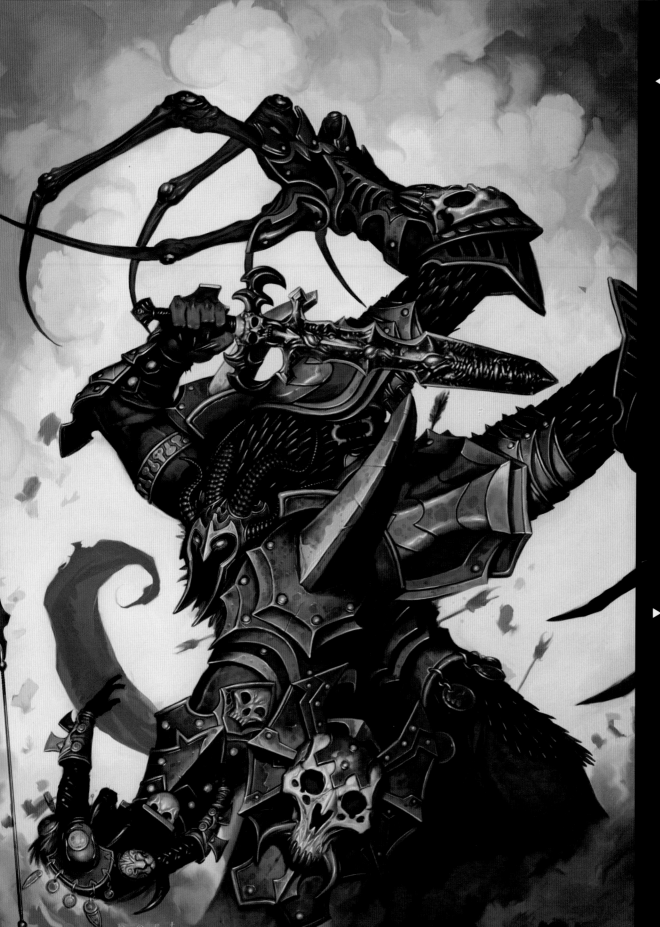

◀ **Zaramoth Unleased**
R. K. Post
Comic book cover for Dark Horse
Based on the video game
Dungeon Siege 2 from Gas
Powered Games
Adobe Photoshop
www.rkpost.net

This titanic, multi-limbed, armored demon, engaged in bloody battle, was inspired by the Dungeon Siege game world. But R. K. was under a lot of pressure to create the piece within a very tight production schedule, as he explains: "I didn't have much time to complete this one because it was done while I was working as an in-game artist for Gas Powered Games, and I was asked to produce this additional promotional painting."

▶ **Dragon's Nest**
Anne Stokes
T-shirt design for Spiral Direct Ltd
Adobe Photoshop
www.annestokes.com

Anne needed to produce artwork that was mostly light against dark, to look good when printed on black t-shirts. "The foreshortening on the figure's pose, and the diagonal line between the dragon, the fire, and the warrior, are intended to heighten the sense of drama and action. This mother dragon will viciously guard her nest of eggs, and the adventurer is in for a lot of trouble."

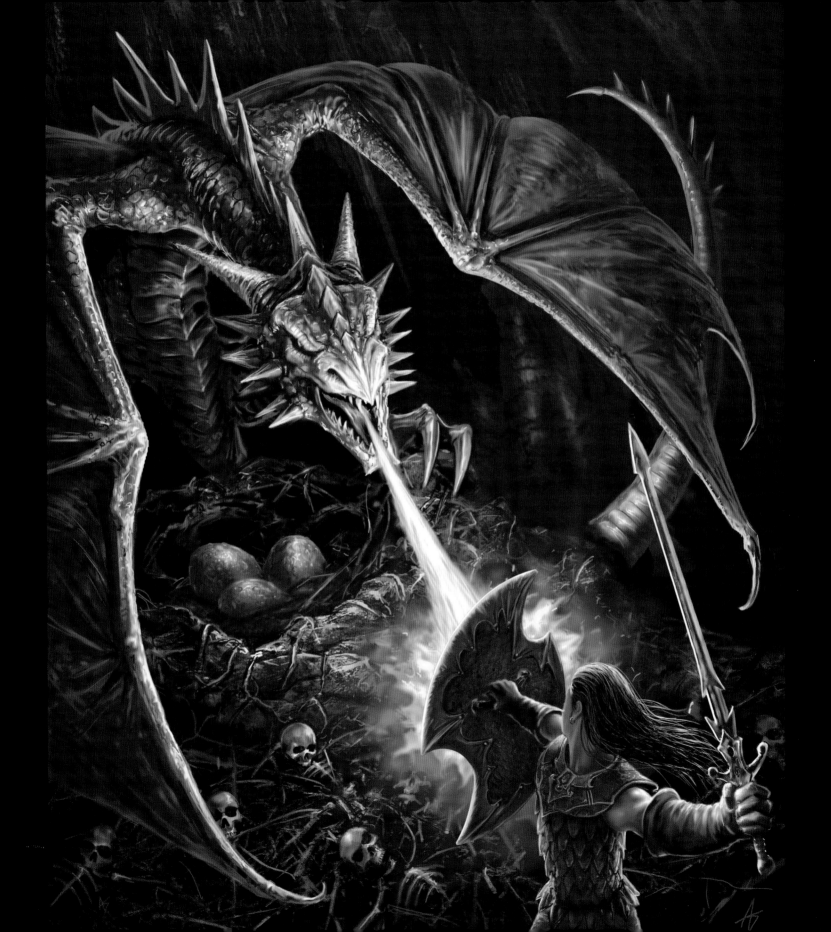

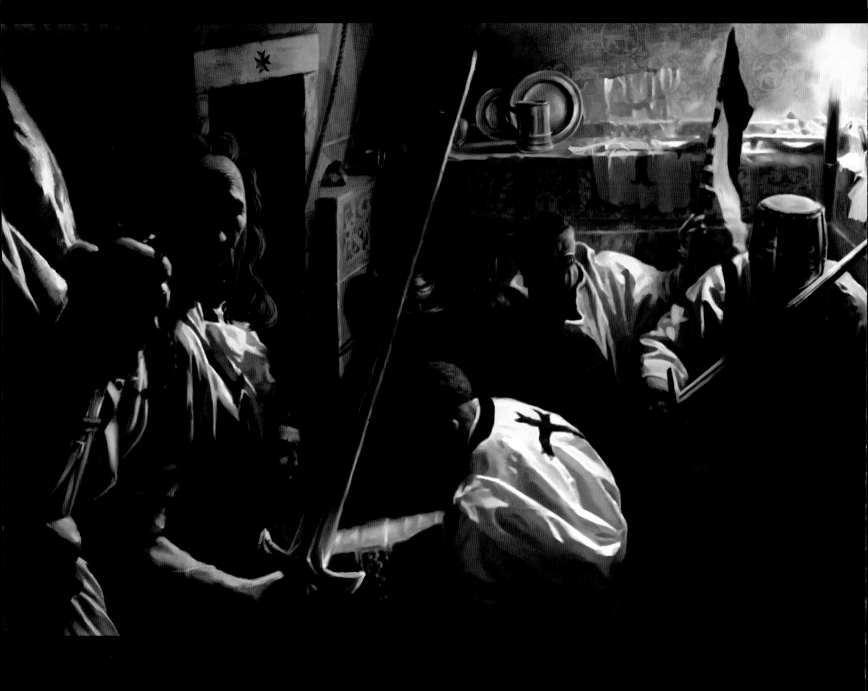

◀ **Friday the 13th, October 1307**
Cyril Van Der Haegen
Portfolio work
Adobe Photoshop and
Corel Painter
www.tegehel.org

*On this fateful night in France,
hundreds of Knights Templar
were arrested by agents of Philip
IV, and later tortured into
admitting heresy. Cyril explains,
"These poor fellows are escaping
through a secret passage, while
the militia pounds on the door
upstairs. They're frantically
hiding a chest, which might even
contain the Holy Grail." What
became of the great Templar
treasures in France has long
been a mystery.*

▶ **Kicking Back**
Ralph Horsley
Book illustration
Cityscapes from Wizards
of the Coast
Acrylic
www.ralphhorsley.co.uk

*Ralph was asked to compose a
busy tavern scene containing
several key elements. "One of the
hardest aspects was that the two
key characters, a halfling and
a gnome, were also physically
the smallest. I tackled this
challenge by placing them above
the action. This enabled a good
overview of the bar scene, and
the ability to make them a lot
larger within the perspective. The
other incidents were then subtly
picked out with brighter lighting,
as if sunlight were coming in
through a high window."*

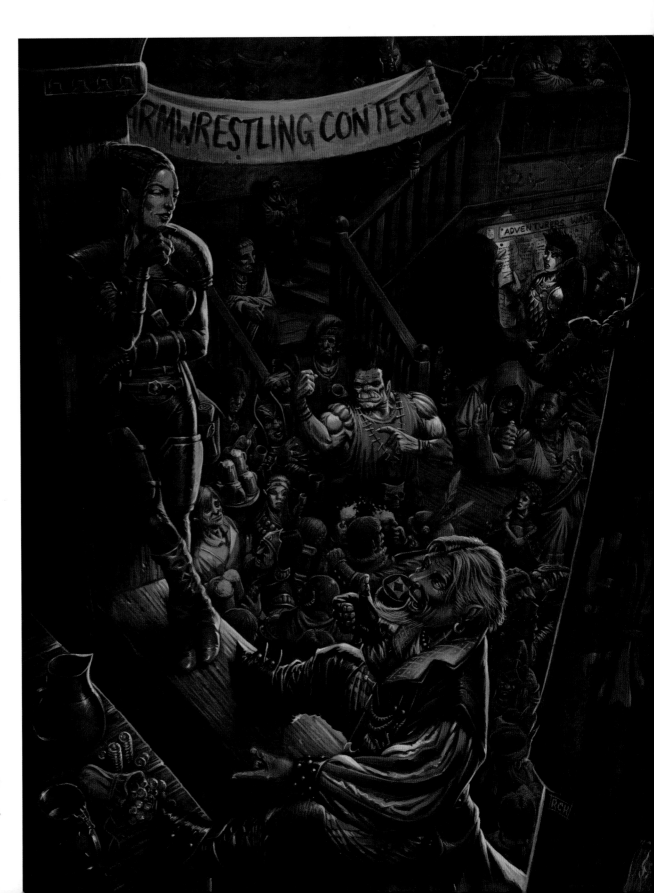

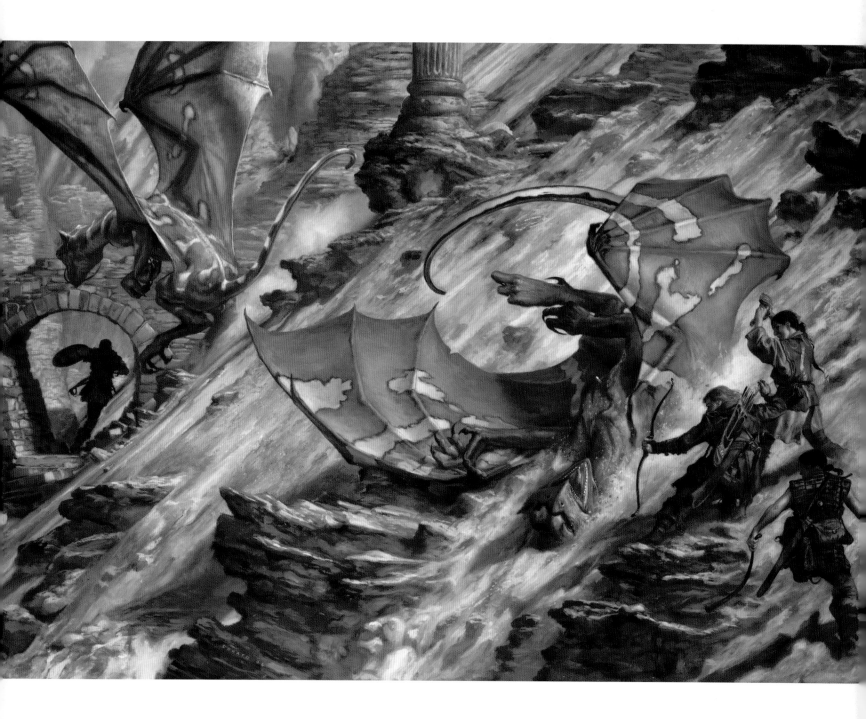

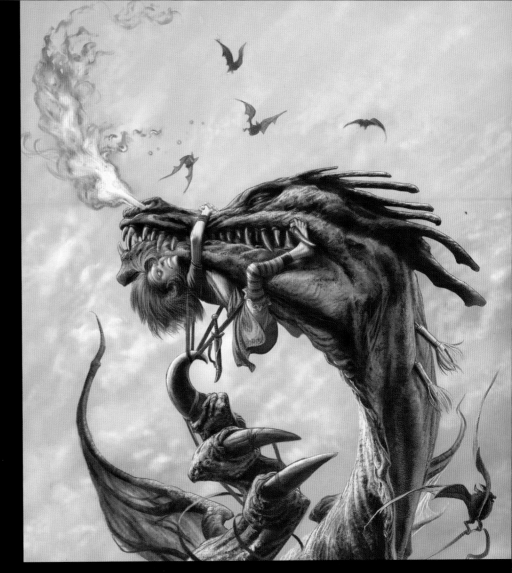

◀ **Wyvern Hunting**
Donato Giancola
Book cover
The Mirror of Worlds from Tor Books
Oil on paper on masonite
www.donatoarts.com

*Selecting the precise moment to show the tensions of conflict
is one of the most difficult jobs in narrative illustration, as
Donato explains: "Rewind the moment too far and you've lost
the posturing of battle. Fast forward and you've provided the
resolution. Ambiguity is the essence of what I wanted here; the
placement of characters at that pivotal moment when there is no
winner or loser. This unknown state allows us to project our own
assessment of the variables and guess at a possible future and the
image engages and creates a dialog with us. Is that man on the
left hunting the wyvern, or being hunted by it?"*

▶ **The Dragon Wrangler**
Nick Harris
Portfolio work
Adobe Photoshop and Corel Painter

*Nick describes how the complex textures on this dragon are
simply a result of playing with the large chalk variant in Painter,
combined with a variety of paper surfaces. "You can adjust the
scale of paper, invert it, and even control how much grain a tool
picks up, so there's wonderful potential, even within this one
combination. If you add experimental mark-making over the top
to help define the contours of the form, it really does become a
powerful tool."*

▶ **Their Feeling**
Ryohei Hase
Portfolio work
Adobe Photoshop
www.h4.dion.ne.jp/~ryohei-h/index.html

*Ryohei uses his images to express his melancholic feelings towards
daily life; feelings, he says, that he would find difficult, if not
impossible, to express in words. In this picture, Ryohei tries to
convey all the desperate, violent motion, and simple brutality of
an animal's slaughter; the flapping, noisy attempts of a terrified
hen as it struggles to escape man's all-consuming hunger. Its
distraught movements are captured in a sequence of frozen
moments, as the clutching arms seize upon it.*

▲ **Serra Angel vs Spectre**
Greg Staples
Collectible card game illustration
Magic: The Gathering from
Wizards of the Coast
Corel Painter
www.gregstaples.co.uk

Greg has long been inspired by
classic fantasy imagery, and like
many other leading artists work-
ing today, it was the heroic fan-
tasy paintings of Frank Frazetta
that first captured his young
imagination. "Frightening and
epic, dark, and powerful; these
are the things that drive me
today, and needless to say the
images have never left me."

▶ **Garhunt**
Karl Richardson
Collectible card game illustration
World of Warcraft from Upper Deck
Adobe Photoshop
http://karlrichardson.co.uk

Karl's brief was to portray an Orc
Warlock, flanked by his guard.
"When illustrating for cards,
I usually fill the composition
with a closeup. It's generally a
subconscious decision because
I enjoy painting facial detail,
which can be lost when the art is
printed so small. With this image,
I had to pull back and show more
of the figures, because the demon
guard is such a big character."

◀ **Werewolf the Pure**
Abrar Ajmal
Game book cover
Werewolf: the Pure from White
Wolf Publishing
Adobe Photoshop
www.aaillustrations.com

A pack of cruelly rapacious
lycanthropes destroy all in their
path in Abrar's aggressive
vision. "I approached this image
with the desire to dramatically
illustrate rage, and also to
produce as eye-catching a
cover for the book as I could. I
wanted the piece to tell a story.
The burning buildings in the
background indicate events
leading up to this moment,
and give us an idea of what
these guys are capable of."

▲ **Dark Riders**
J. P. Targete
DVD tutorial
Imaginative Illustration with J. P. Targate for the Gnomon Workshop
Adobe Photoshop
www.targeteart.com

Demon riders charge into battle upon hell-beasts, in this infernal
scene. J. P. tells us more: "In the DVD demonstration, I started
the image as a thumbnail sketch and took it all the way to the
finished piece, using Photoshop's tools. The emphasis was on
composition, mood, and lighting. I've always loved drawing big
action pieces. It's something I picked up from reading adventure
novels, comic books, and watching action movies."

▶ **Dragon Warriors**
Jon Hodgson
Game book cover
Dragon Warriors from Magnum Opus Press
Adobe Photoshop and Corel Painter
www.jonhodgson.net

This painting is a personal favorite of Jon's, for very particular
reasons. "It was wonderful to be offered the opportunity to make a
new cover for the favorite role-playing game of my youth. This is a
classic, old-school fantasy scene, with an adventuring party about to
encounter some horror in the deep. The setting is a nod to the game's
original cover."

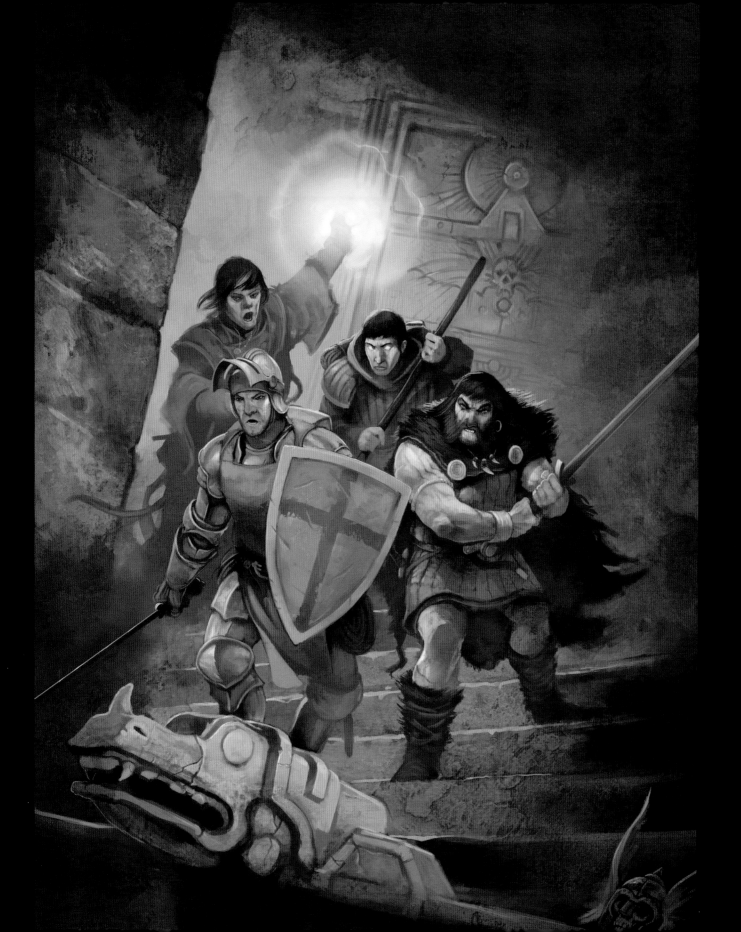

▲ **Fire and Shadow**
Glen Angus
Portfolio work
Adobe Photoshop
www.gangus.net

*This is Glen's interpretation of the confrontation between Gandalf
and the Balrog in the Mines of Moria, from Tolkein's* The Lord of
the Rings. *"This was the first of many personal pieces that I decided
to create in an attempt to further my skills as a painter. It was also
the start of my attempts to draw entirely in Photoshop. This scene is,
to me, one of the most inspiring and thought-provoking clashes
between good and evil in modern fantasy. As I was going to paint
purely for practice and pleasure, I wanted to create my own unique
rendition of this battle."*

▶ **The Battle of Agincourt: 25 October 1415**
Donato Giancola
Book cover
The Crippled Angel from Tor Books
Oil on paper on panel
www.donatoarts.com

*In this powerful painting, Donato didn't want to capture the heroics
of battle, but rather show the great equalizing force that conflict
has upon those engaged in face-to-face mortal combat. As he says,
"Nobleman, mercenary, and peasant share a common fate upon the
battlefield, especially during a conflict such as Agincourt. There are
no true winners."*

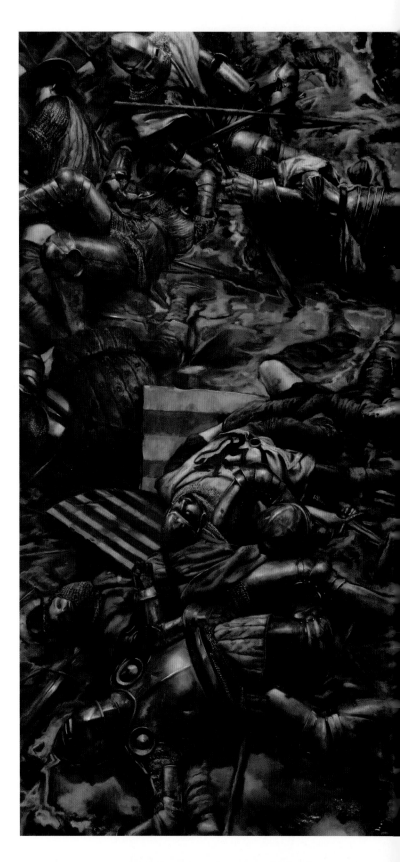

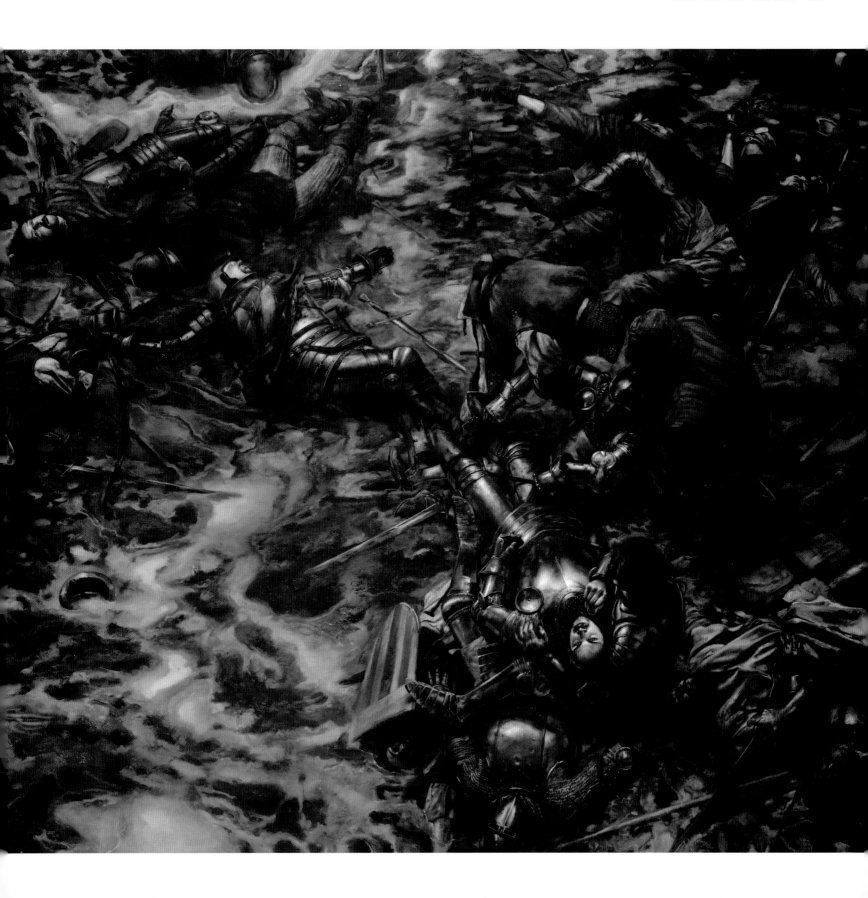

ADEL ADILI
www.adel3d.com
adel3d@yahoo.com
Daphne & Apollo *p67*
Rostam *p32*

ABRAR AJMAL
www.aaillustrations.com
abrar.ajmal@ntlworld.com
Angel of Death *p128*
Pirates *p11 & p176*
Werewolf the Pure *p185*

JULIA ALEKSEEVA
http://julax.ru
email@cg-warrior.com
Dragon's World *p87*
Drizzt Do'Urden *p33*
Guenhwyvar *p4 & p61*

JEFF ANDERSON
jeffand145@aol.com
Riddler's Fayre *p21*
Riddler's Fayre 2 *p24*
Shadow's Edge *p120*

GLEN ANGUS
www.gangus.net
gangus@ravensoft.com
Fire and Shadow *p188*
Odin *p12-13*
Thor, Ultimate *p80-82*

SAM ARAYA
www.paintagram.com
paintagram@gmail.com
Aisha *p42*
© White Wolf Publishing
Blood Inside *p117*
© White Wolf Publishing
The Tongues of Fire *p130*
© White Wolf Publishing
Whispers *p22*
© White Wolf Publishing

MARCEL BAUMANN
www.marcelbaumann.ch
marcelbaumann@gmx.ch
Rose River *p148-149*
Water Valley *p162*

ALESSANDRO BAVARI
www.alessandrobavari.com
info@alessandrobavari.com
Citta' di Sodoma: Ritratto di
Pastore con Idolo (City of Sodom:
Portrait Of Shepherd with Idol)
p161
Cura dell'Incanto in Chiave
Minore (Cure for Enchantment
in a Minor Key) *p122*

Gala Dell'Anonimia alla Corte di
re Birsa (The Anonymity Gala at
the Court of King Birsa) *p98*

BRYAN BEAUX BEUS
www.beauxpaint.com
untitleduser@gmail.com
Honey Queen *p91*
Rapunzel *p112*

KEREM BEYIT
http://kerembeyit.gfxartist.com
kerembeyit@hotmail.com
Claw Clan *p92*
White Tiger Clan *p26*

PASCAL BLANCHE
www.3dluvr.com/pascalb
lobo971@yahoo.com
Dead End *p93*
Hunters *p25*

PAUL BOURNE
www.contestedground.co.uk
paul@contestedground.co.uk
The Broken Orrery *p160*
"Thou Shall Not Pass!" *p18*

DAVID M. BOWERS
www.dmbowers.com
davidmbowers@comcast.net
Stages of Life *p131*
The Pig Walker *p119*

MATTHEW BRADBURY
www.epilogue.net/cgi/database/art/
list.pl?gallery=11601
mattbradbury2000@yahoo.com
Changeling *p76*
Dragon Rider *p50-51*
The Last Days *p84*
The Watchmaker *p57*

SIMON DOMINIC BREWER
www.painterly.co.uk
simon@painterly.co.uk
Minotaur *p83*
Morphogenesis *p93*

CARLOS CABRERA
www.carloscabrera.com.ar
sayhi@carloscabrera.com.ar
Minotaur *p52*

ROBERTO CAMPUS
www.robertocampus.com
bob@robertocampus.com
Little One *p146*
Shell Fairy *p144*
© Becker&Mayer

BENJAMIN CARRE
www.blancfonce.com
benjamincarre@gmail.com
Locke Lamora *p157*
© Bragelonne
Prophecy *p85*
© Flammarion
Ulysse *p73*
© Père castor-Flammarion

ROBERT CHANG
www.ethereality.info
web@ethereality.info
Black Wolf Ronin *p17*
Scythe Wolf *p48*
Till Death Do Us Part *p26*

MIKE CORRIERO
www.mikecorriero.com
mikecorriero@gmail.com
Keeper of the Fields *p94*
Tiltadron *p90*

KEVIN CROSSLEY
www.kevcrossley.com
bombjak69@hotmail.com
Angelic Corruption *p145*
Krike Dragon *p72*

MELANIE DELON
www.eskarina-circus.com
esk@eskarina-circus.com
Surprise *p100*
What I See *p109*

SACHA "ANGEL" DIENER
www.angel3d.ch
angel@angel3d.ch
Flames of Magic *p107*
Spellsword *p49*

TONY DITERLIZZI
www.diterlizzi.com
Old World Leprechaun *p139*
Peter Pan in Scarlet *p136*

JASON ENGLE
www.jaestudio.com
jae@jaestudio.com
The Battle of Four Armies
p172-173
Dark Knight *p33*
Dreamfall *p43*
Knights of Ansalon *p24*

JASON FELIX
www.jasonfelix.com
jasonfelix@msn.com
Male Medusa *p76*
Wooden Wizard *p56*

FELIPE MACHADO FRANCO
http://finalfrontier.
thunderblast.net
newdimensionart@yahoo.com
As Holy as They Come *p106*
Mystica *p123*
The Golden Armour *p15*
Walk the Earth *p121*

XIAO-CHEN FU
www.krishnafu.com
krishna860@hotmail.com
Chi You and Taotie *p28*
Kill the Winter *p44*

DENISE GARNER
www.towerwindow.com
denise@towerwindow.com
Dragon Skins *p40*
Kiss *p144*
Temptation *p2 & p66*

JOHN GARNER
www.shadowsofthunder.com
john@shadowsofthunder.com
Forest Dragons *p69*
Lancelot's Secret *p170*
Spawning Ground *p70*

MATT GASER
www.mattgaser.com
mgaser@mac.com
Amphibula *p156*
Garga's Concern *p125*
Gluba Vanderhon the Giant *p166*
Goondabar Discovery *p171*

DONATO GIANCOLA
www.donatoarts.com
donato@donatoart.com
The Battle of Agincourt:
25 October 1415 *p189*
Wyvern Hunting *p182*

YVONNE GILBERT
www.yvonnegilbert.com
yvonne.gilbert@dsl.pipex.com
Ice Dragon *p62*
Lady of Shalott *p111*
Merlin *p123*

REBECCA GUAY
www.rebeccaguay.com
rebeccaguay@yahoo.com
Angel of First Love *p101*
© 2007 Rebecca Guay and Angel
Quest Inc
Beauty and the Unicorn *p74*
Cupid and Psyche *p63*
Mev *p108* © 2007 Rebecca Guay
and D. Legro

JIAN GUO
http://breathing2004.gfxartist.com
beathing2004@yahoo.com.cn
Bone of the Ocean *p38*
Goddess of Industry *p140*
The Last Guardian *p55*

EMILY HARE
www.emilyhare.co.uk
emily.hare@gmail.com
Sorcerer *p116*

NICK HARRIS
(Virgil Pomfret Artists Agency)
virgil.pomfret@online.fr
Dragon Wrangler *p183*
The Enchanting *p138*
Siren Song *p102*

LEO HARTAS
www.hartas.eclipse.co.uk
leo@hartas.eclipse.co.uk
Mountain Dragons *p54*

RYOHEI HASE
www.h4.dion.ne.jp/~ryohei-h/index.html
ryohei_hase@f6.dion.ne.jp
Bound *p77*
Cannot Prevent *p168*
Untitled *p175*
Their Feeling *p183*

TONY HAYES
www.my-art-gallery.co.uk
tonyhayes@blueyonder.co.uk
Day Dreamer *p103*
Empty Vessels *p169*

KORY HEINZEN
kory@korysdiner.com
http://korysdiner.homestead.com
Hard Day's Work *p21*

RICHARD HESCOX
www.richardhescox.com
triffid@charter.net
Night *p98-99*

JON HODGSON
www.jonhodgson.net
Jonnyhodgsonart@aol.com
Dragon Warriors *p187*
© Magnum Opus Press
Shugenja *p45*
© Alderac Entertainment Group
Yobanjin Wyrm *p53*
© Alderac Entertainment Group

KAREN ANN HOLLINGSWORTH
www.wreditions.com

karen@wrenditions.com
A Fool's Love (Alas) p126
Imagine p139

KUANG HONG
www.zemotion.net
noah@zemotion.net
End of Godliness p39
The Disciplinant p83

RALPH HORSLEY
www.ralphhorsley.co.uk
email@ralphhorsley.co.uk
City of Peril p78
© Wizards of the Coast
Kicking Back p181
© Wizards of the Coast
Mialee Prepares Her Spells p127
© Wizards of the Coast
Realms of Sorcery p58
© Games Workshop

TONY HOUGH
www.tonyhough.co.uk
tonyhough2000@yahoo.co.uk
After a Long Silence..... p158
Byakhee p57

MICHAL IVAN
http://perzo.cgsociety.org/about
mivan@ba.psg.sk
Bogatyr p29
Jaga p41
Meatman vs. Werebear p177

UWE JARLING
www.jarling-arts.com
uwe@jarling-arts.com
Majestic Dignity p97
Mighty Dragon p88

CAMILLE KUO
http://camilkuo.com/main.htm
camilkuo@hotmail.com
Cerebrus p91
Dunhuang p82

RAPHAEL LACOSTE
www.raphael-lacoste.com
Raphael.lacoste@gmail.com
Chinese Winter p154
Path to the Gothic Choir p167

CLINT LANGLEY
www.clintlangley.com
anjahemmerich@yahoo.com
Blood of the Dragon p60
Blood of the Dragon novel cover,
for the Black Library/Games Work-
shop Limited (www.blacklibrary.
com). Copyright Games Workshop

Ltd 2005. Used with permission.
Slaine p19
Slaine © Copyright 2007
Rebellion A/S. All rights reserved.
www.2000ADonline.com

STEPHANIE LAW
www.shadowscapes.com
stephlaw@gmail.com
Page of Wands p137
Skimming the Surface p147

SOA LEE
www.soanala.com
soanala@naver.com
A Fascinating Bloom p141

DARYL MANDRYK
www.mandrykart.com
blackarts@shaw.ca
Silver p23
Stalker p8 & p37

MARTIN MCKENNA
www.martinmckenna.net
martin@martinmckenna.net
Blue Queen p118
Eye of the Dragon p70
Spell Breaker p79
Temple of Terror p59

WILLIAM O'CONNOR
www.wocstudios.com
wocillo@comcast.net
Fire and Water p17
Zephyr's Tomb p134-135

JIM PAVELEC
www.jimpavelec.com
Genethoq@comcast.net
Olive Skinned in Cobalt Fur p113
Wererats p95

KRISTEN PERRY
www.merekatcreations.com
merekat@merekatcreations.com
You must like high tea with your
conversation p136
The Same Deep Water as You
p63-65

R. K. POST
www.rkpost.net
Postrk@aol.com
Benrig Medb p110
Eva in Repose p34-35
Ressa p43
Zaramoth Unleashed p178

PATRICK REILLY
http://preilly.deviantart.com/gallery

reilly1138@msn.com
Pirates p163
Tales from the High Seas p84
Technical Difficulties p78
Wrecking Crew p96

KARL RICHARDSON
http://karlrichardson.co.uk
karl.richardson24@ntlworld.com
Garhunt p184
© 2007 The Upper Deck Company;
World of Warcraft © 2004-2007
Blizzard Entertainment, Inc.
Ulk Rider p31

ANDREAS ROCHA
www.andreasrocha.com
rocha.andreas@gmail.com
Home p164-165
Spring Sunset p4-5 & p152-153

RICK SARDINHA
www.battleduck.com
rick@battleduck.com
Elemental Moon p75
Methuselah (Gift of Tongues) p124

ERIC SCALA
www.ericscala.com
eric.scala@free.fr
Crossing The River Styx p89
Little People Parliament p132-133

MICHAEL SEE
http://michaelzhsee.cgsociety.
org/gallery
szxmiko02@yahoo.com
The Journey p155

GREG STAPLES
www.gregstaples.co.uk
gs@gregstaples.co.uk
Sage of the Scroll p69
© Wizards of the Coast
Serra Angel Vs Spectre p184
© Wizards of the Coast
Solomon Cane p14
© Wandering Star/Davis Films
Productions
Zombie Psycho p53
© Wizards of the Coast

MATT STAWICKI
www.mattstawicki.com
mstawicki@mattstawicki.com
The Fox p192
The Sharing Knife p47
ANNE STOKES
www.annestokes.com
email@annestokes.com
Controller p71

Dragon Reflection p8 & p36
Dragon's Nest p179
Scarlet Mage p46

J. P. TARGETE
www.targeteart.com
artmanagement@targeteart.com
Arcana Evolved p174
Dark Riders p186
Fair Folk p150
Quag Keep p23

ROB THOMAS
www.mindsiphon.com
mindsiphon11@yahoo.com
Necro Warrior p27

FRANCIS TSAI
www.teamgt.com
tsai@teamgt.com
Magic Item p30
© Wizards of the Coast
Rowan Blackwood p41
© Wizards of the Coast

LINDA TSO
www.stickydoodle.com
lindatso@stickydoodle.com
Black Dandy p104
© Hotu Publishing
Liante p111

BORIS VALLEJO
www.imaginistix.com
The Junk Collector p6

CYRIL VAN DER HAEGEN
www.tegehel.org
tegehel@cox.net
Friday the 13th, October 1307 p180
The Last Tarot p68

ANTHONY S. WATERS
www.thinktankstudios.com
bightme@thinktankstudios.com
Awakening Maro p114-115
© Wizards of the Coast
Ravnica Forest p171
© Wizards of the Coast
Ravnica Mountains p159
© Wizards of the Coast
Ravnica Plains p167
© Wizards of the Coast
Voidshriek Spectre p86
© Wizards of the Coast

BENITA WINKLER
http://eeanee.com
benita@eeanee.com
Faydrums p150
Lovecats p143

KIEREN YANNER
www.kieranyanner.com
kieran@kieranyanner.com
The Night of Dissolution p174
© 2006 Monte J. Cook
Daniel p142
Death and the Serpent of Caol
p129

MICHAEL ZANCAN
http://zancan.fr
michael@zancan.fr
Backdoor to Luxuriance p105
Garden of Giants p151
Purple-spattered Memories p159

Acknowledgments

A huge thank you to all the artists for their fantastic contributions, enthusiasm, and support.

Special thanks to:
Karen Hollingsworth, Dave Morris, Lou Hankins, Jim Pritchett, Lizzie Franke, and most especially to Mary McKenna.

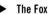 **The Fox**
Matt Stawicki
Book cover
The Fox from DAW
Adobe Photoshop and Corel Painter
www.mattstawicki.com

For his second book cover in this series, Matt found it interesting to return to a character for another portrayal: "The main character was much younger in the first book, and I'd relied on the environment to provide drama. However, with this piece I was able to really focus on the figure. The ship as the backdrop was a great element because of how off kilter a boat can be. It's a great opportunity for a very dramatic angle."

Psalms Picture Book

Jacqueline Melgren

"Be still, and know that I am God; I will be exalted among the nations, I will be exalted in the earth."

PSALMS 46:10, NIV

"Whoever dwells in the shelter of the Most High will rest in the shadow of the Almighty."

PSALMS 91:1, NIV

"Take delight in the LORD and he will give you
the desires of your heart."

PSALMS 37:4, NIV

"For you created my inmost being; you knit me together in my mother's womb."

PSALMS 139:13, NIV

"Create in me a pure heart, O God, and renew a steadfast spirit within me."

PSALMS 51:10, NIV

"I have hidden your word in my heart that I might not sin against you."

PSALMS 119:11, NIV

"I praise you because I am fearfully and wonderfully made; your works are wonderful, I know that full well."

PSALMS 139:14, NIV

"Where can I go from your Spirit? Where can I flee from your presence?"

PSALMS 139:7, NIV

"Search me, God, and know my heart; test me and know my anxious thoughts."

PSALMS 139:23, NIV

"And the words of the LORD are flawless, like silver purified in a crucible, like gold refined seven times."

PSALMS 12:6, NIV

"Taste and see that the LORD is good; blessed are those who take refuge in Him."

PSALMS 34:8, NIV

"Wait for the LORD; be strong and take heart and wait for the LORD."

PSALMS 27:14, NIV

"In you, LORD, I have taken refuge; let me never be put to shame."

PSALMS 71:1, NIV

"Teach us to number our days, that we may gain a heart of wisdom."

PSALMS 90:12, NIV

"Blessed is the nation whose God is the LORD,
the people he chose for his inheritance."

PSALMS 33:12, NIV

"Give thanks to the LORD, for he is good; his love endures forever."

PSALMS 107:1, NIV

"Let everything that has breath praise the LORD. Praise the LORD."

PSALMS 150:6, NIV

"I sought the LORD, and he answered me; he delivered me from all my fears."

PSALMS 34:4, NIV

"Praise the LORD, my soul, and forget not all his benefits."

PSALMS 103:2, NIV

"If I had cherished sin in my heart, the Lord would not have listened;"

PSALMS 66:18, NIV

"I lie down and sleep; I wake again, because the LORD sustains me."

PSALMS 3:5, NIV

"For he who avenges blood remembers; he does not ignore the cries of the afflicted."

PSALMS 9:12, NIV

"I call out to the LORD, and he answers me from his holy mountain."

PSALMS 3:4, NIV

"You, LORD, hear the desire of the afflicted; you encourage them, and you listen to their cry."

PSALMS 10:17, NIV

"The LORD is King for ever and ever; the nations will perish from his land."

PSALMS 10:16, NIV

"Fill my heart with joy when their grain and new wine abound."

PSALMS 4:7, NIV

"Do not cast me away when I am old; do not forsake me when my strength is gone."

PSALMS 71:9, NIV

"To the faithful you show yourself faithful, to the blameless you show yourself blameless."

PSALMS 18:25, NIV

"My shield is God Most High, who saves the upright in heart."

PSALMS 7:10, NIV

"From the LORD comes deliverance. May your blessing be on your people."

PSALMS 3:8, NIV

CPSIA information can be obtained
at www.ICGtesting.com
Printed in the USA
LVHW071043221021
701184LV00002B/22